P9-EAX-416

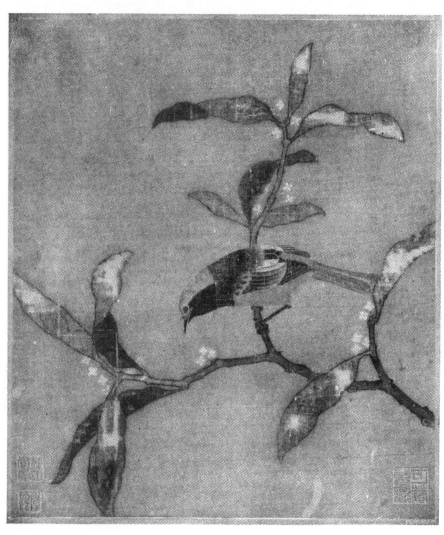

Frontispiece. Bird on Bough. Sung Dynasty.
Collection of G. Eumorfopoulos, Esq.

PAINTING IN THE FAR EAST

AN INTRODUCTION TO THE HISTORY OF PICTORIAL ART IN ASIA ESPECIALLY CHINA AND JAPAN

BY LAURENCE BINYON

FOURTH EDITION
REVISED THROUGHOUT

DOVER PUBLICATIONS, INC.
NEW YORK

This Dover edition, first published in 1969, is an unabridged and unaltered republication of the Fourth Edition of the work first published by Long-mans, Green & Company in 1934 except that the Frontispiece which originally appeared in color is now reproduced in black and white. It is published through the kind cooperation and permission of Mrs. Cicely Binyon.

The publisher is grateful to the directors of the Enoch Pratt Free Library in Baltimore, Maryland for supplying a copy of the above mentioned Fourth Edition for reproduction purposes.

Standard Book Number: 486-20520-7
Library of Congress Catalog Card Number: 70-95201

Manufactured in the United States of America
Dover Publications, Inc.
180 Varick Street
New York, N.Y. 10014

INSCRIBED
TO
THE MEMORY OF
CHARLES L. FREER

PREFACE TO THE FOURTH EDITION

THIS book was first published in 1908, and was, I believe, the first book in a European language on the subject with which it deals. At that time very little had been discovered about Chinese painting, though Professor H. A. Giles' " Introduction to the History of Chinese Pictorial Art " supplied a full account of the painters. It was indeed a generally accepted opinion that Japanese art was altogether superior to Chinese ; yet even of Japanese painting the great achievements of the earlier schools were still unknown except to a few students and collectors. Since then an immense change has taken place. Something at least of the true character and quality of Chinese painting, in spite of the destruction which has left so few authentic relics of the older periods, has been revealed to the West ; and Japanese art is now unduly depreciated in comparison. Every year has added to the material available, both through the acquisition of paintings for European and American collections and through the publication of fine reproductions, especially in Japan. The enlightening discoveries made

by archæologists of various countries in Chinese
Turkestan have proved of the greatest interest and
importance. A National Museum has been created
at Peking. At the same time criticism has been
active, both in East and West; traditional attribu-
tions, long innocently accepted, have had to be dis-
carded; important Chinese texts have been trans-
lated. Since the last edition of this book appeared,
eleven years ago, Mr. Waley has published his
" Introduction to the Study of Chinese Painting,"
especially valuable for its documentation from
original sources and its critical exposition of the
background of religion, thought and literature. Dr.
Osvald Siren's " History of Early Chinese Painting,"
published last year, is based on a first-hand study
of collections all over the world and reproduces for
the first time many pictures in the Peking Museums.
Mr. Arthur Morrison's " Painters of Japan " pro-
vides the student with a very complete account of
Japanese pictorial art. To these works, and other
books and articles on particular periods of painting,
the reader who wishes to explore the subject more
fully is referred. In revising my text for this edition
I have had all this increased material in view and
am in debt to many scholars in the field; I have
also had the benefit of studying collections in Japan
and China and of renewing acquaintance more than
once with American collections. Newly discovered
facts have been incorporated, statements modified;

PREFACE

a number of pages have been re-written. But there has been no attempt to enlarge or alter the scope of the volume, and I hope it may still serve its purpose as an introduction to the study of the great tradition of pictorial art created in China and continued in Japan. If I may quote from the original preface, it is " an attempt to survey and to interpret the aims of Oriental painting, and to appreciate it from the standpoint of a European in relation to the rest of the world's art. It is the general student and lover of painting whom I have wished to interest. My chief concern has been, not to discuss questions of authorship or archæology, but to inquire what æsthetic value and significance these Eastern paintings possess for us in the West."

Six of the illustrations used in the last edition have been exchanged for others which seemed more representative of their periods. I tender my thanks for permission to use them to H.E.H. the Nizam of Hyderabad and Dr. Yazdani (in respect of the Ajantā fresco), to the Trustees of the British Museum, and the Trustees of the Boston Museum of Fine Arts.

<div align="right">L. B.</div>

August, 1934.

CONTENTS

ILLUSTRATIONS

PAINTING IN THE FAR EAST

ILLUSTRATIONS

PAINTING IN THE FAR EAST

xvi

PAINTING IN
THE FAR EAST

CHAPTER I. THE ART OF THE EAST AND THE ART OF THE WEST

IN the great mystical poem of Persia, the " Masnavi," it is told how the Greeks and the Chinese disputed as to which were the better artists. Their dispute was brought before the Sultan ; a contest was arranged, and a house allotted to each party for them to embellish in their own way. The poet tells how the Chinese covered the walls of their house with paintings, while the Greeks contented themselves with cleaning theirs till the walls shone bright and clear as the heavens. The work of the Chinese was greatly admired, but it was the Greeks who were adjudged the prize.

This story is told merely by way of illustration, and is put to symbolic use by the poet. It would be rash to treat it as historic relation. Yet doubtless it reflects some truth of tradition. At any rate it embodies a traditional antithesis between the art of the East and the West.

In what precisely does this antithesis exist ? Does the Persian poet's allusion emphasise, as we might perhaps infer, a reliance of the East on colour, a reliance of the West on form ? Such an interpretation might well commend itself as a plausible conception to general acceptance in this country.

This thesis was, in fact, promulgated some years ago by a thoughtful writer in an interesting and ingenious essay.* In seeking to form a conclusion on such a subject, we cannot do better than follow Aristotle's method, and start by examining some theory already in the field. And as this theory accords with popularly received impressions, we shall do well to see what support it really has from facts.

" The two main ideas," writes the critic in question, " with which all art is concerned seem to have been separately contributed, one by the West, the other by the East. Form is chiefly a matter of the intellect. The arts which deal with form convey ideas. Their appeal is to the mind. Colour, on the other hand, conveys no ideas. It is emotional, and appeals to the senses rather than the intellect. And this being so, it seems natural that the Western temperament, intellectual rather than sensuous, should excel in form rather than colour ; while the Eastern, sensuous rather than intellectual, should excel in colour rather than form."

There is more than one point in these too absolute statements which challenge discussion and criticism. But let us first follow our author in the development of his theory.

After characterising Oriental colour as something different from Western colour, as distinguished by

* " Byzantine Architecture." *Edinburgh Review*, October 1904.

a note of " swarthy and deep half-melancholy rich-
ness," he goes on to say that in the Eastern con-
ception of colour there is " that union of strength
and simplicity which reveals itself only when a
nation is dealing with the things which it under-
stands and which corresponds to its own genius.
To match the Eastern sense for colour we must
have recourse to the Western sense for form." And
the West is weak, trivial, and uncertain in colour,
as the East is unstable, eccentric, and capricious in
form.

But more : " Though the idea of colour is indi-
genous to the East, yet of an adequate expression
of that idea, of its embodiment in any great work
or school of art, the East has never been capable.
. . . Diffused throughout the life of the East as
this sense for colour is, we look in vain for any
great artistic manifestation, any school of painting
or architectural style of Eastern origin and growth,
which shall centralise and collect that sense for
colour for us. The impotence that saps the
emotional temperament has waited on the East."
According to this writer, it was the Byzantine
Greeks who were called upon to effect a mani-
festation of the Oriental ideal of colour, an ideal
which the Oriental races had been too feeble-willed
to do more than trivially illustrate in minor arts and
crafts.

All this is as plausible at first sight as it is inter-

5

esting. But now we must ask : On what evidence is this theory based ? The writer has many and definite illustrations to draw from in the field of Western art, but his illustrations from the East are fragmentary and vague. Have the Oriental races really been so impotent and uncreative ? Do the vague associations of luxury and sensuous magnificence which the " gorgeous East " brings into our minds really represent all that is to be known of it ? Is there nothing besides carpets and embroideries, lustrous wares and richly ornamented metal-work, familiar to our eyes in our shops, as Aladdin's trays of rubies and the glowing furniture and background of the " Arabian Nights," together with a hundred phrases from the poets, are familiarly impressed on our imagination, with the same vague and sumptuous effect ? If so, then we must indeed say that art in the East has never emerged from the barbaric stage, the stage in which decoration precedes design, and in which the sense for beauty remains childish, fascinated by colour and movement, unable to grasp organic relations, incapable of coherent and articulate production.

We say " the East," with how huge a generalisation ! Most Englishmen, if they ask themselves what materials their minds have collected to furnish and fill out this broad idea, will think above all of India. And if they pursue the question into a special field of art, reminiscences of travel or of

6

reading will recall images of architecture that are, at least to our eyes, hardly comparable with the masterpieces of European architecture, together with, it may be, some scattered specimens of Persian miniature painting or Japanese colour-prints, and for the rest mere craftsman's work, textiles, and *bric-à-brac*.

Oriental architecture is now beginning to be more justly appreciated, but it is not in this art that the genius of Asia has found its supreme expression.

Let us take pictorial art : Persian paintings, Japanese prints and drawings, what have these in common ? Are they sporadic outbursts, one on the western, the other on the eastern verge of the vast continent ? Or are they both related to an older and more central art ?

The latter answer is the right one. It is in China that the central tradition of Asian painting must be sought for. Of all the nations of the East, the Chinese is that which through all its history has shown the strongest æsthetic instinct, the fullest and richest imagination. And painting is the art in which that instinct and that imagination have found their highest and most complete expression. If we are to compare the art of the East and the art of the West, in their essential character and differences, we must take as our type of the former the pictorial art of China.

But why not of Japan ? would have been the

7

question asked when this book was first published. For it was popularly believed—though the belief is now extinct—that in art the Japanese had enormously improved on what they had derived from China. Certainly they have added new elements, and in some particular respects have surpassed the older nation, though in other respects they have never attained the same level. So vast an amount of Chinese painting has been lost or destroyed that we have no means for any detailed comparison. Yet even what little remains vindicates its great claim. The Japanese look to China as we look to Italy and Greece : for them it is the classic land, the source from which their art has drawn not only methods, materials, and principles of design, but an endless variety of theme and motive. As in the late nineteenth century Japan took over the material civilisation of Europe, so, more than a thousand years earlier, she took over and absorbed the civilisation of China, its art, its religion, its thought. But it was not foundation and starting-point alone that Chinese art supplied, but a pattern and ideal. Again and again the painters of Japan have renewed their art with fresh life and inspiration from the vigorous schools of the continent. The first great school of painting in Japan derived entirely from the grand and forcible style of the masters of the T'ang dynasty. In the twelfth and thirteenth centuries a school arose which developed a native character in

8

its design, and enrolled in its ranks a number of splendid draughtsmen and gorgeous colourists. When this school decayed, it was again from China that the renaissance came, the great renaissance of the fifteenth century which established the three classic schools of painting in Japan, and gloried in infinite variations on themes already handled with consummate feeling and expression by the galaxy of artists who flourished under the Emperors of the House of Sung. The next phase in Japanese painting was inaugurated by emulation of the rich and decorative colouring of the earlier Ming epoch ; and once more, in the eighteenth century, a last wave from the now declining art of China left its traces on impressible Japan.

The painting of the two countries, therefore, represents one great and continuous tradition, a tradition maintained and made illustrious by countless artists for two thousand years. From China that tradition, with its principles and ideals, originates ; not only Japan in the East, but (to a much less degree) Persia in the West, has derived inspiration for its art from the fertilising overflow of that wonderful nation whose history has been the continued absorption from without of barbarous neighbours and invaders, and the imposition on its conquerors of its own civilisation.

The general conception of Chinese art which till the end of the last century prevailed in Europe was

entirely founded on the productions of its decadence.
Even in the case of the porcelain, it was the later
kinds that were collected and prized : the simpler
and grander forms of the earlier periods were only
beginning to be appreciated. In the case of painting,
the real nature of the art remained unguessed at for
centuries after " Chinoiseries " won their first vogue
in the West. The bastard and comparatively worth-
less productions made now for two centuries for the
European market in Canton represented for those
of the general public who had formed any idea at
all on the subject the pictorial art of the Empire ;
and they associated that art with bright, if harmoni-
ous, colours, a tame and flaccid sense of form, and
the monotonous repetition of effete conventions.

But if we take the central tradition of Asian
painting in its great periods and most typical form
of expression, what do we find ? We find a type
of painting in which colour, so far from being pre-
dominant, is an always subordinate element, and is
often entirely absent.

The painting of Asia is throughout its main tradi-
tion an art of line. The Chinese of the twelfth
century, the Japanese of the fifteenth, evolved an
art of tone, but in both cases eliminated colour.

A Chinese critic of the sixth century, who was
also an artist, published a theory of æsthetic
principles which became a classic and received
universal acceptance, expressing, as it did, the

deeply rooted instincts of the race. In this theory it is Rhythm that holds the paramount place ; not, be it observed, imitation of Nature, or fidelity to Nature, which the general instinct of the Western races makes the root-concern of art.

In this theory every work of art is thought of as an incarnation of the genius of rhythm, manifesting the living spirit of things with a clearer beauty and intenser power than the gross impediments of complex matter allow to be transmitted to our senses in the visible world around us. A picture is conceived as a sort of apparition from a more real world of essential life.

Everyone knows the story of the grapes of Zeuxis which appeared so like real grapes that birds came to peck at their tempting clusters. The Chinese have parallel fables about famous masterpieces, but how different an order of ideas they attest ! A great artist painted a dragon upon a temple wall, and as he put the final touch to it, the dragon, too instinct with life, soared crashing through the roof and left an empty space. The inner and informing spirit, not the outward semblance, is for all painters of the Asian tradition the object of art, the aim with which they wrestle.

Let us take an example, a Chinese painting of the thirteenth century. The subject is " The Moon over Raging Waves." Doubtless to the Chinese mind the theme had its symbolic side ; the peace of the radiant soul above the fluctuating tumult of

the passions is perhaps the parallel suggested ; but we need no more for enjoyment than the inherent poetry of the contrast. The picture presents us with a vision of the sea, a waste of waves curling over into foam, pale under the brightness of the full moon. And the waves are represented by lines which, if they neglect the accidental edges and broken forms of rough water as we see it, emphasise the continuous curve and rhythm by which waves are actually created. Another treatment of this sub-ject—traditional, like so many of the subjects of Asian art—shows the golden moon appearing over the shoulder of a shadowy promontory, and at its base a single wave flung up out of darkness into the moonlight. The same treatment of water persists throughout this art, from the earliest examples we know down to Okyo and Hokusai in Japan. It is always the essential character and genius of the element that is sought for and insisted on : the weight and mass of water falling, the sinuous, swift curves of a stream evading obstacles in its way, the burst of foam against a rock, the toppling crest of a slowly arching billow ; and all in a rhythm of pure lines. But the same principles, the same treatment, are applied to all subjects. If it be a hermit sage in his mountain retreat, the artist's efforts will be concentrated on the expression, not only in the sage's features, but in his whole form, of the rapt intensity of contemplation ; towards this effect

12

every line of drapery and of surrounding rock or tree will conspire, by force of repetition or of contrast. If it be a warrior in action, the artist will ensure that we shall feel the tension of nerve, the heat of blood in the muscles, the watchfulness of the eye, the fury of determination. That birds shall be seen to be, above all things, winged creatures rejoicing in their flight ; that flowers shall be, above all things, sensitive blossoms unfolding on pliant up-growing stems ; that the tiger shall be an embodied force, boundless in capacity for spring and fury—this is the ceaseless aim of these artists, from which no splendour of colour, no richness of texture, no accident of shape, diverts them. The more to concentrate on this seizure of the inherent life in what they draw, they will obliterate or ignore at will half or all of the surrounding objects with which the Western painter feels bound to fill his background. By isolation and the mere use of empty space they will give to a clump of narcissus by a rock, or a solitary quail, or a mallow plant quivering in the wind, a sense of grandeur and a hint of the infinity of life.

Who shall say of such an art that it is not mature, still less that it is impotent to express ideas ? In its coherence and its concentration, in its resolute hold on the idea of organic beauty, this tradition, so old in the East, manifests the character of an art that has reached complete development.

13

This painting, we have said, is an art of line rather than an art of colour. Yet it is not difficult to see how an art of line can come to have for one of its chief characteristics, and for its most obvious attraction, the charm of colour. The Japanese prints of the eighteenth century, for instance, proved a revelation of exquisite colour to Europeans ; and yet they, too, are in their essence linear designs. The reason is that these linear designs, though expressive of interior form, aim at no illusion of relief, and ignore cast shadows. The spaces to be coloured are flat spaces, and the instinct of the artist is to invent a harmony of colours which intensifies and gives added charm to the harmony of line. Such an art never loses sight of the primary condition of a picture as a decoration on a flat wall ; and with this decorative aim the free and undistracted development of colour-harmonies is naturally associated. It is when a new and absorbing interest is added to pictorial art, when the artist attempts to produce the likeness of figures and objects as they appear in relief, and begins to use light and shade as a means to this end, that his mind is distracted from the pursuit of harmony in line and colour ; these become secondary aims, and as a natural consequence the sense for colour becomes weak and uncertain. Why is it that in Italian painting before the Renaissance, even where no decided genius for colour is shown, the colour of quite minor, insig-

nificant, and provincial masters pleases us ? It is because the painting of those early periods was as yet unconfused and undistracted by the problems of chiaroscuro. European painting, however, was soon committed to the portrayal of relief and the ideal of complete realisation. In the North this was inevitable because of the powerful instinct towards realism innate in the races of the Netherlands, the early flowering of whose genius directed the aims of painting. In Italy it was equally inevitable, because of the intellectual passion for science which was inseparable from the genius of Florence ; and it is from the great Florentine school that Europe inherits its main tradition of design for all ideal subjects. Scientific curiosity has, ever since the Renaissance, played a potent part in the history of European art. In painters like Paolo Uccello we find the struggle to master perspective overshadowing the purely artistic quest for beauty, just as in recent times an intense interest in scientific discoveries about the nature of light led a whole school of landscape painters to sacrifice fundamental qualities of design in a passionate endeavour to realise on canvas the vibration of sunlight.

Science must of course play a part in the production of all mature painting. The artist in his desire to discover beauty is confronted with difficult problems which he must acquire the science to solve ; but it is as a means to an end, and only as a means.

15

It is the besetting vice of our Western life as a whole, so complex and entangled in materials, that we do not see things clearly ; we are always mixing issues, and confounding ends with means. We are so immersed in getting the means for enjoying life that we quite forget how to enjoy it, and what is called success is, oftener than not, defeat. So, too, in current criticism of painting, it was till lately commonly assumed that an advance in science is of itself an advance in art ; as if correct anatomy, a thorough knowledge of perspective, or a stringent application of optical laws were of the slightest value to art except as aids to the effective realisation of an imaginative idea.

The scientific aim which has warped and weakened certain phases of modern painting in Europe is a symptom of Western tendencies in extreme. The East has also sometimes carried its tendencies to extreme ; we find the expression of them in what is known as the Literary Man's Painting of China and Japan, a kind of art which has as little reference as possible to external fact and relies entirely on vague suggestions of poetic mood.

But, ignoring these extreme expressions, let us regard rather the sum of classic painting in Asia and in Europe.

The main arresting difference is, as we have seen, that the painting of Europe does not limit itself ; it is not content till it has mastered every possible

16

means of communicating ideas through the representation of the visible world : it emulates the effects of sculpture, in order to communicate the emotions which alone can be produced by figures seen in roundness and relief ; it emulates the effects of architecture, in order to communicate the emotions that only ordered spaces and perspective can evoke. And it wants to produce all these effects at once, as well as the effects of harmonious line and colour.

The painting of Asia, on the other hand, limits itself severely. It leaves to sculpture and to architecture the effects proper to those arts. But it has not remained merely decorative, as so many people assume ; it is in its own way fully as mature as our own.

The great painters of either continent have pursued the same end. They have sought to communicate life-giving ideas of beauty in a sensuous embodiment. The means employed have been different, yet not so different as would appear at first sight. Limited to line, the painters of Asia have concentrated centuries of study on the effort to make that line intimately expressive of form ; and with mere contour they succeed in producing the illusion of perfect modelling. The very ease with which relief can be represented by shadows, as with us, has taken away from our painters the necessity for this concentration and weakened their sense for expressive line. The painters of the East

17

have succeeded in giving life to their figures ; and that the figures in a picture should impress us as real, breathing, laughing, sorrowing humanity, this is the essential thing we demand. Absolute anatomical correctness, which pedants demand, detracts from this impression, and is no more present in the great painting of Europe than in the great painting of Asia. The fact is, we are so used to our own set of conventions that we forget how large a part they play even in the most realistic pictures, and when confronted, in the art of Asia, with a different set of conventions, we are apt to fix our attention entirely on them, instead of allowing ourselves to receive the suggestions of reality which these are intended to produce. So it is often said that there is no perspective in Chinese and Japanese painting. Raphael Petrucci, in a most illuminating, comprehensive, and masterly essay,* entirely exploded this fallacy. He has conclusively shown that the mastery of perspective in Eastern painting is quite comparable to that of European painting, only it is different in the conventions it allows ; it has been naturally evolved out of the past history of art in Asia, whereas in Europe its problems were approached in the fifteenth century from an abstract point of view, as geometry, in a conscious effort to recover effects known to have

* " Les Caractéristiques de la Peinture Japonaise." Par R. Petrucci. *Revue de l'Université de Bruxelles*, Janvier-Février, 1907.

been achieved by the Greek painters. As we shall see, Chinese painters of the eighth century and the twelfth century, among many others, have left treatises on the means of representing in a picture the appearances of the relative distances of objects in space. But Petrucci also showed that in European painting, even in masterpieces of artists like Leonardo and Ingres, the laws of perspective are boldly violated in obedience to æsthetic necessities, although we are entirely persuaded of the reality of the effect produced, and the violation is only perceived when we resolutely discard the artistic impression and make a patient scrutiny from the point of view of science alone. He reminds us, too, how easily Hokusai was able to assimilate European perspective, learnt from the Dutch at Nagasaki, to the perspective of the Japanese.

Readers of Goethe's " Conversations " will remember his striking comment on a landscape by Rubens. He showed an engraving after this picture to the ingenuous Eckermann, and asked him to say what he noticed in it. After minutely describing every detail, Eckermann at last saw what he was intended to see, that the figures in the picture cast their shadows one way and the trees another. Light, in fact, was introduced from two different sides, in a manner " quite contrary to Nature." " That is the point," said Goethe. " It is by this that Rubens proves himself great, and shows to the world that

he with a free spirit stands above Nature and treats her conformably with his high purposes." Admitting that the expedient was somewhat violent, still Goethe praises " the bold stroke of the master, by which in the manner of genius he proclaims to the world that art is not entirely subject to natural necessities, but has laws of its own." " The artist," he continues, " has a twofold relation to Nature ; he is at once her master and her slave. He is her slave, inasmuch as he must work with earthly things in order to be understood ; but he is her master, inasmuch as he subjects these earthly means to his high intentions."

Goethe's mind, so magnificently free from prejudice, at once sheds the light of truth upon the subject. The laws of science are not the laws of art. Yet so permeated are our ways of thought (how much more so since Goethe's day !) by scientific conceptions, that to many this criticism of his will seem a startling paradox and a dangerous heresy. On the contrary, the danger and the heresy are with those who import scientific views into judgments on art. Few of us probably realise how strong this influence is ; to what a degree, in the public, it prevents a free judgment of painting, and how tyrannical a claim it makes upon the painter of to-day.

Here is one thing we can learn from the study of Oriental painting. We can learn to distrust this tendency, absorbed from an age of triumphant

science, to set up an external objective standard, asking of a picture whether it correctly represents the objects it portrays, instead of asking to what service the materials have been used, and whether it is a real experience to our souls. Our art, like our civilisation, too often defeats its own end ; in the thirst for reality it falls into indiscriminate acceptance, and loses or obscures essentials. The art and the life of the East stand, with far more constancy, for a finely valuing choice.

We may now turn back for a moment to re-examine the theory with which we started. The notion that the idea of form is the great contribution of the West to art, and the idea of colour the great contribution of the East, is, we can now see, founded on entirely inadequate evidence, and even if true would not touch the essential question. There is indeed an unreality in the antithesis. What is meant by the idea of colour and the idea of form ? The phrases have no meaning except in so far as the idea of harmony or rhythm underlies both. Nor can the intellectual appeal in art be divorced from the sensuous or emotional appeal. Great art only begins when all these are absorbed and unified in one complete yet single satisfaction. It is a proof of the profound ignorance prevailing in the West of Asiatic art that so earnest and thoughtful a student as the critic I have quoted should totally ignore the painting of China and Japan. In that painting the

Oriental sense for colour is assuredly " collected and centralised " to magnificent effect. Yet I do not believe that the sense of colour is peculiar to the East, and that the West has only a "taste" for colour, without instinctive sense. Remember how easily even the Oriental sense for colour, strengthened by ages of tradition, can be corrupted by the introduction of cheap pigments invented by the chemists of Europe. Nowhere is there lovelier colour than in the Japanese prints of the fine period in the eighteenth century ; nowhere is there viler or more hideous colour than in those same prints when invaded during the 'sixties of the last century by the aniline pigments of the West. In Europe also the multiplication of pigments by chemistry has further weakened a colour sense already enfeebled or obscured among painters by scientific aims imported into art ; just as our sense for form has been vitiated and degraded by the commercial manufactures of machinery. I incline to believe that in the life of mediæval Europe the sense for colour played as strong a part as it is still claimed to play in Oriental life.

Both in this and in other respects, if we take a comprehensive view of the pictorial art of both continents, the differences which arrest at first sight tend to lessen or disappear on closer scrutiny. The critic I have quoted was misled, I think, by concentrating his attention on architecture rather than on painting. With Oriental architecture this book

22

is not directly concerned. Yet all art is one, and I do not wish to ignore conclusions that such a study might provoke. We find that painting in the East has carefully eschewed all emphasis on the solidity of materials ; it ever tends to absorb object in idea ; it is natural, therefore, that we should not expect the Asian spirit to find congenial expression in such an architecture as our own. I write with diffidence on the subject, but so far as I understand the architecture of Japan, for instance, I would say that it was conceived in a different spirit from our own ; that a building was regarded less in itself than as a fusion of man's handiwork into Nature, the whole surroundings of the scene making part, and perhaps the chief part, of the architect's conception. And here we touch what is certainly a very real and animating principle in the pictorial art of the East, and come at last on a more essential difference between the art of the East and the West.

This difference is rooted in philosophy of life, in mental habit and character. An opposition between man and Nature has been ingrained in Western thought. It is the achievements, the desires, the glory and the suffering of man that have held the central place in Western art ; only very slowly and unwillingly has the man of the West taken trouble to consider the non-human life around him, and to understand it as a life lived for its own sake : for

centuries he has but heeded it in so far as it opposed his will or ministered to his needs and appetites. But in China and Japan, as in India, we find no barrier set up between the life of man and the life of the rest of God's creatures. The continuity of the universe, the perpetual stream of change through its matter, are accepted as things of Nature, felt in the heart and not merely learnt as the conclusions of delving science. And these ways of thought are reflected in Eastern art. Not the glory of the naked human form, to Western art the noblest and most expressive of symbols ; not the proud and conscious assertion of human personality ; but, instead of these, all thoughts that lead us out from ourselves into the universal life, hints of the infinite, whispers from secret sources—mountains, waters, mists, flowering trees, whatever tells of powers and presences mightier than ourselves : these are the themes dwelt upon, cherished, and preferred.

The Italian Renaissance, and all the art deriving from its inspiration, represents the glorification of man. Only lately have we begun to feel dissatisfied with the ideas embodied in that movement and its splendid productions ; to become conscious that Europe has lost something which we desire to recover from those times which in the great Gothic cathedrals had power to transmute materials, even the most solid and massive, into ideas and aspirations. Setting out to conquer the material world,

24

to master its secrets and harness its energies to our uses, we have given our devotion to science ; but in the end science has humbled us. In the nineteenth century we in Europe came to apprehend more justly the true place of man in the world, and the art of our time arrives at just such a conception as the art of China had expressed, with perhaps even more truly modern feeling, a thousand years ago. I hope to make this plain when we come in the course of our survey to the painting of the Sung period, and can consider its productions in more detail.

It is in landscape, and the themes allied to land-scape, that the art of the East is superior to our own. The power of the art of the West excels in the human drama.

The Western spirit is full of an overpowering sense of the sublime capacities of mankind.

" What a piece of work is a man ! how noble in reason ! how infinite in faculty ! in form and moving how express and admirable ! in action how like an angel ! in apprehension how like a god ! the beauty of the world ! the paragon of animals ! "

Yet it is inevitable that to this spirit the hour of discouragement and dismay should bring, with a sharpness unknown to the Oriental temper and the

25

detached Oriental mind, the desolation of the sentence of mortality :

> " And yet what to me is this quintessence of
> dust ! "

The high Renaissance pride and glow are apt to leave this bitter taste in the end. Absorption in man as the centre of the world and hero of existence leads certainly to loss of that sanity and sweetness which an openness to the abiding presences of the non-human living world around us infuses into life, and which are so abundant and refreshing in the art we are about to consider. It is not by that absorption that we shall find the full meaning or animating power of our Western faith that in man the divinity is revealed.

I have sometimes thought that if our modern painting had developed continuously from the art of the Middle Ages, without the invasion of scientific conceptions which the Renaissance brought about, its course would appear to have run on very similar lines to that of the painting of the East, where the early religious art, so like in aim to that of the early Italian frescoes, flowered gradually into naturalism, always pervaded by a perfume of religious idealism. As it is, the painting of Europe is richer, more complex, it has added powers and new resources ; its contrast with Eastern art is like

that of dramatic poetry with lyric poetry ; more matter has been taken in hand, more difficulties attempted. The limitations of Eastern tradition keep its art pure and make even the productions of insignificant artists a pleasure to look upon. In our more burdened and more troubled art failure is far more frequent, though to its greatest triumphs attaches, it may be, a greater glory.

CHAPTER II. EARLY ART TRADITIONS IN ASIA

IN the winter of 1895–96, Dr. Sven Hedin, travelling across Central Asia, passed in the district of Khotan the mounded remains of deserted cities, covered up with drifts of sand. Khotan is in Chinese Turkestan. It was a small kingdom, paying tribute to China, lying to the north and somewhat to the east of Kashmir, on the southern edge of the Takla-Makan Desert.

Already there had filtered through to India objects claimed to have been found in the ruined cities of Khotan ; and now the information brought by Sven Hedin suggested that the sites which he had noticed should prove a favourable starting-point for systematic excavation. An expedition was sent out by the Indian Government under Dr. (now Sir) Aurel Stein, and the results of his successful exploration published in 1903, and more fully in 1907, proved of singular interest. That expedition has been followed up by numerous missions to Turkestan, Russian, German, French, and Japanese, as well as English, all of which have added enormously to our knowledge.

The cities of Khotan were abandoned about the eighth century A.D. The sand encroaching in waves

28

from the great desert had made them no longer habitable. It was not, as with Pompeii and Herculaneum, a sudden calamity arresting a people in its daily life; what the people of Khotan valued they took away with them; yet what was left is interesting enough. And the dry sand of the desert has preserved it all with perfect freshness for more than a thousand years.

What, then, do we find in this little, remote kingdom in the heart of Asia? We find sculpture and paintings; we find heaps of letters on tablets of wood; odds and ends of woven stuffs and furniture; and police notices on strips of bamboo. The police notices—couched in just such terms as we use to-day, " Wanted, a man with a grizzled moustache," &c. &c.—the police notices are in Chinese. The letters are written in a form of Sanskrit. But the string with which the wooden tablets are tied is sealed with a clay seal; and in most cases the seal is a Greek seal, the image of an Athene or a Heracles.

Here, then, we touch three great civilisations at once: India, Greece, China.

Each of these three great civilisations contributes to the building up of Asiatic art. What, then, of the paintings and the sculpture?

The paintings are in outline, with a certain amount of flat colour, on a white ground. The subjects are mostly figures from Buddhist legend. The style is of a primitive character.

29

If we ask ourselves what affinities these paintings reveal, with what art we can connect them, we cannot answer very definitely. We are reminded of features in Indian, Persian, Chinese, and early Japanese painting. What is certain is that these paintings represent, doubtless in a provincial type, the traditions of the early pictorial art of Asia, characterised by the definite strong outline on a white ground.

Will the sculptures tell us more ? They at once remind us of other sculpture ; of the numbers of statues and reliefs found in the district once called Gandhara, lying along the lower valley of the Kabul River, where a tribe of Indo-Scythians had occupied the country, succeeding to the Greek dynasties, and were converted to Buddhism. These statues and reliefs, like those of Khotan, are all Buddhist images. We know that the art of the sculptors of Gandhara was at its finest in the first and second centuries of our era. But in their statues we notice a gradual change and development. We see what seems a Greek Apollo ; and then little by little the Greek features become more Indian ; Apollo transforms himself into Buddha. The glad serenity of the Sun-God of the West, so open-eyed, so triumphant, takes on an ever-deepening shade of thought, the rapt smile of the world-withdrawn spirit contemplating eternity.

Here, then, in Gandhara, as farther east in Khotan, the art of Greece makes its power felt.

We know how immense that power has been as a living influence through centuries of European art, and we may be tempted to ascribe to it a governing influence in Asia. Yet in truth these traces that we have noticed mark the ebb of a receding tide.

In 323 B.C., Alexander died in Babylon. He had carried the arts and civilisation of Hellas far into the East. Cities on sites that he had chosen, Kabul, Kandahar, endure to this day. He had penetrated into remote regions north-west of India, and on into Turkestan. From the mouths of the Indus he had sent his fleet westward to explore the Indian Ocean. Arrian's narrative of the voyage reveals to us what a tremendous, unwilling adventure this was to the Greek sailors : they felt embarked on another Odyssey, and at every isle they touched expected legendary monsters to attack them. The will of one man, whose magnificent ambition was to conquer the world for the mind even more than to possess its riches and dominions, had hurried with him a home-sick army thousands of miles from its base, over deserts of burning sand, over mountains of perpetual snow, into the plains of India and to the shores of the Ganges. He reduced the Indian Ocean from a sea of terror and romance to known and navigated waters ; he was preparing, even when death overtook him, to man his fleet again and send it from the Euphrates westward round the continent of Africa.

31

So much a single brain, filled with the conviction that " Man's foe is ignorance," could do. He had brought Asia and Europe into contact, as they have never really been in contact since, till Japan in our own day, filled with the passion for knowledge, absorbed the achievements and the civilisation of the West.

But Alexander died, not forty years old ; and after his death the two continents shrank apart. Even his own exploits relapsed into fable. He became a hero of romance. Even now in common opinion he is conceived as a dazzling figure of knight-errantry in the mists of history, too remote to be more than half believed in. His empire was split into fragments. One of these fragments was Bactria (Bokhara) ; and there, it has been supposed, a school of sculptors maintained some tradition of the art of Greece, though the traces of Greek style visible in the statues of Gandhara may possibly be due rather to later contact with the Roman world. Still, it was Alexander who gave Hellas her footing in Asia.

In spite of the tendency of the two continents to shrink apart, the lines of communication between East and West were more open than is commonly supposed. Darius had already sent an expedition eastwards to explore Asia and discover the mouths of the Indus. Great trade routes were established. Nor was all the enterprise on the side of the West.

32

In 200 B.C. the Chinese, seeking markets for their silk, opened communications with Western Asia. A century later the Emperor Wu Ti sent a mission to the same regions. Greek designs appear on the earliest metal mirrors of China. It is possible that in the Chinese fable of the Paradise of the West * the myths of the Greeks may be reflected.

Conquest and commerce we note, therefore, as two powerful influences in the dissemination of the arts. But a third and far more powerful influence was religion.

The history of the art of Asia is intimately bound up with the history of Buddhism, just as the history of European art is intimately bound up with the history of Christianity. By the growth and spread of Buddhism all the various influences we have noticed in the arts of many races were swept along and fused into a vitalising stream. Sakyamuni, the prince of a little territory in Nepal, who abandoned his throne, his wealth, and his family, stricken with the thought of the miseries of mankind ; who abandoned asceticism after years of practice, as he had abandoned the world before, and at last found enlightenment in the discovery that all evil resided in the individual will to live—Sakyamuni lived and died in the sixth century B.C. Three centuries later the religion of the Enlightened One, the Buddha, Sakyamuni, was embraced by the great

* H. A. Giles, " Adversaria Sinica," No. 1.

Emperor Asoka, that pure and lofty soul whom Marcus Aurelius would have hailed with fraternal emotion, whose name is venerated over all the East, who united India, and whose mild edicts engraved on pillars were set up all over India, some of which are found standing to-day.

Soon Buddhism spread beyond the confines of India. Its destiny was to wander. In time it died out completely from the land which had given it birth, but was passing like a fire over Asia, kindling and transforming new and diverse races. In Gandhara the flame of enthusiasm burnt fiercely, and then died, as it would seem, of its very excess. In A.D. 404 a pilgrim found five hundred temples in that country, thronged with worshippers. By the seventh century all were in ruins. Meanwhile Buddhism had reached China. In A.D. 67 the Emperor Ming Ti sent across the Himalayas to seek the truth about this religion. His messengers, we know, brought back images with them. During the next centuries many were the Chinese pilgrims who crossed the mountain passes to visit the sacred sites. Most famous of these is Fa Hsien, who journeyed, A.D. 399–414, from China through Khotan westward, entered India through Gandhara and Peshawar, visited the sacred sites in the ancient kingdom of Magadha, and returned home over sea by way of Ceylon. This we know from the record he has left.

From China to India Fa Hsien travelled over the

great beaten route which was only to be closed in later times by the conquering Muhammadans. By this same route Buddhism had travelled from India into China. It had, we cannot doubt, a transforming influence on the art of the countries through which it passed. In Gandhara it combines with Hellenism to give a new character to the native Asiatic style. Moving east along the chain of oases which border the great deserts, it impresses its genius on the painting and sculpture of Turkestan, but less perhaps in the way of style than in the way of content. The art of Khotan, as of the more eastern sites, points to the existence of a tradition of painting which seems to have been common to the Asian continent, and may well have flourished in Central Asia before the advent of Buddhism. Passing yet farther north-east, we come to Turfan; and here successive German expeditions have discovered and brought back to Berlin frescoes and paintings on silk and paper which are of great interest, as well as manuscripts of extraordinary importance for the study of philology and religion. These latter throw light on the history of Manichæism and of its founder Mani, a Persian who attempted to combine in one religion Christianity, Buddhism, and Zoroastrianism. The paintings show a variety of styles, and affinities now with Ajantā, now with Gandhara, now with China, while fragments of miniature paintings suggest the beginnings of the rich mediæval art of Persia.

35

But in purely artistic interest even these discoveries have been surpassed by the wonderful finds of Sir Aurel Stein on his second expedition (1906–8). An account of his adventurous and romantic journey was given in the explorer's " Ruins of Desert Cathay " published in 1912, and the detailed description of the treasures found at Tun-huang and other sites has been given to the world in the five magnificent volumes of " Serindia," published in 1922. The immense importance of the paintings brought home from this expedition is that, among a good deal of mere provincial art, there are specimens of the real T'ang art of China, hitherto known only in the most fragmentary way : and a number of the pictures are dated with dates of the ninth and tenth centuries. After Sir Aurel Stein, M. Pelliot visited the same rock-temples of Tun-huang and brought away the manuscripts and paintings left by his predecessor, and these are now in Paris. The Stein collections are divided between the British Museum and the new Museum at Delhi. Besides the mass of paintings on silk which have been removed, there are frescoes in the rock-temples which can be dated as early as the fifth and sixth centuries. These are reproduced in M. Pelliot's " Touen-houang," Paris, 1920.

And so we come to China itself. Though it was once presumed that Buddhism in this long journey northward and eastward created art as it

went, and found in China but rudimentary begin-
nings which its inspiration at once transformed, it
is certain, on the contrary, that Chinese art was
fully developed before Buddhism brought its new
store of motive and imagery. Indeed, the import-
ance of Buddhism as a creative factor in the art of
China can be easily exaggerated. The truer view
would be that it came to infuse with devotional
fervour conceptions already rooted as philosophic
ideas in the mental habits of the Chinese.* I shall
presently show what evidence supports this view.
But first let us see what we have ascertained already.

It must be remembered that the great mass of the
new material discovered by the several missions in
these regions of Central Asia dates from an epoch
(round about the eighth century A.D.) contemporary
with the grandest period of Chinese art, the T'ang
dynasty : little can be assigned to a date so early
as the sixth or fifth century except the Tun-huang
frescoes mentioned above. But it is in provincial
localities that the oldest traditions linger ; and we
cannot doubt that among this material is to be traced
the primitive pictorial tradition of Eastern Asia.

Asia in the first centuries of our era we have
found to be not sharply divided into self-contained
empires, but a continent in which communication
was so free that not only the commodities of trade,

* An admirable and lucid treatment of the question is given in
Petrucci's " Philosophie de la Nature dans l'Art d'Extrême Orient."

but the animating ideals of religion, could bring about a fertilising contact between its different races. To assume that the cradle and origin of Asiatic art belonged to any one country of the continent in particular would be a vain supposition, an unprofitable starting-point for enquiry. We must rather assume that there was, in painting at all events, a common Asiatic style, an art of line ; and our aim should be to enquire which of the races of Asia developed this style to finest use and power. It would be natural to suppose that India, which gave to Asia the kindling ideals and imagery of Buddhism, was the land to which we should turn for the noblest creations of art. There was indeed a magnificent efflorescence of pictorial and plastic art in India which directly influenced the art of China in its greatest period, but there is nothing of comparable grandeur or vigour to succeed it in later times.

One great monument of Indian painting remains —the frescoes of the cave-temples of Ajantā, dating from about the first to the seventh century A.D. In a gorge of the Western Ghâts, among magnificent mountain scenery, the Buddhist monks hewed out of living rock this vast temple of many caves, cool in their gloom even when the neighbouring valleys are scorched with unbearable heat. And here on the walls Indian artists painted scenes from the life of Buddha in his successive incarnations, as deer, as goose, as elephant, and as man. Darkened and

38

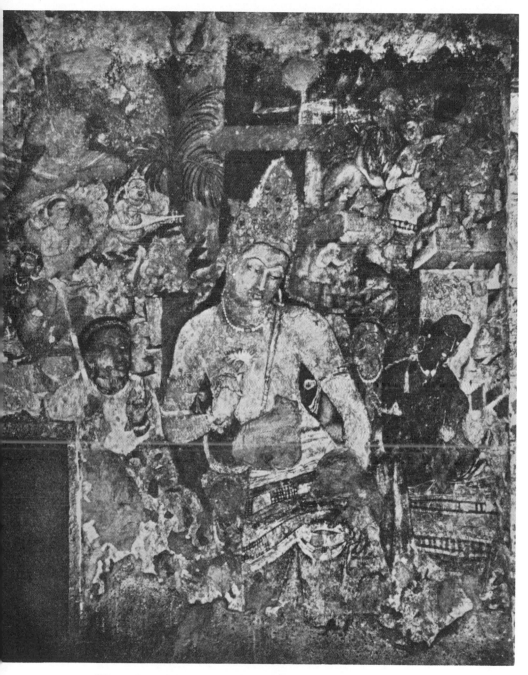

Plate I. The Great Bodhisattva (Padmapani).
Fresco at Ajantā.

damaged copies from some of these frescoes have hung for long in the Indian Museum at South Kensington ; copies made by Lady Herringham with the assistance of Indian artists have been lent by the India Society to the same museum. The paintings can also be studied in the two large and elaborately illustrated volumes published by Mr. John Griffiths in 1896. But since the last edition of this book the paintings are at last being made available in photographic reproductions, the most important being photographed in colour ; and the actual quality and character of the art of Ajantā can be judged far more accurately than through any of the series of copies, made as they were under difficult conditions. This publication, indispensable to the student, is edited by Dr. Yazdani and published under the authority of H. E. H. the Nizam.

Being by many groups of artists and executed over so long a period of time, the frescoes vary in quality, though homogeneous in general style. The compositions are not sharply divided. The exuberance which belongs to the Indian genius is everywhere present ; and at first sight one may be disconcerted by an apparent looseness and casual complexity of design. There is little formal unity in the compositions ; the unity must be sought below the surface in a profound feeling for the unity of all life, in men and women, in animals and birds,

in plants and flowers. One is struck everywhere by the extraordinary beauty of single figures and groups ; but these are not detached, they are always subtly related to the larger groups, yielding a sense of the abundance and continuity of nature. It is indeed the grace of spontaneous attitude and gesture which impresses above all in the work of these artists who, seeming to observe no academic rules, delight by their mastery in drawing the animated movements of the body, and mingled with the human forms, the forms of beasts and birds, drawn with an insight and sympathy rare in European art. And though our Western instincts may crave for a more systematised design, there is ample compensation in the absence of any forced relationships or dictated symmetries. All is warm with the glow of life itself ; there is a corresponding richness and vibration in the tones of colour. But this overflowing vitality is not accompanied by violence of action ; on the contrary there is a singular gentleness. For this art is religious in its inspiration, though in illustrating the legend of the Buddha and his previous incarnations it portrays the actual Indian life of the painters' own time. And the art finds its culmination in the moving figure of Padmapani, the very spirit of Compassion, which is one of the greatest creations in the art of the world (Pl. I.).

This great group of paintings takes in the history of Asian art the same kind of place that is taken in

European art by the frescoes of Giotto and his followers at Assisi.

Possibly of the fifth century A.D. are the paintings in the caves at Bāgh, in the Gwalior State. Only a remnant of these have survived. But these are of an astonishing beauty. They portray scenes at a festival ; a procession with horsemen and elephants, groups of girl-dancers and musicians. There is the same easy mastery of form and movement that we see at Ajantā, with more conscious feeling for rhythm and a plastic sense only found at Ajantā in the art of the ripest period. Copies on the scale of the original from two of the main compositions, made by Mukul Dey, are in the British Museum, and the whole series has been reproduced in colour and published by the India Society of London.

There is also a very interesting series of cave-paintings found in the rock of Sigiri in Ceylon, an abrupt mass rising from a plateau which was occupied and fortified at the end of the fifth century by the parricide king Kassapa. These paintings consist of about sixteen pictures of women deities or queens, attended by maids who carry lotus flowers in their hands.* The colours employed are shades of yellow, red, and green. But after this date what do we find ? Nothing apparently for close

* See the report of Mr. H. C. P. Bell in the *Journal of the Royal Asiatic Society*, Ceylon Branch, 1897, p. 115. For a note on these paintings I am indebted to Mr. A. K. Coomaraswamy.

on a thousand years! This portentous gap and blank is due not only to time and perishable materials, but even more to merciless destruction by Muhammadan iconoclasts. Perhaps further evidence is yet to come to light. The study of Indian painting was for long signally neglected, and it is only in the last decades that, owing chiefly to the impassioned zeal of Mr. E. B. Havell and the enthusiastic research of Mr. Coomaraswamy, the characteristics of the later Indian schools have been differentiated from the Persian tradition fostered by Akbar and his successors. In those Hindu schools reappears something of an antique tradition, but one that appears to have little relation to the early Buddhist painting.

In India, then, we can follow up no line of continuous growth in pictorial art. It is to China that we must turn.

CHAPTER III. CHINESE PAINTING IN THE FOURTH CENTURY

IT was long assumed that nothing of the pictorial art of China, the third of the three great civilisations which we found met together in Central Asia, had been preserved of a date prior to the time of the T'ang dynasty.

Little indeed has survived, even of T'ang painting, but in recent years it has become possible to understand the character of the art of the Han period (second century B.C. to second century A.D.) not only from engraved stones which were translations from wall-paintings, but from painted slabs decorating tombs, such as those now in the Boston Museum. A summary, swift, incisive draughtsmanship, amazingly expressive in its economy of line; a sense of dramatic relation between the figures, emphasised by the use of space as a vital factor in design; a sort of gaiety and extreme animation; these are the qualities manifest even in the minor relics which are all that have been preserved.

Of far greater intrinsic importance is the now famous scroll attributed to Ku K'ai-chih in the British Museum. Ku K'ai-chih flourished in the period between the later Han and the T'ang dynasties. Besides the British Museum painting, there

43

is a scroll, also attributed to him, in the Freer collection at Washington.

This was one of the chief treasures in the great collection of the late Tuan Fang, ex-Viceroy of Tientsin. The Freer picture was painted in illustration of a poem about the nymph of the River Lo by Ts'ao Chih, who flourished in the early part of the third century. It is described in the *Kokka*, No. 253, June 1911 ; and Mr. Taki, who wrote the article, published at the same time reproductions of two of its three scenes. One of these scenes is very remarkable, and shows—what the ancient bas-reliefs also attest—how early the Chinese genius excelled in mastery of movement. It shows us a goddess riding over the clouds in a chariot drawn by six dragons, and the sense of a buoyant rushing through space is inimitably given. The other scene reproduced shows us gods and goddesses floating over earth, with rocks and trees and streams below. The landscape, however, is of a primitive character, as compared with the figures, which are drawn in fine expressive lines.

The British Museum recently acquired a painting of the same subject, repeating the essential parts of the design but with an elaborate landscape setting. It appears to be a Sung copy, completed by a Ming artist.

The Freer painting, though of extraordinary interest, is rather dry or cold in the brush-line, and far

inferior in living quality to the roll in the British Museum.

Since the first edition of this book appeared, this roll has attracted much attention among scholars, and their studies have brought a number of new facts to light. It was at first thought that the scenes represented by the painter were illustrations to a work by a lady known as the Female Historian, Pan Chao. But Professor Chavannes discovered the actual text, which proved to be a short composition by Chang Hua, a third-century writer, consisting of precepts addressed to the ladies of the Imperial Harem. The text has been inscribed on the picture in very early writing, but later than the picture itself. The true title of the painting is therefore " Admonitions of the Instructress in the Palace."

Incidentally M. Chavannes has shown that the picture was longer than it is at present : for the first few precepts are not illustrated, and the text relating to the first of the nine scenes is missing. And this is confirmed by the fact that the beginning of the roll has a ragged edge, though repaired so long ago and with such skill that only a careful scrutiny reveals it. At the end of the roll is the signature of Ku K'ai-chih. This is certainly a later addition. But the painting also bears, among a great number of collectors' seals, the seal of the Imperial collection. Now this collection was cata-

logued in the early part of the twelfth century. The catalogue, published anonymously, is known as the " Hsüan ho hua p'u." In it, seventh among the nine paintings by Ku K'ai-chih, is " Admonitions of the Instructress," the exact title which the picture now in the Museum bears on the outside. The picture is painted on a long roll of silk, and at the end of it is a eulogy of the painter, written in 1746 by the hand of Ch'ien Lung, the famous Emperor, who certainly believed in its authenticity, and who could rely on the most skilled connoisseurship of his day. He had the painting remounted, and wrote the label on it in his own hand. " The picture has not lost its freshness," he wrote ; and " Of the painter's four works this is the best." More important is the fact that the painting was accepted as an original by T'ung Ch'i-ch'ang (1555– 1636), the greatest of Chinese critics.

The character of the design agrees with what few relics of pictorial art, previous to the T'ang era, and subsequent to the Han era, remain for comparison. The basic character of design is the same as in the sixth century Tun-huang frescoes, though the frescoes are in a rather provincial style ; compare, for instance, the horsemen among the hills in Plate CXX of Pelliot's publication. Such things as the group of four riders seen from behind in Plate LI show how far the Chinese painters had got in rendering difficult aspects of bodies in movement.

46

When we add that the types, the costumes, and the style of painting are unlike any later Chinese work known to us, there can be no reasonable doubt that the picture represents the art of the fourth century. Whether it is Ku K'ai-chih's actual handiwork or not, no one can prove with certainty. Most scholars have presumed it to be an ancient copy. The condition of the silk, repaired many times over, shows that it is of high antiquity, as also that it has been most jealously preserved. Even a copy of a fourth-century painting must be of extraordinary interest. But that it is a copy is hard to believe. The brushwork is confident and spontaneous. The hand that painted it was beyond all dispute the hand of a great master. It is true that in China and Japan great masters have copied their predecessors, but in such cases as we know of the copy is a free one, whereas in this case curious details of dress and ornament are rendered in a way that only a servile copyist could reproduce. It has been repaired so many times that only in parts is the original work preserved, but it is the opinion of Prof. Fukui, who has devoted long and intensive study to the picture, that these parts are not later than the sixth century and may be earlier. In any case it is by far the most important of pre-T'ang paintings still preserved.

But it is time to describe the work itself. It is a roll of brown silk, a little over eleven feet long, a little over nine inches wide. On it are painted

nine scenes. The subject of the first is taken from actual history. The story is told that on a certain occasion, when games were being held in the Emperor's presence, a bear broke loose. It was rushing towards the Emperor, when a lady boldly threw herself in its path. In the painting we see her, a superb figure, with folded arms, confronting the furious animal, which two tall guards step forward to despatch with their broad-bladed spears. The three figures are admirably disposed and brought together, and effective use is made of the straight lines of the spears in a pyramidal design.

Another subject which has an historical basis shows the lady Pan Chieh-yü (of the first century B.C.) refusing the Emperor's invitation to ride with him in his palanquin. " In old paintings," she is reported to have answered, " it is only ministers that we see riding beside their monarch." The other subjects illustrate various maxims and admonitions. One is a toilet scene, in which a maid is dressing her mistress's hair before a round mirror ; lacquer boxes lie on the floor beside them. (Exactly similar lacquer boxes have been found in Korea, dated with a date of the first century A.D.) Another, of great interest for the student of architecture, shows a bed-chamber. In another we are introduced to the family circle of the Imperial house. On one side sit the Emperor and Empress, on the other are two children with their nurses ; one of

them, a boy, is having his hair shaved and shrinks with a rebellious grimace. In the background a tutor is holding up a scroll for a child to read. Domestic harmony is the moral. All through these maxims runs a vein of philosophy, applied to the vindication of polygamy. " No one can please for ever. When love has reached its height, it begins to diminish. This is a law of nature to which all must submit." That is the burden of the admonitions.

In the middle of the roll is a landscape. A mountain, wrinkled with fissures, rears up its crags. On a lower ledge are two hares ; higher up is a tiger. Belonging to this subject is a man aiming with a cross-bow at a flying pheasant. The tiger is many times too large ; there is no sense of diminishing planes, nor of atmosphere. The mountain is treated like the hills in some early Italian pictures. This is noteworthy, because (just as we noted in the case of the Freer picture) it is the only primitive feature in the work. It precisely bears out the observation of a Chinese critic * of the eighth century, who writes of the landscape of Ku K'ai-chih's period that the mountains were drawn stiffly " like hairpins and combs," and that the figures were made larger than the mountains. This landscape scene, which seems to intrude so incongruously, illustrates the recurring moral. Fortune lifts us up like a mountain,

* Chang Yen-Yüan, " Famous Painters of Different Dynasties."

but the fall comes sudden as the recoil of a cross-bow.

For the rest, it is obvious that figure-painting at least had already arrived at maturity. The figures are outlined with a brush in ink, the roundness of forms and folds of drapery suggested by light strokes of grey or red. Sometimes the spaces within the contours are left uncoloured, sometimes there is a tint of vermilion, either opaque or diluted. A tawny yellow, a dull green, and a mulberry purple have also been used ; but these colours have sunk into the silk and lost much of their original value. The general effect is of a painting in black, grey, and vermilion red on a background of golden brown ; but the reds especially have been refreshed in later times.

Both types and costume are remarkable. The ladies are of a taller, statelier elegance than any we find in later Chinese art, though recalling such Han types as those in the painted slabs at Boston. They wear flowing robes, from which scarves or ribbons of some light and soft material float and wave in the air. In the thick masses of hair bound up on their heads are two upright ornaments of crimson colour and delicate design ; they look like cups full of springing flames. We note in the toilet scene the refined simplicity of shape prevailing in all the accessories.

In actual beauty of delicately modulated brush-

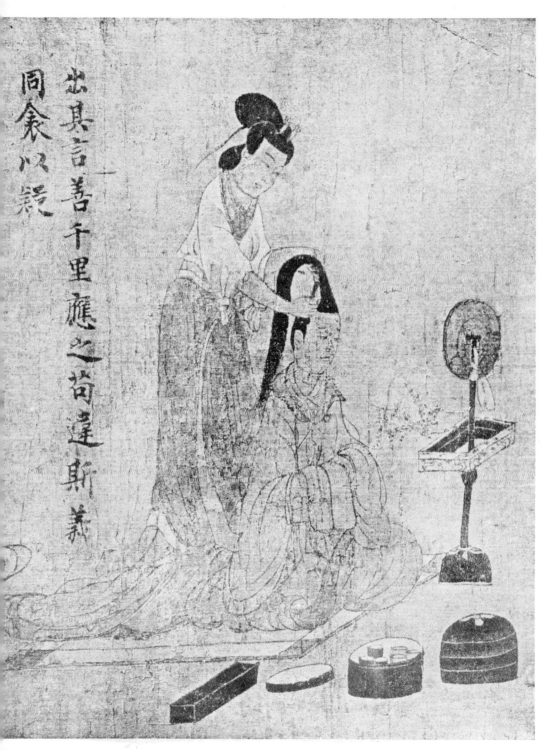

出其言善千里應之苟違斯義
同衾以疑

Plate II. Toilet Scene. Portion of a scroll painting
by Ku K'ai-chih. British Museum.

line, sensitively sweet, yet confident in power, no painting of later ages surpasses this. It is suave and tender, yet never soft or weak ; firm and precise, yet never dry. The calligraphic element is there, as in all Chinese painting ; but there is also unusual lifelikeness and humour. How beautifully felt is the action of the hands of the tall maiden knitting up the coil of hair in the toilet scene ! How delightfully realised the boy struggling on his nurse's knees ! How one feels pride, courage, and will in the attitude of the lady who faces the raging bear ! How the bearers groan and struggle under the weight of the palanquin bearing the serene Emperor ! We are made to feel all this, and at the same time we feel the painter's enjoyment of pure rhythm in following with his fine brush the wave of the light drapery that streams from the ladies' robes.

An undercurrent of humour and playfulness is perceptible in the work, revealing something of the painter's personality. As a matter of fact we know more about Ku K'ai-chih (it is odd to reflect) than we do about many an English painter of the nineteenth century.

He was a native of Wu-hsi, in Kiangsu. He was born in A.D. 344 or 345 and died at the age of sixty-two. In 364 a Buddhist monastery wanted money. Ku put his name down for a million *cash*. This was thought mere boasting, and he was dunned by the priests. He asked for time, and shut himself up

for a month. When the doors were opened, a resplendent full-length figure of the Buddhist saint Vimalakirti glorified the wall, and visitors flocking in wonder and admiration made up the promised sum. Many of his pictures were of Buddhist subjects, but he was especially famed for the spirituality and expressiveness of his portraits. Expression, not merely likeness, was what he aimed at. He remarked himself on the difficulty in portraiture of imparting to his subjects the air that each should have—in short, of revealing personality. The bloom and soft modelling of a young girl's face appealed to him less than features showing character and experience. " Painting a pretty girl is like carving in silver," he said ; " it is no use trying to get a likeness by elaboration ; one must trust to a touch here and a stroke there to suggest the essence of her beauty." When he painted a certain noble character, he set him in a background of lofty " peaks and deep ravines."

Ku K'ai-chih painted landscapes, though, as we have seen, these were doubtless primitive in style ; and also animals. He said of a favourite poem : " It is easier to illustrate the verse, *The hand sweeps the five strings of the lute*, than this other verse, *The eyes follow the flight of the wild goose*." We may infer from this saying that Chinese art was already grappling with the study of birds in flight and animals in motion, which was to play so potent a

part in the painting of the Far East. In fact, the drawings on a vase in the British Museum dating from the Han period or a little later prove it.

What other subjects did Ku K'ai-chih paint ? We know at least the titles of several. Among others are these : " A Hermit of Pure Fame," " Three Heavenly Beauties," " The Great Yü Draining the Empire," " An Ancient Worthy," " The Spring Dragon Rising from its Winter Sleep," " Making a Lute," " Tending Sheep," " Eleven Lions," " Tiger and Leopard with Vultures," " Goddesses," " A Buddhist Assembly," " Division of Buddhist Relics."

A famous critic, two centuries later, praised Ku K'ai-chih for his fineness of detail and unerring hand, but pronounced his execution to fall short of his conceptions. Some of the titles just given certainly suggest conceptions of poetic force and grandeur, such as the characteristics of the work known to us would hardly lead us to expect. But, as every student of the art of the Far East is aware, the painting of the ancient schools is singularly various in style : the style varied with the subject, for a traditional mode of treatment attached to each order of themes. Some of Ku K'ai-chih's religious pictures may have been in a grand and monumental style, as the story of his painting of Vimalakirti suggests.

It was said of Ku that he was supreme in poetry, supreme in painting, and supreme in foolishness.

53

We may conceive of him as an original nature, careless of the world's opinion, going his own way and rather enjoying the bewilderment of ordinary people at his behaviour. He is said to have been a believer in magic. He was noted for his way of eating sugar-cane : he began at the wrong end, and entered, as he expressed it, gradually into Paradise. He had a whimsical, exaggerated manner of expressing himself.

Professor Chavannes relates some instances of the artist's skill at one of the literary games dear to the Chinese. At a party of friends it was proposed to find an image which should give the most vivid idea of a thing finished and ended. One of the company suggested this : " A fish thrown into deep water ; a bird let loose into the air." Ku K'ai-chih said : " A plain entirely consumed with fire, the last flame of which has died out." On another occasion danger was the theme. One said : " To gather rice with a spear, and cook it on the sword's point." Ku K'ai-chih said : " A sightless man riding a blind horse on the brink of a fathomless lake." This was too much for the nerves of one of those present, the artist's patron, who had weak eyes, and left the room.

Do we even now seem so remote from such an atmosphere as Ku K'ai-chih breathed ? It is the atmosphere of an age of civilised grace, of leisured thought, of refined culture. The artist himself deals in critical ideas. There is a modern tone in his

comments on art. He has an Epicurean strain in his nature.

The paintings we have been discussing are not all that we know of the master.

In the temple of Confucius at Ch'ü-fou hsien is a figure of the sage with a disciple incised upon stone in the year A.D. 1118. This was copied from a painting by Ku K'ai-chih. But of greater importance as a document is a book of woodcuts, published during the Sung dynasty after Ku K'ai-chih's designs, called " Lives of the Heroines." The woodcuts were copied and republished in 1825, and this later edition is in the British Museum. These later prints, which are all I know, are not very accomplished ; but despite the craftsmen's intervention we recognise, if at third hand, the same essential features which distinguish the Museum painting and the Freer painting, the same expressive draughtsmanship in the figures, the same mastery in the suggestion of movement, the same contrast of primitive character in landscape accessories.

History and literature fill out the picture of the age. It was a time of revolt from convention. Artists and poets were under the spell of the teaching of Lao Tzŭ, who, as against the social obedience prescribed by Confucius, taught the virtues of individuality and freedom. To this epoch belongs that coterie of men of letters, afterwards so favourite a theme of painting, called " The Seven Sages of the

55

Bamboo grove," who met by moonlight in the woods to regale on wine and song. A famous contemporary of Ku K'ai-chih's, T'ao Ch'ien, was a typical figure of the time and its ideas. He obtained an appointment as magistrate, but resigned it in three months because he could not bring himself to receive a superior officer with the recognised ceremonial. "I cannot crook the hinges of my back for a salary," he said. So he retired into private life and devoted himself to poetry, music, and the culture of the chrysanthemum. The poem he wrote on his retirement and return home is a charming piece, and a celebrated classic.*

This reaction to simplicity and nature, the symptom of an advanced not of a primitive civilisation, is reflected in that intimate glimpse of the Imperial family which we have noticed in Ku K'ai-chih's picture : it is naturalness rather than homeliness which distinguishes the group from the ceremonial stiffness usual to courts ; there is no absence of dignity in the absence of pomp and parade.

And now let us turn again from these scenes, this life of social charm, of elegance and leisured philosophy, to the cave-temples of Ajantā. We seem to step back to a more primitive time, and an earlier stage of art. The fourth-century Chinese painting seems modern in comparison. The Indian frescoes, exuberant in grace and vigour, yet suffused with

* See the prose translation in Giles, " Chinese Literature," p. 129.

spiritual aspiration, promise, and at times attain, a grandeur and creative power that seem as yet outside the aim of Chinese art. The contrast is great. Yet this Indian art, with the religious impetus behind it, is in succeeding centuries to impress itself directly upon the Chinese genius, to enlarge the scope of Chinese painting and enrich it with imaginative conceptions. Already in the fourth century Chinese masters, like Ku K'ai-chih, were painting Buddhist subjects ; but on the secular art the Indian inspiration has no direct influence at all.

It used to be assumed that the art of China only rose from a rudimentary stage at the vitalizing touch of Buddhist inspiration from India. This we now see to be a complete misconception. And Buddhism could never have taken so firm a hold in China had the mystic ideas of Lao Tzŭ not prepared the Chinese mind for its acceptance. We note in Ku K'ai-chih a certain lightness of tone, far removed from the fervent religious intensity of the Ajantā frescoes ; and indeed that intensity of conviction and feeling does not seem to have prevailed in the Buddhist painting of China till the time of the T'ang dynasty, when the religion had penetrated far more deeply into the soul of the nation.

To China then, rather than to India, we must turn to find, if not the parent art of Asia, its central representative and its earliest maturity. And from this early epoch onward, while the other countries

of Asia yield but scattered evidence of their schools of painting, China has left a continuous record of famous artists, and an endless amount of allusion and criticism, which testify to the unrivalled vitality of its schools and their importance in the life of the nation. Religious art is naturally conservative in types and forms and mode of treatment. The union of Indian conceptions and symbolism with the forms of Greek plastic art, which produced what we call the Græco-Indian style, has left, no doubt, its traces on the Buddhist painting and sculpture of China and of Japan. But this Greek element can easily be exaggerated. In T'ang times certainly it was not through Gandharan models but directly through the art of the Gupta period that India inspired the Chinese Buddhist painters.

I have quoted already the story, from the Persian poem of the twelfth century, of the competition between the two opposed schools of art, the Greek and the Chinese. I believe that here we have the clue to the right conception. The great original art tradition of Europe has its home in Greece ; the great original art tradition of Asia has its home in China. Each race is pre-eminent in its feeling for harmony and rhythm, the foundation of all art.

CHAPTER IV. THE ORIGINS AND
EARLIEST PHASES OF PICTORIAL ART
IN CHINA

CENTURIES, it is obvious, many centuries, must have gone to the moulding of an art which could produce so mature and so refined a work as this painting of Ku K'ai-chih's.

Legend, indeed, throws back the origin of Chinese painting to 2700 B.C. There is no need to doubt that the art is of great antiquity. According to native historians, it came into existence at the same time as the art of writing; and throughout the history of China the two arts are intimately connected. A fine piece of calligraphy is valued as highly as a fine painting; and what is most prized in a picture is that the brushwork should be as personal to the artist as his handwriting. In either case the strokes should be full of life, an immediate and direct communication of the artist's mood and thought to the paper or silk on which he paints. The typical Chinese and Japanese painting corresponds, in fact, rather to the drawings of European masters; there is nothing in the East like the highly finished oil-picture, in which the painting is a sort of confection, and there is no obvious revelation of the way in which the pigments got to be there. In

59

the early frescoes, however, of the East and the West there is no essential difference.

Bronze vases and incense-burners dating from various periods B.C. still exist, masterpieces of this kind. The sculptural reliefs adorning a mausoleum in Shantung, built in A.D. 147, have become famous through the woodcut illustrations of a Chinese work devoted to them ; and they have been treated in an exhaustive monograph by the eminent scholar, the late Edouard Chavannes. More important sculpture seems to have been destroyed by time. But for all evidence of pictorial art anterior to Ku K'ai-chih, apart from the fragmentary relics of Han times, already noticed, we must rely on literary record and allusion.

Professor Giles, in his " Introduction to the History of Chinese Pictorial Art," has collected the evidence available. We find a definite mention of portraiture as early as 1326 B.C. But not till the third and second centuries B.C. do references to painting become at all frequent. Already the Dragon is a favourite subject, and pictures of animals were common, but portraiture remains predominant for many centuries. We have noted in the text of the Admonitions illustrated by Ku K'ai-chih the interesting reference to old paintings of emperors in their chariots, put into the mouth of a lady of the first century.

The encouragement of portraiture accorded indeed

with the teachings of Confucius, that great and grave moralist of the sixth and fifth centuries B.C., whose code of ethics has sunk so deep into the mind of China. Confucius, like Plato, held that art should serve the State ; it should kindle and sustain the patriotic virtues. He attached high importance to the ballads of a nation ; and the literature he rescued from oblivion and edited for posterity was chosen and prized for its effect on character. Filial piety was a supreme virtue in his eyes ; therefore the portraits of the great men who had gone before were to furnish to each generation a stimulating and ennobling example. Music he also encouraged as promoting harmony between man and man ; for the individual was to merge his own desires in the cause of the community. In Confucian theory the empire was one vast brotherhood recognising mutual duties, and the emperor's parental authority was based on nothing but the consent and choice of the people. How far the socialistic tendencies implied in the Confucian ideas could be developed into actual practice is seen in the attempt of a usurper in the first century A.D. to carry out an equal division of land among the whole people. He had already published an edict abolishing slavery. But the outraged nobles rose, and he was killed as he sat, unresisting, in his palace.*

* Okakura, "Ideals of the East," p. 35.

" Better fifty years of Europe than a cycle of Cathay ! " cries the hero of " Locksley Hall," for whom, as for most Englishmen, the name of China is a symbol of stagnation. More knowledge of China's history might have made the exclamation more appropriate to the mouth of a Tory landlord.

The power of Confucius over his countrymen lay, doubtless, in the fact that he represented the national character in a noble and commanding type. He represented what we may call its orthodoxy, its eminent reasonableness, its social instinct, its aptitude for peaceful living, and its genius for order. Yet Confucius does not sum up the whole of the Chinese nature.

The late Mr. G. Lowes Dickinson's eloquent little book of letters, put into the mouth of " John China-man," has justly found many admirers. It provoked in America the indignation of Mr. Bryan, who supposed it to be really the work of a Celestial pen, and was wroth that an Oriental should presume to indict our Western civilisation. The view adopted in these letters is that China stands for the Con-fucian ideal and nothing else ; and from this stand-point it is, of course, easy to contrast the ugliness and hypocrisies of Europe and America with the harmony and clearness of Chinese life. The letters hold up the success of the Chinese in embodying a sensible and practicable ideal in conduct against the failure of the West to make any reality of its profes-

sions of faith in its " idealistic religion." Yet this " John Chinaman," though he writes such glowing and persuasive prose, is, I think, unjust both to China and to Europe. The solution of the problems of government, the dwelling together of a people in harmony—these are admirable things to attain, but they alone will never satisfy human nature. After all, it is not likely that we shall ever rival ants in this respect. Lowes Dickinson made his Chinaman write as if all idealistic religions were a mistake, and as if no such impossible aspirations had ever disturbed the serene centuries of China.

Yet listen to the voice of a Chinese sage :

" The Way that can be expressed in words is not the eternal Way."

" Follow diligently the Way in your own heart, but make no display of it to the world."

" Recompense injury with kindness."

" Do nothing, and all things will be done."

These are words of Lao Tzŭ. How different an accent from the reasonable prose of Confucius !

Lao Tzŭ, the mystic, the proclaimer of paradoxes, the man of imagination, the seer, represents the other side of the Chinese genius. It is largely from this other imaginative side that the elements most glowing and alive in Chinese painting and literature have come to flower. And surely it is not least by

her painting and her literature that China will live for the world.

Lao Tzŭ, said to have been born fifty years before Confucius, inspired the reaction of the individual soul against the communistic system of the latter. The Confucian ideas, especially as interpreted by the pedantry which is the besetting weakness of the Chinese intellect, tended in time to harden and to freeze. A revolt was necessary. However, Kakuzo Okakura has suggestively observed that " in this Eastern struggle between the two forces of communism and individual reaction, the ground of contest is not economic, but intellectual and imaginative."

In all creative art there is a similar contest or dualism. For all art conveys in varying proportions, but inextricably combined, ideas of order and ideas of energy or freedom. In pictorial art we find this dualism expressed, in its rudiment and essence, through the straight lines or regular curves of man's making, and the free lines of nature ; the erect tower, the Roman road, contrast with the sinuous stream, the fretted branch, the melting edge of clouds. Perfect art holds the two elements in equilibrium ; it satisfies both our instinct for order and our instinct for freedom. At bottom, the tendencies we label Classic and Romantic are based on this antithesis, and the preponderance now of one element, now of the other.

64

The ideas of Lao Tzŭ impregnated, as may be imagined, but rare and naturally original minds. He is traditionally regarded as the founder of Taoism, that popular cult which is chiefly associated with magic rites and exorcisms, and especially with the chimerical pursuit of the elixir of immortality. But as in Taoism the pure authentic doctrine of the sage has been entirely submerged in a wild mass of superstition, Mr. Okakura has proposed the name Laoism as a conveniently distinctive title for the yet uncorrupted teaching of Lao Tzŭ. And in the third, fourth, and fifth centuries A.D. Laoism was a spirit of power.

In the third century we meet with the name of a painter, Wei Hsieh, said to have been the first artist to paint detail, who excelled in " Taoist and Buddhist subjects." The collocation of the names is significant. Buddhism, which by now was taking hold of China, found its adherents chiefly among the followers of Lao Tzŭ. They found in the Indian religion their own philosophy presented in a more developed form. The Buddhist images too were welcomed as those of one of their own gods.

Before long, it is true, rivalry was engendered, and Buddhism had to face bitter persecution. But at first the attitude of Taoism was friendly, and the Indian religion was allowed to take strong hold. Indeed, the special doctrines of the Dhyana, known

65

in Japan as the Zen sect of Buddhism, so potent in inspiration for the art of the Sung period in China and the Ashikaga period in Japan, derived not a little from the teaching of Lao Tzŭ. So we come to the fourth century, and to Ku K'ai-chih.

CHAPTER V. CHINESE PAINTING FROM THE FOURTH TO THE EIGHTH CENTURY

AN older contemporary of Ku K'ai-chih's is recorded to have painted a picture on white hemp paper. This, according to Professor Giles, is probably the earliest mention of that material. Paintings were usually made with a brush, upon silk, which about the first century had superseded the earlier bamboo and stylus. From now onwards to the present day both silk and paper have been used in China, as in Japan, for painting ; but silk has always been the more common material.

From the fourth century to the eighth, though there are beautiful monuments in sculpture, we have only the Tun-huang frescoes as monuments of pictorial art. In these we see the gradual establishment of the Chinese conventions of picture-making and their way of dealing with problems of representation ; we note the power of suggesting movement, the rhythmic line, and the gradual realisation of space.

Some wall-paintings in Korea have been discovered, published by the Japanese, which date from the early fifth century ; but they are in a pro-

vincial style. Yet history records the names and works of a long roll of painters. To fill these pages with the records, for which the student should refer to Dr. Giles's book, is not my purpose. But it may be well to say something of the various subjects which formed the content of these painters' art, since they will recur again and again in the works of later times.

First we must mention those great symbolic figures which had early taken shape and meaning in the Chinese imagination—the Dragon and the Tiger. Both are symbols of power. In the superstition of literal minds the Dragon was the genius of the element of water, producing clouds and mists ; the Tiger the genius of the mountains, whose roaring is heard in the wind that shakes the forest. But in the imagination of poets and of artists these symbols became charged with spiritual meanings, meanings which we should regard as fluid rather than fixed, and of import varying with the dominant conceptions of particular epochs. In the Dragon is made visible the power of the spirit, the power of the infinite, the power of change ; in the Tiger, the power of material forces. When the Tiger was portrayed simply as the royal beast, it was painted in the colours of nature. But when conceived as a symbolic power, it was always painted in ink only, like the Dragon. The two subjects have been painted as a pair of pictures by almost

68

every artist of note who worked in the Chinese tradition, whether in China or Japan.

The Dragon is typical of the creative faculties of the Chinese genius, which had a singular gift for moulding into shapes of vivid and formidable reality those shadowy terrors of the unknown and the non-human world that survive in mankind from the infancy of the race ; not without unconscious actual memory, perhaps, of a time when the monsters of primæval ages still existed. The earliest Chinese bronzes betray a power akin to that which inspired such mediæval sculptors of Europe as those who carved the famous gargoyles of Notre-Dame. And in the creation of demons and fantastic beasts and birds the Chinese genius is vividly inventive.

The Confucian ideals promoted portraiture, also the exploits of heroes and the classic stories of filial piety. Of these last there is a chosen set of Twenty-four Examples. In most of the stories they illustrate there is an element of childishness and extravagance, and this is probably one reason why these themes do not seem to have provoked master-pieces. Another reason is that imaginative artists were attracted rather by the ideas of Taoism and Buddhism.

Taoism gave to art some of its most romantic subjects. Chief among these are those themes connected with the Rishi or Wizards of the Mountains. These were human beings who had aban-

doned the world, who abstained from all nourishment but fruits and dew, and who by the practice of certain mystic arts had attained to an ethereal existence and the enjoyment of immortality. They form a mysterious brotherhood, who ride on storks through the air, or traverse the mountains on the backs of fabulous animals, or meet together in mountain retreats. They are pictured as beings of mystery, yet with nothing of the haggard foulness of the European conception of witch and wizard ; their genius is one of gaiety and world-forgetting youth. The stork, the tortoise, the pine, plum, and bamboo are their accompanying emblems. With such conceptions the Buddhist Arhats might seem at first to have a not unfraternal kinship. These were the immediate disciples of Buddha, first sixteen, afterwards eighteen, in number—the Chinese call them Lohan, the Japanese, Rakan—and their figures are familiar in every form of the art of the two countries. They too haunt the mountain solitudes ; but theirs is not the careless smile of the wild Rishi : they are rapt in intense meditation, they breathe a spiritual air, they are forms of grandeur and intellectual power. Yet sometimes, when represented in a company, they lose their solemn Indian aloofness ; their aspect takes on something of the genial lightness of the Flowery Land, and we see them crossing the waters of ocean to the Paradise of Mount Horai in the legendary West, where the Faerie Queen, the

goddess Hsi Wang Mu, awaits them with the mystic peaches in her hand, the taste of which is immortality. Here we have in a single subject the blending of Buddhist and Taoist conceptions ; for Hsi Wang Mu belongs to the supernatural world of Taoism, though originally, as Dr. Giles has suggested, her legend may reflect Greek myth, the goddess Hera, the apples of the Hesperides, and the river of Ocean at the boundaries of the world. Yet normally the Arhats are pictured as single figures, each with his attendant lion, tiger, or other guardian emblem, and thus portrayed often strangely recall the hermit saints of Christian art. The first mention of the Arhats in Chinese painting dates from the sixth century.

Endless were the subjects of the Buddhist painters ; for Buddhism, as it grew and spread abroad, absorbed into itself a mass of alien conceptions, and transformed to its uses a hundred forms from the Pantheon of Indian mythology. Moreover, the personification of every varying mood of Buddha and Bodhisattva created through the multiplication of images an ever-increasing array of individual deities.

Here, since it is impossible to suggest more than the outline of so vast a subject, I will merely touch on two points. One is the absence of the dramatic instinct. In the story of Sakyamuni there are moments of moving drama, which the artists of Europe would, one cannot doubt, have eagerly seized on for representation. There is, for instance, that

moment when the young prince, brought up in luxury and ignorance of death as of pain, meets outside the gates of his city an old man leaning on a staff, withered and bent. What ails him ? Has he been so from his birth ? asked the Prince, only to learn from his attendants that this was the inevitable end of youth and glorious manhood, the end to which all must come. There is a little painting of this subject among the pictures found at Tunhuang by Sir Aurel Stein, but it is a rather impassive treatment of the subject ; and the only other renderings I can remember, by Japanese masters of the Kano school, get still less out of the theme. Think what Giotto would have made of it, or Rembrandt ! Again, there is the moment when at midnight Sakyamuni, resolved to quit the world for solitude, comes to take farewell of his sleeping wife, and his boy, Rahula. He longs to take the child up in his arms ; he stretches out his hands to do so ; but he fears to wake them, and silently goes out. What a subject for Leonardo, for Correggio ! Pictures of it must exist, but I never saw nor heard of one. The Buddhist painters concentrate their power rather on types of intellectual peace, every line in whose calm features, in drooped eyelid, in wide forehead bent slightly forward, in unruffled fold of drapery, lays a spell upon the mind, woos it from the restless world and draws it inward to the divine ecstasy of absolute contemplation. In all the art of the world

72

there is nothing more impressive, nothing of more pure religious feeling, than some of those noblest creations of Buddhist genius. Yet how we miss in the religious art of Asia those consecrations of humanity which form the centre of the religious art of Europe ! Even in the East those human cravings and instincts which have been touched to ennobling beauty by the painters and sculptors of Christendom have not been without some outlet of expression ; and the abstraction of Love and Mercy which found form in India as Avalokitesvara, named in China, Kwan-yin, in Japan, Kwannon, is transformed * in the course of time from a male angelic figure to that of a woman. Another deity, Hariti, originally the goddess of small-pox and the devourer of little children, becomes in time (she was converted by the persuasions of Buddha) their protectress ; and her image, with a child on her lap, has been mistaken sometimes by Europeans for an Oriental borrowing of that perpetual theme of Christian art, the sublimation of Motherhood in the Madonna.

The other point I wish to notice is an element which pervades the Indian mythology, and which was taken over by the Chinese artists, but was not, I think, congenial to their instincts. I refer to those symbolic figures of deities with many heads, or eyes, or arms, which are not genuinely pictorial or plastic

* The change appears to date from the twelfth century. Giles, " Introduction, &c.," p. 21.

conceptions, but literal translations of the verbal imagery of which Indian literature is profuse—an origin totally different from that which gave birth, for instance, to the Chinese dragon. It has been claimed that these forms are no more monstrous than the winged angels of Christian art, or the centaurs and satyrs of Greek art. An impartial judgment is perhaps impossible. It is really a question of the artist's success in presenting unnatural forms with plausibility. Hieratic art preserves its types with little change ; but in the religious painting of China and of Japan, the early productions of which are often almost impossible to distinguish between, there is a visible effort, whether conscious or unconscious, to subdue this inherited element by cunning disposition of forms into harmonious rhythm.

It was in this period that the criticism of painting was formulated by a writer who was himself an artist, Hsieh Ho (Shakaku in Japanese), who flourished in the sixth century.

The Six Canons of Hsieh Ho crystallise the conceptions of art which had already long pervaded the minds of his countrymen in a less definite form, and have been unanimously accepted by posterity. Scholars are at variance as to the precise meaning of the first and most important of these canons. Giles gives it as " Rhythmic Vitality," Okakura as " the life-movement of the spirit through the rhythm

of things." Mr. Waley translates " The operations of the spirit, producing life's motion." The phrases seem to have borne varying connotations at different periods to the Chinese themselves : but the main idea seems to correspond to what we call Inspiration ; that is, a possession by the spirit of life, by something greater than the artist ; but the idea of movement is emphasised, and as the movement of life is natur-ally rhythmical, rhythm seems to be implied. Next to this principal canon comes organic structure. The creative spirit incarnates itself in a pictorial conception, which thereby takes on the organic structure of life. Third comes the law of conformity with nature ; fourth, appropriate colouring ; fifth, arrangement ; sixth, the transmission of classic models.

Throughout the course of Asian painting the idea that art is the imitation of nature is unknown, or known only as a despised and fugitive heresy.

CHAPTER VI. THE T'ANG DYNASTY

THE main great epochs of Chinese painting are easy to grasp and remember. After the immense tract of time from which no painting of importance is known to survive except frescoes at Tun-huang and the roll attributed to Ku K'ai-chih which we have described—whatever may be hidden in Chinese private collections—after this long period we arrive at the T'ang dynasty, extending from A.D. 618 to 905. A short period of half a century follows, known as the Five Dynasties. Then come :

The Sung dynasty, 960–1280.
The Yüan or Mongol dynasty, 1280–1368.
The Ming dynasty, 1368–1644 ; and finally
The Ch'ing or Manchu dynasty, overthrown in 1911.

The T'ang era stands in history for the period of China's greatest external power—the period of her greatest poetry and of her grandest and most vigorous, if not, perhaps, her most perfect, art. Buddhism now took hold on the nation as it had never done before, and its ideals pervaded the imagination of the time. China was never in such close contact with India ; numbers of Indians,

76

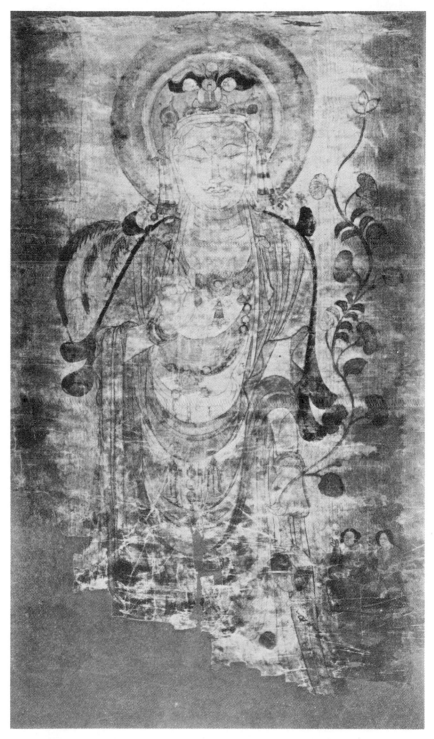

Plate III. Avalokitesvara (Kwanyin). From the Cave of the
Thousand Buddhas, Tung-huang. British Museum.

including three hundred Buddhist monks, actively preaching the faith, were to be found in the T'ang capital of Lo-yang. And Buddhist ideas permeate T'ang painting.

Until recently, it could not be said that we had any but the scantiest first-hand knowledge of T'ang art. But in the last few decades extensive discoveries of sculpture, clay figures, and paintings have brought us a store of material on which some conception of the art of this great period may be founded. It is with the paintings that we are here concerned.

The mass of paintings brought from Tung-huang by Sir Aurel Stein and M. Pelliot have this in common, that they are practically all Buddhist. But in style there is a surprising variety. This is, doubtless, partly due to differences of local schools, but also to differences of date. Actual dates occur on some of the pictures, mostly dates of the end of the dynasty. But among the undated examples are a few paintings which may well be earlier than these : and some of the manuscripts found in the same rock-temple go back to centuries before T'ang. Many of the paintings appear to be of a provincial character ; but a few certainly belong to the central Chinese tradition of Buddhist art, which passed on to Japan, and on which the early Japanese schools were closely modelled.

As we should expect, the Indian element is very

strong. But in what precisely does it consist ? It supplies the elaborate symbolism with which these paintings are saturated. We find it also in the ideal of the divine form, which has the slim waist and pronounced hips of Indian heroic art. The formula and prescription, the ritual, the attitudes, are Indian ; the fervent religious mood of contemplative ecstasy is of Indian inspiration. None the less, the Chinese element is also powerful. Many of these paintings have the portraits of Chinese donors below the heavenly vision which they depict. Many, too, are bordered with small paintings, in the manner of the predella pictures of an Italian altar-piece, representing various legends of the earthly or former existences of the Buddha ; and it is very noteworthy that here the Chinese element entirely prevails, for the personages, architecture, costume and accessories have become Chinese instead of Indian, just as in Brueghel's " Massacre of the Innocents " (for example) everything is taken from the life of the artist's own time and country. This alone testifies to the powerful vitality of Chinese art. But even in the pictures of the Buddhist Paradise, so frequently recurring in the series, we find an element easily recognised when we turn from them to the frescoes of Ajantā ; I mean an extraordinary feeling for the music of flowing sinuous line, and of movement in the line, a beauty as of gliding streams or the filmy wave of smoke ascending in the air ; and we are

78

reminded of Ku K'ai-chih's forms, his love of rhythmic motion and his floating draperies.

Among those pictures which, as I have said, seem to belong to the main stream of Buddhist art in China, are a few of memorable beauty. Now strangely vivid in colour, now richly smouldering, the vision of the compassionate Presences of heaven reappears before our eyes, after so many centuries of oblivion, as long ago, in the days when Charlemagne was filling Europe with his fame, these forms appeared to humble worshippers in the shadow of rock-hewn temples of farther Asia with the promise of eternal peace. The Guardians of the Four Quarters of the Universe, demonic figures of fierce energy, maintain the lordship of the Enlightened One; Kwanyin, in many forms and aspects, looks down with pity on all that suffers and is mortal; and Amitabha, among the concourse of the blest and the dances of angels, presides over his Western Paradise, where the lotus flowers for ever on the heavenly lake. Mere fragments though these are of the Buddhist art of T'ang, we can build up from them some conception of its grandeur.

The silk paintings from Tun-huang, some of which are dated, belong almost entirely to the later part of the T'ang era, though the large and majestic embroidery picture of Buddha preaching, which hangs on the staircase of the British Museum, may date from the eighth century. It seems probable,

79

however, that they preserve earlier designs, which were copied or traced by monkish painters.

Of early T'ang painting a precious document is now available to students. This is " The Thirteen Emperors," lately acquired for the Boston Museum, by the famous seventh-century master Yen Li-pēn. Yen Li-pēn is said to have modelled his style on that of Chang Sēng-yu (sixth century), who introduced a new type of feminine beauty : instead of the long, oval faces preferred by Ku K'ai-chih he chose the round face with plump cheeks and the more massive type of figure which became characteristic of T'ang art. This greater massiveness is seen in the powerful line-drawing of " The Thirteen Emperors."

The Boston Museum has also acquired a very fine copy by an early Sung painter from a work by the same master : " Scholars Collating Classic Texts." Here the figures are less formally disposed ; free play is given to the accident of gesture and movement, yet there is a masterly control of design.

To the seventh century also belong the wall-paintings in the Golden Hall of Horyuji Temple, at Nara. These may be by a Japanese or Korean master, but are certainly in the early T'ang style, if not actually by a Chinese hand. Here are Buddhas with attendant Bodhisattvas, noble, solemn and tranquil. The style is restrained, and compared

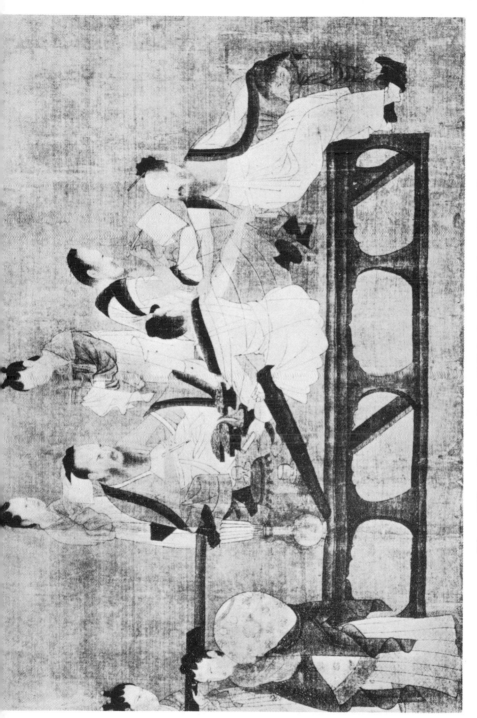

Plate IV. Group from "Scholars Collating Texts."
Painting after Yēn Li-pēn. Boston Museum.

with Ajantā, wanting in animation, though the drawing is sensitive and refined. This was the style which Wu Tao-tzŭ was to transform with his impassioned power.

Among the Tun-huang frescoes also are some which belong to the early T'ang time; and these are very interesting for the landscape setting of the scenes and the animation of the figures. They are reproduced in Pelliot's publication: but several actual fragments, brought back by Mr. Langdon Warner, are in the Fogg Museum of Harvard University; and there we find an extraordinary vigour and dramatic feeling in the figure-painting, as well as powerful colouring.

The great movement of the eighth century was fostered at the court of the emperor Ming Huang, whose tragic story has inspired endless poems and pictures in later times. A born enthusiast for beauty, he reminds us of princes like René of Anjou or our own Richard II. Poetry, painting, and music were with him a passion, only exceeded by his adoration of the fascinating Yang Kuei-fei, by whom came his fall. His army revolted, and he was forced to see his lovely favourite strangled before his eyes.

Among the men of genius who gave splendour to this period were poets like Tu Fu, Li Po, and Po Chü-i, now widely known to English readers through Mr. Waley's translations, and the painter who by

universal consent ranks above all other masters of his country. Wu Tao-tzŭ was born about the beginning of the eighth century, near the second capital city of Lo-yang. He showed as a youth extraordinary powers, and the Emperor gave him a post at court. His fertility of imagination and his fiery swiftness of execution alike astounded his contemporaries. He is said to have painted over three hundred frescoes on the walls of temples alone. He was prodigal of various detail, but what chiefly impressed spectators was the overpowering reality of his creations.

In the art of T'ang there was a conscious effort to unite calligraphy with painting. By this we must understand that painters strove for expression through brush-work which had at once the life-communicating power of lines that suggest the living forms of reality and the rhythmical beauty inherent in the modulated sweep of a masterly writer ; for to write the Chinese characters beautifully is to have a command of the brush such as any painter might envy. We cannot doubt that Wu Tao-tzŭ possessed this union of qualities in an extraordinary degree. After his death an old man attached to a certain temple used to tell how, when the great master painted the aureole of a god, all the people of the place, young and old, educated men and labourers, gathered in crowds to watch him. With a single stroke the aureole

82

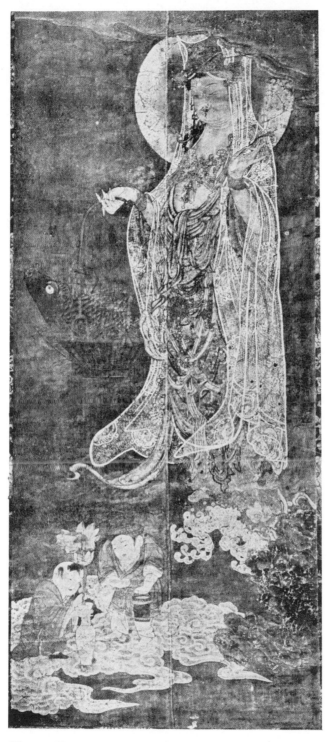

Plate V.　Kwanyin.　Artist unknown.　Sung Dynasty.
Perhaps after a design by Wu Tao-tzŭ.　Freer Collection.

was completed, as if a whirlwind had driven the brush : his hand, all declared, must have been guided by a god. We are told that Wu Tao-tzŭ used a fine brush when young, but one of great thickness in middle life. But though his calligraphic mastery was so wonderful, it was his imaginative realism and his tremendous powers of conception that made him supreme. The robes of his angels moved as if the wind were in them. His dragons seemed to shake the air ; his men and women breathed, charmed, awed, ennobled. His picture of the Buddhist Purgatory affrighted thousands from their sins. He painted a great picture of Sakyamuni among ten of his disciples. But most famous of all his works was the large composition of the " Death of Buddha," of which more than one version existed.

Another quality to which contemporaries bear witness is the plastic sense which made his forms sometimes appear like sculpture.

Alas ! of all the mighty works of Wu Tao-tzŭ none now is known certainly to survive. It is one of the greatest losses that the art of the world has suffered.

There is something to build our dreams on, but all too little. A few paintings in Japan were long attributed to Wu Tao-tzŭ, though modern criticism questions or rejects them. The most important of these is a set of three pictures, representing Sakya-

muni, and two Bodhisattvas, Samantabhadra, and
Manjusri. It may be that these pictures are copies
from lost originals. Boldly outlined, the figures
betray a latent force and impress as if by a living
presence. There is a grandeur and freedom in their
form and attitude such as we should expect from
Wu Tao-tzŭ, though the actual brush-work is in a
much later style, that of the Yüan dynasty. The
types of face are rather round, with a certain open
largeness of aspect, though the Buddha himself con-
forms more or less to the accepted type of tradition.
A pair of landscapes is also preserved in Japan, and
for centuries passed as the work of Wu Tao-tzŭ ;
but modern criticism assigns them to a later period,
and there seems no real ground for connecting them
with his name.

Of the famous " Death of Buddha," painted in
742, we know at least the composition, for Wu
Tao-tzŭ's design was repeated by more than one
early master of Japan, and the original is described
in Chinese books. In the British Museum is a
large painting of this subject, by the hand of a
great artist of a school entirely modelled on the art
of T'ang. Magnificent indeed is the conception.
The whole of creation is wailing and lamenting
around the body of Buddha, who alone lies peaceful
in the midst, having entered into Nirvana, under a
great tree, the leaves of which are withered where
they do not cover him. Saints and disciples, kings,

84

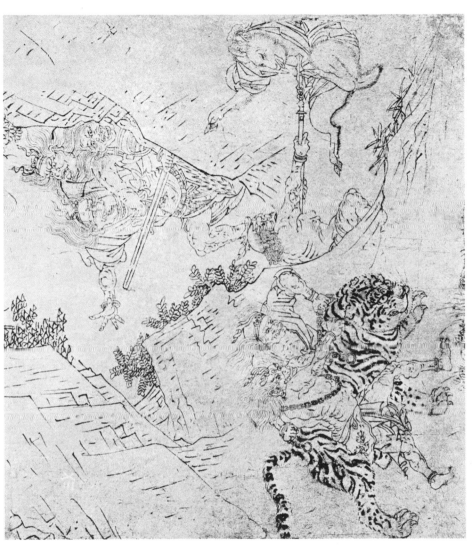

Plate VI. Demons and Animals. From a set of drawings
said to be copies by Li Lung-mien, after Wu Tao-tzŭ.
Formerly in the F. R. Martin Collection.

queens, priests and warriors, weep and beat their breasts ; angels are grieving in the air ; even the beasts of the field and the forest, the tiger, the panther, the horse, the elephant, show sorrow in all their limbs, rolling with moans upon the ground ; and the birds cry. An ecstasy of lamentation impassions the whole work. What must have been the effect of the original ?

The late Dr. F. R. Martin, the well-known authority on Persian art, possessed, and published, an album of drawings which profess to be Sung copies after originals by Wu Tao-tzŭ. In a case where certainty is impossible, it may be thought rash to pronounce ; but to me it seems that the traditional ascription is quite likely to be correct. In some at least of these drawings one feels the tremendous energy of conception and draughtsmanship which all the records tell us was the pre-eminent characteristic of Wu Tao-tzŭ. The reader may judge for himself from the example reproduced.

Another splendid design traditionally ascribed to the T'ang master is the subject of Chung-Kuei chastising a demon. An old version of this exists in Japan in the collection of Marquis Inouyé, and has been reproduced in the *Kokka*, No. 230. A Japanese copy from it is in the British Museum (Morrison collection).

Again, in the Freer collection is a picture, magnificent in design, of a male Kwanyin holding a

great fish in a basket and looking down on two children who set lotus flowers in a bowl. This is said by Fenollosa to be a copy from Wu Tao-tzŭ by an artist of the Sung period, but is translated into later style.

In the Louvre and also in the Musée Guimet are rubbings from stone engravings after a Kwanyin by the master. A rubbing for another Kwanyin, engraved on stone in the twelfth century, is in the Freer collection. And in the British Museum is a rubbing, the gift of Mrs. S. W. Bushell, which bears the name of Wu Tao-tzŭ, and which represents a traditional Chinese subject, the Snake and the Tortoise, the symbol of the North.

It is on such more or less faint echoes as these that we are driven to build our conception of Wu Tao-tzŭ's art.

The last painting of Wu Tao-tzŭ, according to legend, was a landscape, commissioned by the Emperor for one of the walls of his palace. The artist concealed the completed work with a curtain till the Emperor's arrival, then, drawing it aside, exposed his vast picture. The Emperor gazed with admiration on a marvellous scene : forests, and great mountains, and clouds in immense distances of sky, and men upon the hills, and birds in flight. " Look," said the painter; " in the cave at the foot of this mountain dwells a spirit." He clapped his hands; the door at the cave's

entrance flew open. " The interior is beautiful beyond words," he continued ; " permit me to show the way." So saying, he passed within ; the gate closed after him ; and before the astonished Emperor could speak or move, all had faded to white wall before his eyes, with not a trace of the artist's brush remaining. Wu Tao-tzŭ was seen no more.

It is a relief to turn from legends and doubtful vestiges to something authenticated. If no original by Wu Tao-tzŭ exists, we have some actual specimens of T'ang figure-painting, preserved at Kyoto. These are five portraits of saints, all but one of which are in a ruined state. They were brought to Japan in A.D. 804. Though by an artist of little fame, Li Chēn, they show greatness of style. The one best preserved impresses both by its austere sincerity and by its plastic quality, suggesting the solidity of sculpture. We can conjecture from this one specimen, far better than from any of the copies from T'ang masters, what the figure-painting of the period was really like.

Landscape, we must note, had by this time risen into prominence and favour.

Already in the earlier part of the T'ang era Li Ssŭ-hsün had made a great reputation, enhanced by his descent from the Imperial family. He is known as the founder of what is called the Northern School of landscape. It used to be thought that the division into Northern and Southern schools was founded on a difference in geographical origin : but it has been

shown by Mr. Waley that the division merely reflected a division of the Zen sect of Buddhism and had no significance except as an opposition of styles, which were adopted by painters according to their temperament and training, whatever their place of origin. No original by Li Ssŭ-hsün exists ; but the style of his school appears to have been rather dry, with much detail but decorative and rich in colour, the contours sometimes emphasised in gold. A long roll in the Freer collection may perhaps be a copy from this master. With its bold and broad opposition of white and green and blue, it has a most stimulating effect on the eye. In an album in the British Museum are what seem to be Ming versions of designs by Li : one of them is reproduced in colour by Mr. Waley. A fragmentary version of a landscape by the master's son, Li Chao-tao, now in the Boston Museum, exemplifies with a certain charm the peculiar character of the " Northern " style ; its external presentment of a richly diversified scene, severe delineation combined with a fantastic element, as of a country seen in a dream.

The founder of the southern school was Wang Wei.

Wang Wei was a physician ; and he was even more famous for his poetry than for his painting. Born in 699, he entered official life, and became a prominent member of the court circle at Chang-an, the capital. When he was thirty-one he lost his wife ; and thereafter spent more time on his country

88

estate and in the cultivation of his chosen arts. In 755 the Court was put to flight by a famous rebel, and Wang Wei was imprisoned for a time. He was a devout Buddhist, and died in 759. A portrait of the artist by himself is reproduced by Dr. Laufer in the article to which I refer below, from a seventeenth-century woodcut. It represents him seated in a chair, with his face turned away from the spectator. The attitude seems quite in keeping with the poet-painter's character.

Wang Wei's pictures were of the same character as his poems. To interpret a mood, not to record facts, was his aim; and from him the landscape-painting most expressive of the Chinese genius has derived. In the Southern school this aim was sometimes carried to extravagance, for Wang Wei's art was the parent of what is known as the Literary Man's Painting, in later ages to become a paramount fashion, in which the naturalistic element was discarded for a soft and vague idealism. Wang Wei himself was criticised for combining incongruous features in one picture, such as flowers belonging to different seasons. He was defended on the ground that his aim was to realise the spirit, and not merely the outward form. A famous picture of his was of a banana-tree in snow, which was thought an audacious defiance of nature. But in certain districts of China, as of Japan, flowering trees blossom while snow is on the ground, and in later

times the combination was a favourite subject for its rare beauty. A late copy of Wang Wei's picture has been published by Professor Hirth.* It is a sketch in impressionist style. A waterfall, in the same broad, simple, suggestive manner, is in Japan and is reproduced by Mr. Tajima.† It has been traditionally ascribed to Wang Wei, but is generally thought by Japanese critics to be of later date, though perhaps an echo of the master. In the British Museum (gifts from General Sir Ian Hamilton and from Mr. F. E. Wilkinson) are a series of sketches suggested by poems by Wang Wei, the return of a sage to his country home, where the familiar flowers still climb about the door-way ; the delicate-leaved bamboo springing up beside dark rocks ; a field full of bare young trees just tipped with flushing buds, and a distant mountain in the mist beyond ; an angler happy in his solitude under a willow on the river-bank ; an old plum-tree beginning to blossom by a full torrent ; a castle built into the sea, where a few sails ride the curling waves and faintly coloured peaks seem suspended in the haze of the horizon. The painter relies less on inventive design than on the subtle powers of association, choosing just the elements which will evoke the mood which possessed himself.

In the British Museum collection also is a long

* " Scraps from a Collector's Note-book," p. 76.
† " Select Relics," vol. ii.

90

roll, over seventeen feet long, painted almost entirely in blues and greens on the usual warm brown silk. The actual painting is attributed (probably without foundation) to the famous artist of the Yüan dynasty, Chao Mēng-fu; but it is a copy of a picture by Wang Wei, and depicts the scenery of the older master's home, the beautiful estate on which he spent so much of the last thirty years of his life. It is one continuous landscape, in which the scenes melt into one another. Such rolls are not meant to be exhibited or looked at all at once, but enjoyed in small portions at a time, as the painting is slowly unrolled and the part already seen rolled up again. No small mastery is requisite, as may be imagined, to contrive that wherever the spectator pauses an harmonious composition is presented. One has the sensation, as the roll unfolds, of passing through a delectable country. In the foreground water winds, narrowing and expanding, among verdant knolls and lawns, joined here and there by little wooden bridges; and the water is fed by torrents that plunge down among pine-woods from crags of fantastic form, glowing with hues of lapis lazuli and of jade; under towering peaks are luxuriant valleys, groves with glimpses of scattered deer, walled parks, clumps of delicate bamboo, and the distant roofs of some nestling village. Here and there is a pavilion by the water in which poet or sage sits contemplating the beauty round him.

These happy and romantic scenes yield at last to promontory and reed-bed on the borders of a bay where a fisherman's boat is rocking on the swell ; and finally all melts into open sea and distant mountains beyond, lost on the large horizon.

The original of this roll seems to have been the most famous masterpiece of Wang Wei. Some centuries after his time, when presumably it was in a bad state of preservation, it was more than once engraved on stone, as was a frequent practice in China. Dr. Laufer, in a learned and interesting article,* has published portions of rubbings from the stone engraving. From this we learn that the copy in the Museum is a free version, not only in detail but in style, and not at all a literal copy. The original appears to have been uncoloured. A very early copy, which probably takes us near to the aspect of the original, is in the Freer collection.

Dr. Laufer suggests in his article that these long landscape makimono had their origin in map-making, which at this period was a well-developed art. But surely the form had been long used already for figure-subjects.

It is to be noted that, in spite of the idealist tendencies in Wang Wei's art, the treatise he has left on the study of perspective in landscape shows that it was built on a basis of close observation of natural appearances, weather, &c.

* *Ostasiatische Zeitschrift*, April 1912.

92

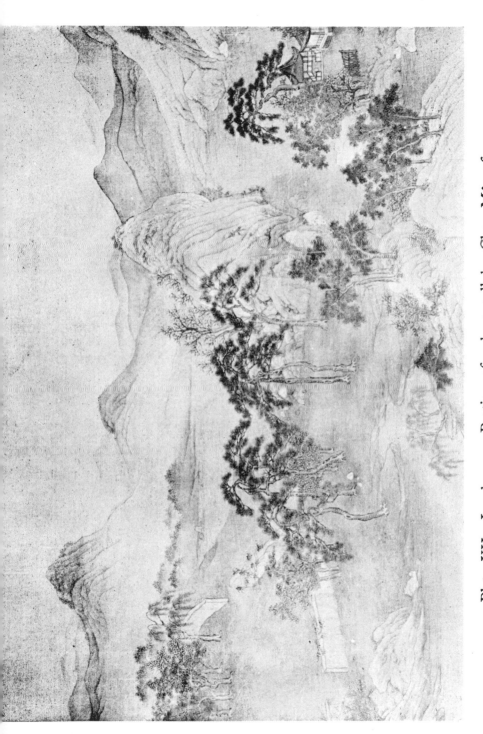

Plate VII. Landscape. Portion of a long roll by Chao Mêng-fu, freely copied from a painting by Wang Wei. British Museum.

THE T'ANG DYNASTY

Three hundred painters of the T'ang dynasty have left their names and the record of their work to posterity. Alas that we must be content with dreams and with regrets !

I will mention two or three artists whose names can be connected with existing pictures. A master to whom a number of existing pictures are attributed is Han Kan. Han Kan began life as a pot-boy at an inn from which Wang Wei was wont to get flasks of wine to take with him on his country walks. Wang Wei was not always ready to pay his bill, and the boy beguiled the waiting time by drawing men and horses in the dust. The elder artist was so struck with his gift that he gave him money to study. Han Kan became a skilled portrait-painter, and produced many religious pictures also, but devoted himself especially to the painting of horses. The Emperor of the time is said to have had not less than forty thousand in his stables, some of which were sent to him as tribute from Western countries, and Han Kan studied them assiduously. He painted horses being trained for polo, or being exercised, or gambolling in freedom on the pastures of the plains. A painting in the Freer collection of " Envoys bringing Horses as Tribute " seems to be of later execution, but to represent Han Kan's design. Perhaps we come nearer to the master in a small monochrome picture of a tethered horse in Prince Kung's collection,

reproduced by Siren ("Early Chinese Painting," pl. 61 and 62). The horse is full of fire and drawn with a masterly simplicity ; but the painting struck me, when I saw it in Peking, as too dry in touch to be the master's actual work.

In the British Museum is a small painting of a white pony (from the Olga Wegener collection) once attributed to Han Kan. It is unfortunately much damaged, but enough remains to show a virile delicacy and animation of outline. Probably this is by a Sung artist.

In the same collection is a fine picture which Japanese tradition assigned to this master, though the style proclaims it rather to be of the Yüan period. It represents a Boy-Rishi of Taoist legend riding on a goat of supernatural size, while goats and rams of small terrestrial breed gambol and frisk around. The Rishi carries over his shoulder a flowering plum-branch, on which a bird-cage hangs. We note the freedom, the nervous vigour of the strongly outlined drawing, which the Japanese were to study and imitate with such enthusiasm.

A rough sketch of horses in movement, actually contemporary with Han Kan, though rude and provincial in style, was among the pictorial fragments brought back by Sir Aurel Stein from his third expedition to Central Asia. The most interesting of these fragments (now in the Delhi Museum) are portions of a roll representing apparently a

94

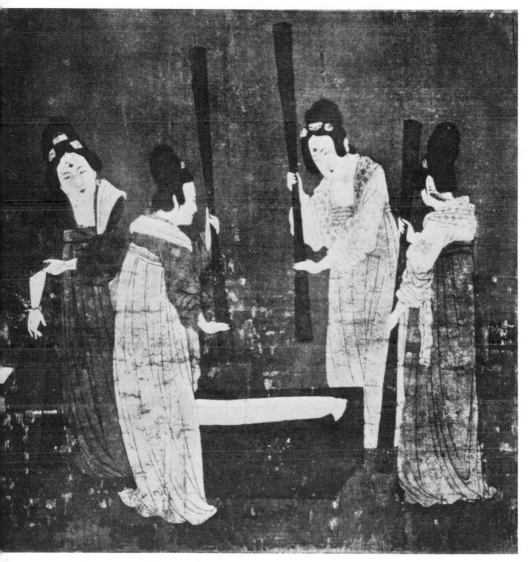

Plate VIII. Ladies Preparing Silk. Part of a roll said to be after Chang Hsüan by the Emperor Hui Tsung. Boston Museum.

festival in honour of Spring ; ladies standing under trees, dancers, etc. Coloured reproductions are given in Stein's "Innermost Asia," Vol. II, pl. cv. and cvi. Thus early we find a type of picture which was to make a particular appeal to the Chinese.

Chang Hsüan in the eighth century was famous for his genre-painting. In the Boston Museum is a short roll, " Ladies preparing Silk," said to be a copy after Chang Hsüan by the Sung emperor Hui Tsung. We may suppose this kind of picture to have been developed from representations of ceremonies ; and a ceremonial air gives extraordinary dignity to the figures, in spite of the perfect naturalness of attitude and movement. The great beauty of the design is perhaps more readily appreciated in reproductions, for the colour seems in its delicacy almost irrelevant, and to belong to a later age than the robust forms and the grandeur of the spacing. Of a like nobility and charm is another painting of T'ang design in the collection of Mrs. William Moore of New York, " Ladies Sewing." And with these we may group the exquisite composition by Chou Fang, another master who excelled in genre, " Listening to Music." This is reproduced by Waley (pl. 27) and by Siren (pl. 68) from a version in a Chinese private collection : two other versions are in America. The complete felicity of the grouping, the creation of a felt beauty in the spaces or intervals, no less than in the attitudes of the forms

themselves, make us realise that not only in majestic visions of Buddhas and Bodhisattvas but in profound and subtle harmonies won from the aspect of everyday life T'ang painting was supreme.

Among the paintings of Han Kan was " A Yellow Horse, a Tribute from Khotan." The mention shows in what relation the kingdom of Khotan stood to China. The police notices found by Sir Aurel Stein in the sand-buried cities of that country attest the presence of a Chinese garrison. And though the paintings also found there seem so early and primitive in style, we must remember that they were contemporaneous with the grand creations of Wu Tao-tzǔ. I think, therefore, that in those paintings we may recognise a provincial survival of the primitive Asian style of outline-painting from which Chinese painting was developed. And if we wish to form a conception of what Chinese painting of really primitive times was like, these Khotan pictures possibly afford the best available suggestion.

But Khotan could produce, we cannot doubt, finer art than the paintings that have been found there. At any rate, one Khotan artist who flourished early in the seventh century is known to fame—Wei-ch'ih Po-chih-na. It is significant, however, that he migrated to China, where he acquired considerable reputation, especially for his pictures of " Western Peoples " and of Buddha. His son,

Wei-ch'ih I-sēng, seems to have surpassed him as a painter, and was ranked among the eminent names of the T'ang dynasty. Of these artists Professor Hirth has written in his pamphlet on foreign influences in Chinese art. We cannot tell to what their " influence " amounted, though it is recorded that the Koreans founded their style on theirs, and we know that the foreign element in their work excited interest and attention.

The history of China is the history of a nation which is continually absorbing other races from without, and impressing on them the character of its own civilisation. China has expanded by absorbing her invaders rather than by going out to conquer : her Great Wall was built for no other purpose than to keep barbarians out ; to territorial aggrandisement, as such, she has usually been indifferent. In the same way Chinese art has absorbed foreign elements and influences only to give them its own powerful stamp. The natural tendency of artists is to gravitate towards the metropolis, the centre of most productive vitality within their ken ; and the attraction of China was doubtless irresistible to painters of talent arising in the kingdom of Khotan, which was itself a centre of art, but compared with China was a provincial centre.

Two versions of a picture by Wei-ch'ih I-sēng exist, one in the Palace Museum, Peking, the other in the Freer collection. Both are reproduced by

Dr. Siren in " Early Chinese Painting." The subject is a " Heavenly King," before whom a girl is dancing and musicians playing. These last are non-Chinese, but exhibit Central Asian types occurring in wall-paintings found in Turfan by Van le Coq.* They occur again, hardly modified, in a most interesting short roll belonging to Mr. Berenson, which also may well be a version of a picture by the Khotan master. He is said to have painted flowers which looked as if they were seen in relief. This peculiarity attracted attention in China, and may have been imitated for a time, but was not permanently adopted. The devices of modelling in two tones or shading to suggest relief, which are sometimes found in Central Asian paintings, were occasionally borrowed by Chinese and Japanese Buddhist painters, but, being essentially uncongenial, died out.

In general we shall, I believe, be safe in conjecturing that a Chinese influence would be one of style, the influence of a paramount centre of teaching and tradition, while foreign influence on Chinese work would show itself rather in subject-matter, whether religious conceptions, motives of decoration, of portraiture and costumes of Western folk, as we know was the case with the two painters, father and son, who came from Khotan.

* Professor Hirth, " Ueber fremde Einflüsse in der Chinesischen Kunst " (Munich, 1896), p. 44, quotes from a Chinese work published in 1365 some particulars on the technique pursued by the painters of Turfan.

CHAPTER VII. EARLY PAINTING IN JAPAN

WHILE the ancient empire of China was thus attaining and passing its climax of power and productiveness, a new era was opening in the neighbouring islands of Japan. Nothing is certainly known about the origin of the Yamato race whom we call Japanese. What is probable is that they came as invaders from the mainland in two successive waves, represented by two distinct types among the Japanese of history and of to-day, the descendants of the later invaders being marked by delicate features, oval face, and regular proportions, those of the earlier by a more robust frame, flatter and broader face, and more plebeian features. The Yamato race has kept its original characteristics : brave and essentially war-like in character, it is distinguished by energy and thoroughness, intensity of purpose, courtesy, a passion for cleanness, neatness, and order, and extraordinary sensibility to natural beauty. This last quality of the Japanese has been fostered and intensified by the beauty of their native land. Not only are the features of those volcanic islands arresting and stimulating by their strangeness and variety, the sea-indented coast, the torrents, the

99

mountains, above all the pure and peerless cone of Fujiyama, higher than Etna or Tenerife and as solitary, an inspiring symbol, sacred in art and poetry, hovering a distant and sublime presence in the view of half the nation ; not only in form and character has a country of such scenes power over the imagination far different from lands of sleepy meadows and soft hills and wooded plains, but the atmosphere too of that ocean climate clothes the features of the rocky islands with a changing bloom of mist and colour denied to continental countries equal or superior to Japan in natural grandeur.

To these native qualities we must add an ardent patriotism. The Shinto religion, the vague original faith of Yamato, was in essence a religion of patriotism, bound up with absolute loyalty to the Emperor and faith in the divine descent of the house that has ruled Japan from legendary ages down to the present day.

Such were the original characteristics of the nation which was so profoundly to modify itself by the complete acceptance and adoption of Chinese civilisation. We who have witnessed in our day the swift and thorough absorption by Japan of the civilisation of the West see only a repetition of what happened twelve centuries before.

In the third century A.D. the Japanese became acquainted through books and through learned

100

visitors from the continent with Confucianism ; but the great change came at the end of the sixth century, in the wake of the advent of Buddhism. In a few decades, almost in a few years, society was transformed. It may be that the real cause of the adoption of the Indian religion was the assurance that it had been accepted by the great empire of the continent, for Japan has ever been resolute and eager to prove herself able to acquire the best that the world could offer her ; but its adoption could not have been so fervent and enthusiastic had it not been for the zeal of a succession of notable women who were empresses, and inspired the whole people with the fire of their own devotion. But the first impulse to the spread of the religion was due to the influence of a great man, the Crown Prince Shotoku, regent under the Empress Suiko, a man of fine intellect and of ardently religious nature, than whom among rulers few in the world's history have won a purer fame ; he is one of the company of kings like Alfred and Saint Louis.

It is with a portrait of Shotoku and two princely youths that the story of Japanese painting * as an

* The paintings on the Tamamushi Tabernacle are earlier (sixth century). Their decorative and abstract style shows striking parallels —in the attenuation of form, in the flying scarves, and in the symbolic landscape element—with some of the Tun-huang frescoes published by Pelliot. They are painted in oil, a medium scarcely used in later times.

independent art begins. The Prince stands between the two boy princes, wearing a cap and ceremonial robes, and with a long sword at his belt. His arms are folded, and his hands, hidden in full sleeves, hold a wand of office. The two youths are also in ceremonial dress, and with arms also folded turn their gaze in the same direction as the Crown Prince. Their hair is knotted on each side of the face with a ribbon. Japanese archæologists tell us that certain details of the costume cannot date from Shotoku's lifetime. He died in 621. But if not actually from life, the portrait must have been made soon after the Prince's death, within the seventh century. In spite of the primitive stiffness of pose, we feel as if in the presence of living persons. The different character of the two boys is finely distinguished, and the countenance of the principal figure radiates that spirituality, gentleness, power, and intellectual candour to which the story of his life bears witness. The author of this portrait is unknown ; it is generally held to be the work of a Korean artist, but is quite probably the work of a native hand.

We are now on the threshold of a great era in Japanese art and history—the era known as the Nara period, from the name of the capital city of the time, just as later ages are called after the later capitals of Kyoto and Kamakura. The Nara period extends from A.D. 709 to 784. Nara, the

capital city, with its nine gates and nine broad avenues, its spaciousness and its splendour, was itself a monument to the rapid energy by which the new civilisation was absorbed. It was especially magnificent in the number and richness of its Buddhist temples. Monasteries and nunneries were built all over the land; Buddhist prelates, attended by priests and acolytes, supervised the building of bridges, the making of roads and canals. The elaborate ceremoniousness of the Buddhist religion communicated to the court and society a taste for pomp, elaborate costume, and etiquette. The literary amusements of China were introduced: poetry became a rage; flower-festivals were instituted, when poems were hung on trees among the blossoms; dancing and music were studied with enthusiasm. It so happens that of the court life of this period we have a unique relic in the personal belongings of an emperor and empress presented after their deaths to Buddha by their daughter, and preserved in the Sho-so-in, the treasure-house of the Totaiji temple, to this day. There are the robes they wore, mirrors in brocade-lined cases, swords, bronze censers, lacquered chessboards, the bamboo brushes they wrote with, laid on rests of coral, fruit-dishes of white agate, golden ewers of Persian workmanship, musical instruments, and screens. In this wonderful collection of relics of Nara's luxury much is of foreign origin—from China, from India, or from

Sassanian Persia. Native art flourished chiefly in the form of sculpture ; but the sculpture of this period has never been surpassed by Japanese artists since.

Many painters there were, we know, but almost all their work has perished. The chief monument of the period in painting is the wall-paintings in the temple of Horyuji, which was repaired or rebuilt A.D. 708–715. These have been already mentioned as, if not actually by a Chinese artist, completely Chinese in style and a most precious monument of the Buddhist art of the early T'ang era. Their influence on Buddhist painting in Japan must have been immense.

Two other relics of the period were once thought to reveal the beginnings of a more definitely Japanese style in painting. One of these is a set of six screen-paintings, called " The Beauties under the Trees." These are outline-paintings, representing single figures each under a tree, with a suggestion of landscape background. The trees and the landscape are not distinguishable from Chinese work ; and further, both the motive and the feminine types are closely recalled by the fragments discovered by Stein near Turfan and described above (p. 94).

Again, in the second and more beautiful of these two precious monuments of the painting of Nara, what seemed distinctively Japanese may turn out to be merely a slight variation on Chinese prototypes.

This other relic is reproduced somewhat crudely in the *Kokka* (No. 85), and with much greater delicacy of tone and colour in Mr. Tajima's " Select Relics " (vol. ii). It is a " Buddhist Angel," bearing in her hand the jewel of life. This is one of those enlightened spirits, purged of human grossness, purged of the hates, the fears, and the desires of mortality, all the struggle and the suffering attendant on the individual will to live, who hover still on the brink of Nirvana, soon to attain the final blessedness, to lose the self in the eternal Oneness. Only tenderness, a divine compassion, lingers like a soft colouring on the white peace of her soul, as she moves in that calm world above the longings and the strifes of men. The dreams of Buddhism have created no more gracious figure than this, revealing as it does that side of infinite tenderness and sense of brotherhood in all life which constitutes that religion's most universal appeal.

The painting is exquisitely coloured, in tones of subdued richness. What poignant regrets must such a relic evoke when we think of all that we have lost of this epoch's painting !

In 794 the capital was removed from Nara to Kyoto, and from this year to 1100 extends the age known as the Heian period, Heian being another name for Kyoto. Throughout the later part of this era the country was ruled, through the Emperor, by the all-powerful family of Fujiwara ; the first

instance of that ascendancy of a clan which has been so dominant a feature of Japanese history.

From the beginning of the tenth century Japan ceased intercourse with China, and the country was closed to foreigners. The energy of the nation was now devoted to assimilating the mass of continental ideas which had poured in upon it with such over-whelming profusion. At the same time the original impulses of the race revived. Now was inaugurated a consciously national tradition in literature and in art. Classics in prose and poetry were produced ; and it is remarkable that some of the most famous works were written by women. It was a woman who wrote the " Genji Monogatari," the long prose story of Prince Genji, which was to form the subject for innumerable illustrations by painters of every generation. It is now becoming familiar in the West through the exquisite prose of Mr. Waley's translation. This was the age of the poetess Komachi, of the poet Narihira, famed, like Byron, for his beauty no less than for his poetry. Not only the works but the lives of these two have furnished favourite themes for painting. Narihira on horse-back fording the clear stream of the Tamagawa, or riding across the plain with Fuji towering on the distant horizon, a poem on his lips : Komachi in her glory, the envy of the court, putting to shame a rival poet who had sought by a trick to convict her of plagiarism, honoured by the Emperor, the

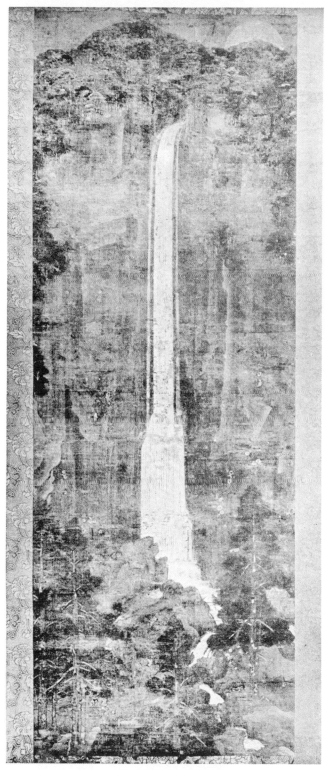

Plate IX. The Waterfall of Nachi. Kosé School.
Attributed to Kanaoka. Tetsuma Collection, Tokio.
(From the *Kokka*.)

wittiest, loveliest, and frailest in the court she dazzled ; and then in the days of disaster, old, grey, wrinkled, and in rags, begging from door to door among the peasants, mocked by village boys, or telling to priests of wayside temples the sadness of her heart and the vanity of vanities.

With the ninth century, too, we come to the first pre-eminent name in Japanese painting—Kanaoka, one of the greatest names in all the art of Japan, if we are to accept the unvarying voice of tradition, but alas ! a name only. As has happened to Cimabue in Europe, Kanaoka, to whom formerly any painting of sufficiently imposing antiquity was generally attributed, has now been shorn by modern criticism of all those floating glories, and not a single picture now existing is allowed to be by his brush. Some among the masterpieces formerly attributed to Kanaoka are worthy of the greatest genius ; for example, the full-length portrait of Shotoku reproduced in colours in the *Kokka* (No. 78), representing the Prince in ceremonial costume, a long rose-coloured robe under an outer garment of dull bronze and black, holding a censer—a portrait of the utmost nobleness and grandeur of design, glowing with solemn colour. This painting is now considered by the majority of native judges to be some centuries later in date. A similar judgment is passed on the " Waterfall of Nachi."

This painting is of singular interest as, if not the

107

earliest example, the earliest masterpiece of pure landscape in Japanese art. It has hardly been surpassed in beauty by later ages, or in the art of any country. Landscape being so late a growth in Europe, we can show nothing to compare with the almost devotional mood of this picture, so pure, lofty, and remote in atmosphere, so richly simple in design. In its conventions it is based on the T'ang landscape as we see it in the backgrounds and borders of the Buddhist paintings discovered by Sir Aurel Stein.

The portrait of Michizane, reproduced in earlier editions of this book, has passed from Mr. Arthur Morrison's collection into the British Museum. Sugawara Michizane, now worshipped as Tenjin, the tutelar deity of a celebrated shrine, was one of the great men of the ninth century. As the Emperor's minister, he was hated by the Fujiwara, and their intrigues at last succeeded in driving him into exile. He said farewell to the plum-trees in his garden, then blossoming, in a famous poem : " Though your lord be afar, forget not you the spring ! " He is often represented, as in this portrait, holding a flowering plum-branch in his hand and wearing Chinese dress. This particular painting, which is on very old silk, has always been ascribed to Kanaoka, and was for centuries in the possession of the Sugawara family. As in the case of Wu Tao-tzŭ, the great fame of Kanaoka perhaps causes us to conceive

of his work, of which we have so little knowledge, as uniformly stupendous in character. But in both cases probably we should find, if these masters' lost works were revealed to us, that they worked in a fine and delicate as well as in a large and sweeping manner. Mr. Morrison has shown in his book that the character of this small portrait agrees with what is known of one style at least of Kanaoka, and, though it must doubtless be regarded as an early copy, we can be fairly sure that it transmits an authentic work.

Stat magni nominis umbra. Kanaoka's greatness may in any case be securely inferred from the works of the school he founded. He lived on into the tenth century ; but his exact date is unknown. He painted figures, landscapes, animals, birds, and flowers. He was noted, like Han Kan, for his horses. A series of portraits of sages was painted by him for the Emperor. He was also skilled in landscape gardening, an art introduced from China, which was to develop with extraordinary enthusiasm and elaboration, as we shall see, in later times.

One painting which is still regarded as a work of the ninth century is a portrait of the priest Gonzo, preaching with earnest intensity shown in attitude and expression, and holding a rosary in his outstretched hand. This painting shows remarkable lifelikeness and vigorous simplicity of design. It is attributed to the hand of Kobo Daishi (774–834),

the most renowned of all Japanese saints. Kobo was not only priest, but painter, sculptor, and calligraphist. He studied in China, and brought back with him the tenets of the Shingon sect of Buddhism.

But still grander and more impressive are certain Buddhist masterpieces which also still survive, and which are undoubted productions of the Kosé school, the school which takes its title from the family name of Kanaoka, and which was in fact sustained by the Kosé line for a number of generations, from Kanaoka in the ninth century to Hirotaka in the twelfth.*

Such are the paintings of Samantabhadra and of Manjusri, the god of wisdom, reproduced in colours in the *Kokka* (No. 65 and No. 109). Samantabhadra sits, as always, throned on an elephant ; Manjusri on a lion of symbolic aspect, holding in one hand a drawn sword, in the other the sacred flower. Against the dark background the forms of the Bodhisattvas, mild or severe, appear with a soft radiance, like a presence from the unknown. The fluid lines of form and drapery are of an indescribable sweetness and harmony, as if sensitive themselves with life ; the colour also discloses itself

* This is the earliest example of that noticeable phenomenon in Japanese art, the continuance of a tradition of painting in a single family. Later the Tosa and Kano families were similarly eminent. Though the practice of adoption makes hereditary talent seem more common than it actually was, yet undoubtedly in some of these families the flower of genius was continually being renewed and revived in the course of many generations.

as part of the calmly glowing life within, veined with fine lines of gold, not as something applied from without. Such images as these, of which this early Buddhist art has created not a few, images of the infinity of wisdom and of tenderness, not only express the serenity of the spirit, but have in a degree unreached in any other art the power of including the spectator in their spiritual spell : to contemplate them is to be strangely moved, yet strangely tranquillised.

It was contended by M. Gonse that the early religious art of Japan is nearer to its Indian proto-type than anything Chinese. But when M. Gonse wrote, almost nothing was known of Chinese Buddhist painting. The numbers of pictures of early date discovered in the last decades quite disprove this contention. The Japanese followed the Chinese with singular closeness, infusing into their work only a certain sweetness and refinement of grace. In general the Chinese design is more vigorous and on a grander scale ; the Japanese prefer to work on smaller lines. But this of course is not an absolute rule.

Professor Hirth explained the supposed nearer affinity of Japanese with Indian Buddhist painting by the recorded fact that the Korean school of painters founded their style on that of the Khotan master already mentioned (p. 97), Wei-ch'ih I-sēng ; and it is well known that Japan derived the arts of

China through Korea. This evidence must not be disregarded ; yet as it is certain that the art of T'ang impressed itself directly on the school of Kanaoka, and we hardly doubt that masterpieces of Wu Tao-tzŭ or his compeers and successors were familiar in Japan, the influence of the Khotan artist can assuredly not have been preponderant.

As I have already mentioned, the British Museum possesses a masterpiece of this early art—a representation of the Nirvana of Buddha, based on the great conception of this subject by Wu Tao-tzŭ. Damaged by time and incense smoke as this painting is, parts of it are quite well preserved, and enable us to judge of what the whole once was. I have already, in discussing the work of Wu Tao-tzŭ, described this passionate and magnificent conception. In Anderson's catalogue of the Museum collection this picture is placed among the Chinese paintings (No. 1), and attributed to Li Lung-mien, the great religious master of the Sung dynasty. It is, however, wholly different in style from that artist's, betraying the earlier, more vigorous and impassioned style of T'ang ; but it is certainly Japanese, and a work of the time when the schools of Japan were closely modelled upon the T'ang art. It was first repaired, as records preserved within the wooden roller of the picture testify, as early as the fourteenth century ; and though some maintain it to be a work of the Takuma school, it was ascribed by a Japanese

112

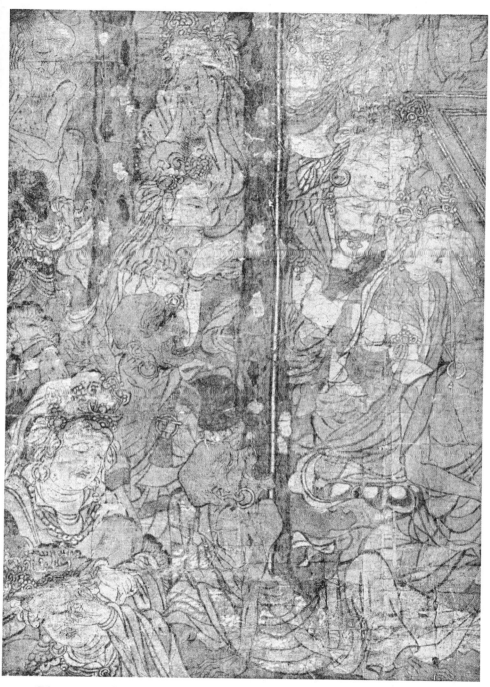

Plate X. Group of Lamenting Figures, from the " Death of
Buddha." Kosê or Takuma School. British Museum.

connoisseur of learning and authority, Mr. Rionin Kohitsu, to the great master Hirotaka, great-grandson of Kanaoka, and, after him, the mightiest of the Kosé family. The design is well known through the many ancient versions which exist in Koya-san and other Japanese temples. One of these was exhibited at Shepherd's Bush in 1910. Far better preserved than the Museum painting, this was distinctly inferior in intensity of mood and force of draughtsmanship.

In later paintings of this subject, which all follow more or less the original composition, Buddha is painted entirely in gold colour, and with the appearance of a statue. Here it is a human body, wrapped in a crimson robe, and painted with arresting truth. And the same sense for life and nature is seen in the animals mourning in the foreground; they have none of the symbolic or heraldic convention which later painters use, but remind us in their noble realism of the lions and horses of the Assyrian friezes. The extraordinary power of the picture, apart from the conception, lies in the expressive force of line-drawing, culminating in the figure of a man who in an agony of grief flings himself backward on the ground. Some of the sorrow-convulsed faces and vehement gestures might have come from an " Entombment " by Mantegna. But the whole glows with an intense and splendid harmony of colour, cut across by the strong brush-lines; pale

orange, green, and crimson, and white, and gold, and brown.

The Kosé school, as I have said, derived its inspiration directly from the Chinese masters of the T'ang dynasty, and like them pursued above all things the representation of movement and life-like vigour in a grand style.

Other schools, however, were coming into being. Takuma Tameuji in the eleventh century founded the Takuma line, which, at first an offshoot of the Kosé school, attained an independent manner of its own, not without influence from the contemporary Sung masters of China.

More purely Japanese in character was the Kasuga school, founded at about the same time by Kasuga Motomitsu.

To a European eye the distinctions between these styles seem at first sight hardly perceptible, and indeed cannot easily be expressed in words. It is enough to say here that the growth of these schools implies the gradual grafting of the Japanese delicacy on the vigorous qualities of the Chinese style. By the twelfth century the Japanese character had become fully developed. The Takuma and Kasuga lines coalesced. The name Yamato or National was given to the matured style, though the title by which it was best known in later centuries derives from yet another family of painters—the Tosa line founded by Tosa Tsunetaka in the thirteenth century.

114

EARLY PAINTING IN JAPAN

Outside of the temple collections of Japan, the religious art of these schools can best be studied in the splendid series of paintings owned by the Boston Museum.

Though the surviving pictures of this earliest period are all either religious subjects or portraits (and these usually of an ideal character), yet we know from records that secular subjects and landscapes were also among the painters' themes. In fact, like Kanaoka, they followed the masters of China in range of subject as in style.

With the eleventh century, however, we shall come to the beginnings of a new kind of painting, the scrolls (*makimono*), on which were portrayed scenes of court life or scenes of war and adventure. But before quitting the Buddhist painters, we must notice a painter who stands among the most eminent of the religious artists of Japan. Yéshin Sozu belonged to no school in particular, and blended both Chinese and Japanese elements in his style. He was author as well as artist ; his literary works were published in 150 volumes. IIe died in 1017, aged seventy-six.

One of the most striking things in Eastern art is the difficulty of tracing any one pictorial conception to its first origin and creator. Especially is this the case with religious art. We see for the first time what impresses us as a profound and original conception, and we say to ourselves : The

mind from which this came was surely a great inventive spirit. And then we find that this work, so fresh and so immediately inspired as it seems to be, repeats with only the personal variation of the artist's style or temper an older painting by another master; and that again one yet more ancient; and so back into the mist of time. The truth is, these conceptions seem to be images that have been born out of the imagination of a race rather than moulded by any individual mind.

In the work of Yéshin Sozu, however, we find one august conception which is said to have originated in a vision of the artist's own. It is told that on a mountain near Kyoto the priest-painter saw one night a vision of the great and mild Buddha rising between two hills clothed with autumnal woods; in the air beneath on either side floated two celestial beings, whose robes waved with the movements of their adoration; heavenly flowers fell through the darkness and filled it with strange sweetness. This was the vision which in his ecstasy the painter saw, and as he saw it, so he painted it; Buddha, a golden figure, greater than the hills, filling the picture with his own unearthly peace, and the angelic figures moving as if to divine melodies. Few paintings in the world surely have in deeper degree the religious sentiment of rapture and devotion.

To Yéshin also must be assigned the concep-

116

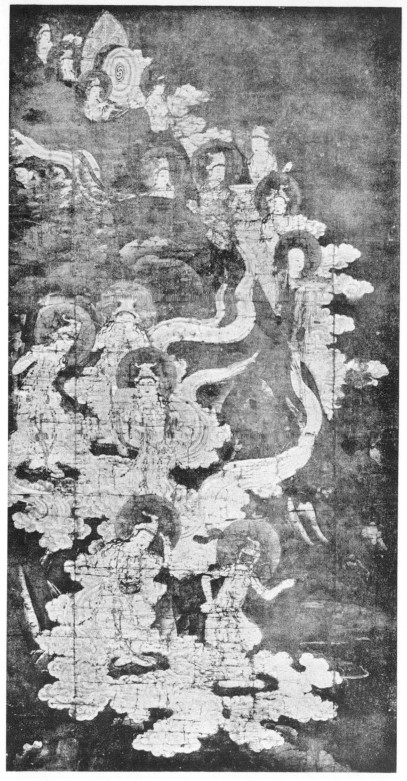

Plate XI. Amida with angels descending to meet the spirits of
the Blessed. Artist unknown. Kamakura Period. Formerly
attributed to Yéshin Sozu. Jofukuji Temple, Kioto.
(From the *Shimbi Taikwan*.)

tion of another glorious work, the great triptych representing Amida descending with the hosts of celestial beings on a cloud that streams and wavers into the night of space behind like a scarf of glimmering gold. Mild and benignant he looks down upon the earth, while the inhabitants of Paradise play all manner of musical instruments, and perfumed petals softly fall about them. Did the painting convey no import to our minds, yet merely as a design its undulating and mysterious harmonics would affect us like a strain of solemn music. What then must have been the impression on those for whom it was painted, for whose souls, not only for whose senses, it brought the message of welcome and compassion, and attuned world-troubled hearts to the serene spaces of Paradise? Only Fra Angelico among the painters of Europe has this beauty of devotion, this intensity of tenderness.

In the British Museum is a large painting, formerly in the Morrison collection, which came from a temple near Kyoto, where it was for centuries treasured as the work of Yéshin Sozu. It is on silk of very ancient date, and the drawing of the features is identical with that in the great work just described. This also is a picture of Amida, with two attendant spirits, floating through the night-blue of heaven.

Though such noble art was perfected in the Heian period, the history of Japanese life, so far as it centred in the capital and the court, was a history of

strange and exquisite sophistication. Æstheticism dominated the interests of life. The ferment of religious enthusiasm was subsiding into superstition and the study of magic, into elaboration of paralysing ritual and the pullulation of mythologies. Effeminacy was the fashion. Men used rouge and powder ; they gave way to gusts of hysteric passion and to floods of tears. Ministers of State disowned their functions ; it is recorded of one that he devoted every day of nineteen years to the practice of kicking a football. The armour in fashion had become so elaborate and heavy that in the hour of crisis the captain of the guard found himself unable to move a step, and the commander-in-chief could not mount his horse. Writing verses, drawing on fans, burning various kinds of incense, and improvising poems on the scented fumes, hawking, football (in a less violent version of the game than our own) ; these were the only serious occupations. As high and strict a canon prevailed in all that belonged to manners and accomplishments as in mere conduct it was relaxed. To a successful costume, to a happily turned couplet, all merely moral offences were forgiven.

Of life in the palace at this period we get a glimpse in the scroll-paintings of Takayoshi. In these, as in all the subsequent scrolls of the Yamato school, certain definite conventions are adopted. Interiors are represented not as on a level with the eye, but

118

below it ; we look down, as if from the ceiling, on rooms divided by gorgeous screens and on the figures within, equally gorgeous in their stiffly ornate costume. Ladies of fashion would wear twenty dresses, one over the other, the edge only of each undergarment showing, in a series of narrow borders of skilfully harmonised colour ; their black hair was unbound and trailed in a long cascade over the shoulders, much admired if it fell to the feet. Their faces, that disown expression, look small and masklike, the apex of a pyramid of dress. Human bodies seem instruments for the propping up of the costumier's rich work of art rather than wearing clothes for the use of moving limbs. The painter, too, was enthusiastically conventional. In representing a garden, he chose a few flowers and trees, and, painting them with exquisite delicacy, made them symbols of nature's luxuriance. Clouds and mist were introduced, for quite arbitrary reasons of composition, as solid bands of gold with perfectly definite outline. A strangely original, exotic, sumptuous art, far removed from Chinese impressionism, as indeed it was in essence purely Japanese. Within its very decided limitations, the delicacy of workmanship, the inventions of colour and composition, attract the more it is studied. There is nothing like this in the world's art elsewhere. The principles of design which this style inaugurates persist through Japanese art, wherever it reverts to native tradition.

Korin's flowers, Hokusai's clouds, are treated in the same spirit. In the frank use of straight line and angle, which play so little part in the fluid rhythms and curves of Chinese design, we find something symptomatic of the Japanese character, which lends a certain strength of order and decision to a too refined, voluptuous, and secluded art. And soon this style and tradition were to be taken up and transfigured into virile life. For the days of the Fujiwara, and the indolent court of Kyoto, with all its fantastic and coloured solemnity, were passing away. Impatient hands knocked at the door ; armed and resolute actors appear upon the scene.

CHAPTER VIII. JAPANESE PAINTING IN THE KAMAKURA EPOCH OF THE CIVIL WARS

WE enter an age of battle and bloodshed. While the court at Kyoto was daily more lost in exquisite and fantastic pleasures, the provincial families were acquiring strength, taking into their own hands the powers dropped from an enervated rule, and viewed with increasing contempt the effeminate corruption of the capital.

At the opening of the twelfth century military power was concentrated in two great clans, the Taira and the Minamoto. The Taira at first, under a strong chieftain, Kiyomori, a man without fear as without scruple or feeling, had the predominance. But the struggle was fierce and continuous. The two factions contended for the guardianship of the Emperor's person ; for the Emperor, though his sacred dynasty was never deposed and he was still treated with a figment of veneration, was without real power ; there were times when he was driven to fly in feminine disguise. At last the Minamoto began to gain the upper hand. They owed a series of successes to their chieftain Yoritomo, one of the great and formidable figures in Japanese history, and to the generalship and devotion of his younger

brother, the hero Yoshitsune. At the final battle of Dannoura, on the coast, the forces of the Taira were utterly destroyed. In later Japanese art, pictures of Yoshitsune in his ship, haunted by the ghosts of his slain enemies, who rise in their hundreds from the sea with threatening and accusing gestures, the very foam of the waves, as they break on the ship's bows, forming into pale clutches of spectral fingers, show how deep the remembrance of that day of drowning and slaughter had burned into the imagination of the race.

Yoshitsune's brilliant captaincy and triumph earned him not gratitude but jealousy and hatred from the elder brother in whose cause he had fought. Yoritomo plotted against him, and set spies to take his life. Yoshitsune escaped in disguise to the north of Japan with a few trusted companions, chief among them the giant Benkei, whom as a youth he had defeated in a famous combat, and who ever after served him with passionate devotion. Pictures and colour-prints endlessly celebrate the deeds and adventures of these heroes, the darlings of Japanese story. The brave and chivalrous Yoshitsune died fighting, or as some say by his own hand, the victim of his brother's hatred.

Yoritomo became absolute in power, though he made no attempt to depose the Mikado from his nominal sovereignty. He established his capital at Kamakura, which grew speedily into a great

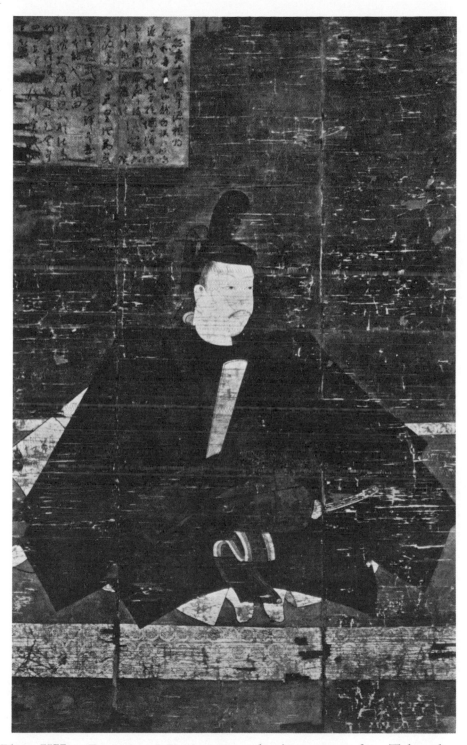

Plate XII. Portrait of Yoritomo. Ancient copy after Takanobu.
British Museum.

city. In 1192 he forced from the unwilling court
the concession to himself of the title of Shogun,
" Great General." The title has become historic.
Henceforward, down to 1868, when the Shogunate
was at last abolished, Japan had two masters : the
Mikado, supreme in name and sacrosanct in person,
but without power ; and the Shogun, nominally
deriving his office and authority from the sovereign,
but in reality treating that sovereign as a puppet
and exercising himself an armed supremacy. The
Shoguns ruled ; but their line was not continuous
like that of the Mikados ; revolutions were accom-
plished, ruling houses overthrown, and successive
dynasties of Shoguns were set up.

A large portrait of Yoritomo, seated in ceremonial
costume, is preserved in Japan and attributed to
Takanobu, a contemporary painter. An ancient and
fine copy of this picture is in the British Museum
(Pl. XII) and is specially interesting because it shows
the feet which, with most of the band of decoration
below, has been effaced in the original. This may
be taken as a type of Japanese portraiture. The
astringent formality of the design, with its sharp-
cutting straight lines and undisguised angles, admir-
ably foiled by the curves of the end of the girdle,
seems congenial to the subject. How far removed
it is from Chinese art !

Strong ruler as Yoritomo was, his own house of
Minamoto had but a brief spell of power. In the

next generation his family lost its supremacy, and another family, the Hojo, took its place. It was during the Hojo rule, in 1274, that Japan was threatened, for the first and only time in her history, with foreign invasion. The great Mongol conqueror, Kublai Khan, despatched an armada to subjugate the Island Empire. But, as with Elizabeth's England, the winds and the waters fought against the invader, and a tremendous tempest sank the ships of the great Khan. Yet relief from this overwhelming danger brought no peace. Japan remained torn and distracted till in 1333, after fierce bloodshed and convulsions, the rule of the Hojo was destroyed, and a new house, the Ashikaga, came to power. Strange to say, it was in this time of desperate and incessant battle that, as Mr. Y. Okakura has pointed out,* Buddhism in its deeper sense became finally rooted in its hold on the Japanese spirit. It was as a spiritual discipline that it appealed, a discipline which by steady contemplation of death and all possible disaster, confronting every man at such a time whether he would or no, could lift the spirit above change and calamity, and enable it to meet fate smiling and unsubdued. Like Christianity, Buddhism in its progress over the world developed many diverse characters and assumed a variety of forms. Penetrated severally with the predominant importance of some one aspect or interpretation of

* " The Japanese Spirit," p. 78.

the original doctrine, numerous sects came into being. The sect of Shingon or the True Word had been supreme in the Heian epoch ; and the mysticism of that sect, with its emphasis on the pronouncing of sacred charms, was peculiarly liable to the degeneration which popular belief in magic helped on. But during the Kamakura epoch another sect took hold on the Japanese, the Dyāna or Zen sect of " abstract contemplation." The characteristic doctrines of this sect inculcated a high indifference to the changes and chances of the world ; they bred in its votaries a stoical fortitude and self-control. Hence its appeal to the warrior natures of Japan, an appeal strengthened by the Zen indifference to book-learning, and reliance on personal intercourse and elementary symbolism. Incalculable has been the influence of the Zen teaching in the moulding of the Japanese character, bearing fruit, as we ourselves have seen, to-day. Charity, patience, energy, contemplation, the wisdom and sweetness that ripen from self-conquest—these were the paramount virtues instilled into the Samurai, the warrior class whose actions fill this epoch with a keen air of daring and devotion. The brutality of war was ennobled by a religious inspiration ; to suffer and to die for others was the Samurai's ideal. Not seldom do we read of famous warriors shaving their heads and retiring from the world ; some even wore a priestly robe over their armour. We are reminded of our own

Crusaders. And indeed I think we can understand this age of Japanese history better if we recall what conditions were brought about when the Norman race had assimilated, with Christianity, the arts and civilisation of the South. The Normans, like the Yamato warriors, were high of spirit, supremely energetic, strong of will. In great characters like William the Conqueror we find the same combination of consummate foresight with unscrupulous force that we find in Yoritomo, the creator of the Shogunate ; the love of art and poetry, the religious devotion, the adventurous deeds, the extravagant chivalry of the Norman knight, have all their parallel in the Kamakura Samurai. The life of each has its darker side. In Captain Brinkley's great work we read of cruelties, vices, and effeminacies among the knights of Japan, reminding us vividly enough of the courts and camps of our own Norman kings.

Before the rival houses of Taira and Minamoto had joined in their long conflict, a painter had arisen whose spirited brush was destined to re-create the native school of art. This was a Buddhist priest, named Kakuyu, who rose to be a bishop and in 1138 archbishop in the Buddhist Church. He is famous in art under the name of Toba Sojo, his official title. He died in 1140. Though a bishop, he was a man of the rarest geniality, with a genius for fun and playful malice. His name is popularly associated with the invention of caricature. The

126

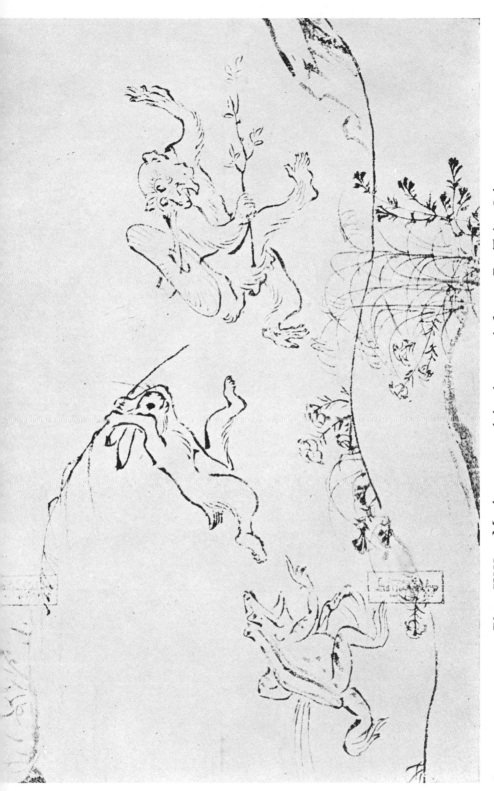

Plate XIII. Monkey pursued by hare and frog. By Toba Sojo.
From one of the set of three rolls reproduced by the Shimbi Shoin.

comic style of drawing is called after him Tobayé, and he has left some scrolls filled with drawings of frolicking animals, satirising the ways of the Buddhist monks and clergy.

Frogs, monkeys, and hares are made to travesty the ritual of the priests and the devotions of pilgrims, whether in mere light-heartedness or in condemnation of clerical perfunctoriness and slothful ways I do not know. Three out of six famous *makimono*, filled with sketches, have been published entire with admirable fidelity by the Shimbi Shoin. Here are drawings of groups of people watching a cock-fight or a tug-of-war between a fat man and a lean, frogs at archery, horses in the meadows, bulls fighting, animals engaged in all sorts of games. Fresh, diverting, and amazingly modern as these drawings are, they are not the whole of Toba Sojo's achievement. He painted solemn subjects like the Nirvana of Buddha. But his great importance in the history of his country's art is his invention of dramatic painting. It was Toba Sojo who inaugurated the style of swift and vigorous figure-drawing applied to scenes of actual life, which answered to the high and gay spirit of the Japanese race. Nothing in Chinese art (so far as we know) afforded a parallel or pattern for the amazing life and energy which he and his successors show in handling crowds of figures. In one of Toba Sojo's scrolls, devoted to the life of a famous priest, a crowd of people witnesses a miracle,

the bodily uplifting of a building into the sky. How swiftly and how powerfully he seizes the varying expressions of the people : the frenzy of wonder, the grimace of stupefaction, the exultation of the devout !

The same gift in perhaps even greater force appears in the scroll-paintings of the next great master of the period, Mitsunaga. A son of the ancient and potent house of Fujiwara, Mitsunaga enjoyed immense fame in his lifetime. He received a commission from the Emperor in 1173, but almost nothing is known of his career.

A typical scene from Mitsunaga's brush is reproduced in the *Kokka*, No. 182. The gate of the palace has been set on fire, and before it stands a hesitating and alarmed multitude, paralysed by the spectacle of the rushing and swirling flames, which are fastening on the woodwork and scatter burning splinters at their feet. Divided counsels possess them : some would be running, but the flames bewitch them ; others give commands, which no one hears. Their bodies are alive with movement or tense inaction ; their very hands talk, their faces grin with excitement.

A Japanese critic, Mr. Sei-ichi Taki, has chosen this painting of Mitsunaga's to illustrate * an essential characteristic of Japanese painting : the tendency to find its subject not in a single central

* " Three Essays on Oriental Painting " : London, 1910.

object, but in the mutual relation of figures or objects. Stress is laid not on forms but on ideas. The criticism is a subtle and suggestive one. For though in European art we are accustomed to compositions with numerous and crowded figures, it is certainly the exception for these figures not to be grouped in convergence on one central figure or group. This convergence obeys the instinct for unity which is inherent in all artistic creation. In these dramatic scenes of Japanese painting the unity is not formal and obvious, may appear even to be lacking ; but the same principle of a mutual relation conceived of as the unifying factor is to be found also in the Japanese designs of flowers and birds. In fact, we must recognise that at bottom it is landscape which controls the type of Japanese, as of Chinese, painting. Figures and groups are treated as parts of a landscape might be treated. We are dealing with an art which differs from European art, as we have said before, in the absence of that concentrated attention on the human form which is at the core of Western painting.

Yet in drawing the figure, what could be more expressive of the capacities of the body for movement, force, and animation than the brush of Mitsunaga ? Those who know the pen drawings of Rembrandt will recognise a kindred power in Mitsunaga of creating the living, acting, suffering presence of human beings by a few summary

strokes. True, there is a certain trace of the calligraphic element in the Japanese master which is entirely absent in the Dutchman; this and the sense of suppleness, alertness, and fire in the brushline ally Mitsunaga's drawing to that of Leonardo. Yet, on the other hand, the profound and pervading Italian sense for ideal beauty of form that lives in every sketch of Leonardo's is alien to the art of Mitsunaga, who, like Rembrandt, accepts humanity in all its various common types.

In another scroll of Mitsunaga's we have pages from the contemporary life of the court, which illustrate in their way the over-refined, exhausted temperaments produced by the times. So in an odd scene we see a neurotic patient lying in bed, while creatures of his feverish dream, little gnome-like figures, troop in to visit him.

But the tremendous imaginative power of the painter is best seen in the scroll which portrays the terrors of hell. Here are nude figures, almost unknown in Japanese art (though treated finely by some of the Ukiyoyé masters in their colour-prints), treated with extraordinary expressiveness and force of line.

With Toba Sojo and Mitsunaga may be ranked two other masters who stand pre-eminent above the artists of the period, Keion and Nobuzane.

Like Mitsunaga, Nobuzane belonged to the noble Fujiwara clan. He was equally renowned for his

poetry and for his painting, and his portraits of poets are among the pictures attributed most securely to his hand. He was born in 1177, and lived to 1265. Among the works which tradition calls by his name are *makimono* of court life, following the conventions of Takayoshi's design, but adding the vigour and expressiveness of drawing which Toba Sojo had introduced. And with this Nobuzane united the glow of a subdued but splendid colouring, which no artist of his race has surpassed ; strange harmonies of deep lapis-lazuli and orange, and opaque green, fawn colour, black, and gold.

In his portraits he used lighter tones ; they are drawings rather than paintings. They show an intimate sense of character. But the crown of Nobuzane's achievement, one of the supreme classics of Japanese art, is the ideal portrait of the famous priest and saint, Kobo, represented as a boy kneeling on a lotus dais, with hands joined in prayer. Here we are far from any Indian symbolism such as for our eyes mars with its monstrous features, however disguised and subdued, so much of Buddhist painting in China and Japan. It is the simplicity of direct vision, as if the poet-painter were actually transcribing on the warm brown silk the definite features of a vividly remembered dream, which has created this pure image. Without material surroundings, set on the symbolic lotus, sacred in Eastern art as the flower which from mud and ooze rises to unfold

unsullied blossoms above the peaceful water, type of
the soul aspiring from the muddy passions of gross
nature, the figure of the young saint might have
been a merely hieratic form. But Nobuzane's
profound feeling has filled it with a real humanity
that has power to touch us : its innocence is not
mere ignorance, deriving charm and pathos from
our knowledge that it is soon to be destroyed, it
is a positive purity of the spirit that we feel will
endure beyond experience. In Reynolds's " Infant
Samuel " it is the charm of a child's sweet
docility and trust that informs the sentiment of
the picture. But Nobuzane lifts us into a rarer,
a severer atmosphere. In the young face is fore-
knowledge :

> O meek anticipant of that sure pain
> Whose sureness grey-haired scholars hardly learn !

What mood, we may ask, is his ?

> Some exile's, mindful how the past was glad ?
> Some angel's, in an alien planet born ?

Not these ; for though there is the gravity of fore-
knowledge, there is also the intensity of a pure
will ; there is, in Dante's deep and haunting phrase,
the " beginning of peace." The world, as Nobu-
zane symbolises in the enclosing circle and in the
emptiness of background and surrounding—the
world has fallen away, does not exist, for that isola-

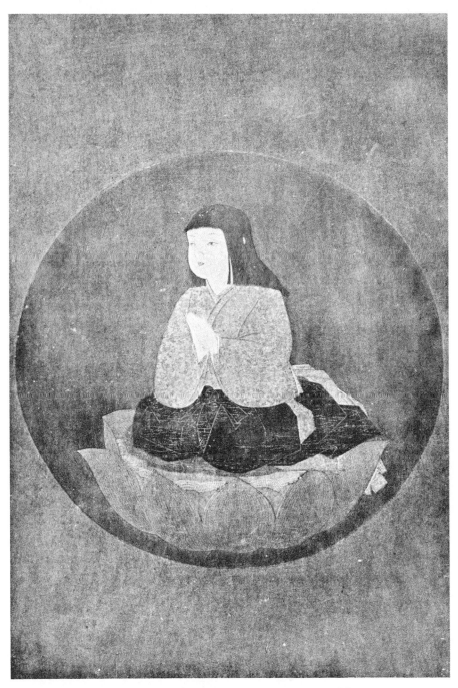

Plate XIV. Kobo Daishi as a child. By Nobuzané.
Murayama Collection. (From the *Kokka.*)

tion, in which prayer is a state even more than an act of the soul.

As a painting this picture is of strange beauty, with its unfretted simplicity of design, its delicacy of drawing, its imaginative colour. And its beauty is of a different type from that of Chinese painting, as it is still more different from that of European painting. It is a new, rare flower in the world's art.

We pass from Nobuzane to the fourth great master of the period : Keion. The existence of this artist has been denied, I do not know upon what grounds. He is said to have flourished in the thirteenth century, and to have been attached to the Sumiyoshi shrine.

In any case, there exist three famous *makimono*, two of which are in private possession in Japan, while the third is in the Boston Museum. They are by a single artist, and it is with him, whether his name be Keion or another, that we have to deal. They depict scenes of the civil war, when the strife between Taira and Minamoto raged. Never surely has the excitement of movement and action been portrayed with such amazing energy as in some of these splendid scrolls.

In his own way Keion is the greatest of Japanese draughtsmen. When Kiyomori, the Taira chief, was absent from Kyoto, the Minamoto invaded the court and set the palace on fire, hoping to seize

133

in their turn the sacred person of the Emperor. Disguised as a woman, the Emperor was smuggled into an ox-cart. Keion has painted the scene, when a group of armed Minamoto, arriving in the courtyard, surround the ox-cart : one holds up a smoking torch, others roughly pull aside the curtains of the hood and exclaim with disappointed anger at finding only a woman. The men are alive : we can hear the stamp of their feet ; we can see their swift and menacing gestures. But the full measure of Keion's power is seen rather in another scene, from the Boston scroll, the " Flight of the Court." What a fury of fear, what a riot of speed, in the headlong flight of the men, in the mad race of the ox-carts, some of which are overturned in the wild onrush ! Could even Rubens have given us a more overwhelming impression of energy and despair, of terror and of tumult ?

Toba Sojo, Mitsunaga, Keion, Nobuzane : these are the greatest masters of their period and of the whole Yamato school. But they are the greatest among a host. Korehisa approaches Keion in the fierce vigour of his battle scenes : there is more than one copy from a famous scroll of his in the British Museum collection ; Takakane rivals Nobuzane as a colourist ; he is a master of strong harmonies of lapis blue and vermilion, white and gold, and green, a summary and decisive draughts-man. And these are only a few among many

134

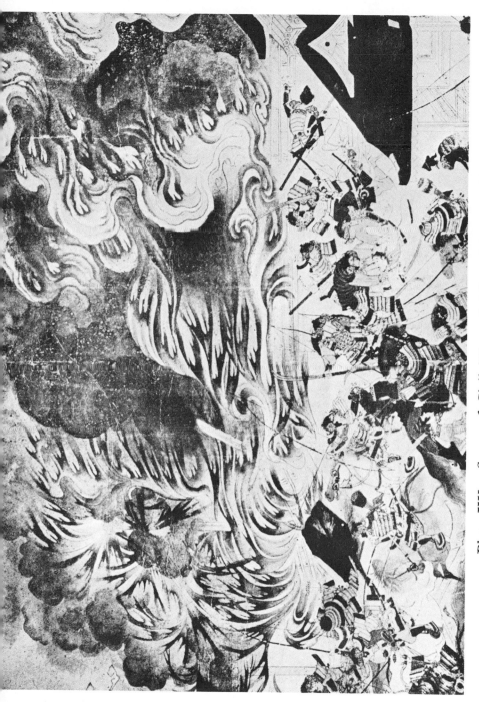

Plate XV. Scene of Civil War. Soldiers firing a palace.
Portion of a scroll-painting By Keion. Bostor Museum.

pre-eminent names. This is one of the greatest periods of Japanese painting, one in which there is no influence of Chinese ideals. Yet to Europe it is practically unknown. With the exception of the one Keion scroll at Boston, all of these master-pieces are in Japan, in the hands of noble families, in collections that no traveller sees. It was inevit-able that M. Gonse should have passed them over, for at the time when he wrote his book there was no means for a student, unless provided with most unusual influence and facilities in Japan itself, of knowing of their existence, except from native books. It was inevitable, too, that Dr. Anderson should depreciate the whole school, which he judged chiefly by later degenerate works and by copies. Indeed, it is only by the wonderful reproductions published in Japan that students are now able to realise how glorious and how significant a period this was, and to understand why Japanese connoisseurs prize the master works of the early Yamato painters above all other paintings of their country.

With the end of the fourteenth century the school began to decline ; and though great painters of the Tosa line arose in this and the succeeding century, there was soon to come a strong reaction in the form of a renaissance from China. A new era in art was at hand, with a different ideal and a totally different style ; and the masters of this new era derived their inspiration from the works produced

135

in China, while Japan was absorbed in her own national problems and internal struggles, under the dynasty of Sung. It is to China that we must now return.

CHAPTER IX. THE SUNG PERIOD IN CHINA

IN a lecture delivered at Oxford, which has never, I think, been reprinted, Matthew Arnold discussed the Modern Element in Literature. He took for illustration the contrast between the words with which Thucydides opens his history and the words with which Sir Walter Raleigh opens his. The Athenian, he points out, has the modern tone, the modern conception of history, while to the Elizabethan the world is still a theatre of romance, where fact and fable are admitted on equal terms.

What, in effect, do we imply by this word modern ? We mean, I think, by a modern age, an age in which the interests of the race have passed beyond dependence on the struggle for existence ; in which the mind is free, has found a clue to life, and can disinterestedly review and estimate the forces operating outside itself ; in which the state of society has emerged from a state of warfare, such as the wearing of weapons implies, to a state of civility and amenity.

The age of Sung has this modern character, if we are to judge it by the art it has left.

We left China at the opening of the tenth century. The T'ang dynasty fell in 907. Between that time and the establishment of the House of Sung

there is a short period of fifty years, in which five brief dynasties rose and fell ; a period of trouble and unrest. Of the art of this time we know little at first hand, though certain painters like Huang Ch'üan and Hsü Hsi are famous. To the latter artist are ascribed a pair of pictures of Lotuses, in Japan, unsurpassed of their kind, and combining sensitiveness of touch with grandeur of design. A delicate fineness of style and an interest in the lighter things of life were characteristic of the period, in reaction from the largeness and vigour of T'ang. In the British Museum is a small oblong painting which came from a private collection in China and which was certified by a well-known painter and connoisseur of the thirteenth century as the work of Chou Wēn Chü. It has suffered much from re-painting, so that it is difficult to judge of its original state. This painter flourished in the first half of the tenth century, and was famous for his picture of women. Our painting, of which a portion is reproduced, represents groups of women and children on a terrace by a lotus-pond. In a basin at one side a child is washing melons : a woman cuts a melon for some elder children, and another woman, with a baby in her arms, holds out a toy to a small boy who is being washed in a basin at the other side. A small picture of a boy in a garden, with a dog and a cat, in the Boston Museum, is ascribed to the same master.

138

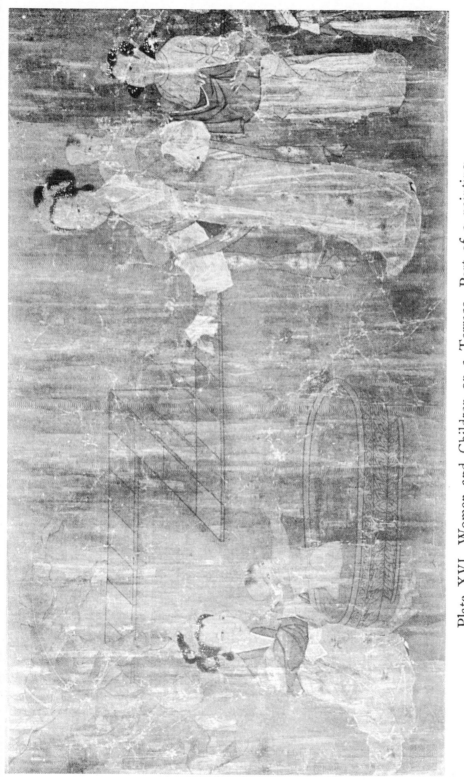

Plate XVI. Women and Children on a Terrace. Part of a painting. Attributed to Chou Wên-Chü. British Museum.

Now also begins the passion for landscape-painting in monochrome, which was to be so characteristic of Sung art.

The Sung dynasty reigned from 960 to 1280; three centuries of splendour for art and literature, though of gradually waning power for the empire, owing to Tartar encroachments from the north. In 1127 the Tartars took K'ai-fēng and the emperor Hui Tsung was made captive. The period known as Northern Sung thus came to an end, Northern China passing under foreign domination. A new capital was made in the South, at Hang-chow.

Whoever wishes to obtain some conception of the external aspect of Chinese life at this period cannot do better than read Marco Polo's description of the Southern Sung capital, Hang-chow, upon the Ch'ien-t'ang river; a city even then, when its heyday was over, " beyond dispute the finest and the noblest in the world." He tells of the vast compass of the city; of its canals and twelve thousand stone bridges; of its twelve guilds of handicrafts, with their many thousands of workmen each; of the merchant princes, who lived " nicely and delicately as kings," and those " most dainty and angelical creatures " their wives; of the great lake, some thirty miles in circuit, within the city, its shores studded with palaces, abbeys, and churches, and on each of its two islands a vast mansion royally fur-

nished, free for the use of any citizen who desired to give a wedding-feast or other entertainment ; of the numerous police ; of the three hundred public baths of hot water ; of the ten principal markets, filled with stores of fresh fish, vegetables, and magnificent fruit ; of the throngs of house-boats and barges on the lake, and of carriages in the streets.* The citizens,, Marco tells us, were of peaceful character, neither wearing arms nor keeping them in their houses. You heard no noisy feuds or dissensions of any kind among them. Their goodwill and friendliness was not confined to their dealings with their own countrymen ; they were equally cordial to foreigners, entertaining them " in the most winning manner," and giving them help and advice in their business. In the palace grounds of the Emperor were delectable gardens, shady with fruit-trees, cool with fountains, a demesne enclosed by ten miles of battlemented wall ; and in the many spacious halls of the palace itself were paintings on a gold ground of beasts and birds, warriors and fair ladies, and marvellous histories.

Would that the Venetian, so curious of manners and customs, so observant of facts, had found means to tell us of the inner life, the animating thoughts of the poets, philosophers, and artists, which informed so splendid and mature a civilisa-

* In the Freer collection is a roll which gives a panoramic view of Hang-chow, as it existed in Sung times.

tion ! It is true that when Marco Polo came to China the Sung dynasty was at an end ; but in Hang-chow and the south the soldiers of the conquering Mongol were no more than a garrison, hated by the inhabitants, and the glory of Sung had not yet wholly departed. Had he questioned " the idolaters," as he terms them, he might have transmitted to us Platonic discourses from the votaries of Zen, that sect which in the Sung era came to inspire and give significance to so much of its art and literature, and, as we have already seen, passed on to even greater power in Japan.

As Wu Tao-tzŭ to the age of T'ang, so, at least in fame, is Li Lung-mien to the age of Northern Sung : great in all branches of art, but of especial originality and power in his religious paintings. He is renowned in Japan as Ri-riu-min. He served for thirty years in official posts, but whenever he could get a holiday he would take a flask of wine, we are told, and go out into the woods, and spend the day on some rocky seat beside a running stream.

Painting was a passion with him ; even in old age when racked with rheumatism he would make as if he drew upon the bed-clothes with his crippled hand. In his youth he was famous for his pictures of horses, and would spend hours watching the horses in the Imperial stables. A Buddhist priest even rebuked him for this preoccupation, and warned him that in his next metempsychosis he

might find himself in a horse's body. His later years were devoted to the religious masterpieces on which his fame chiefly rests. In 1100 he retired to the Hill of the Sleeping Dragon, from which he took his fancy name Lung-mien (his real name being Li Kung-lin), and died there six years later.

Among this master's greatest works was a vast painting of the " Five Hundred Disciples of Sakya-muni " ; and he painted several notable pictures of Kwanyin, the Goddess of Mercy. But with Li Lung-mien we come to a perplexing problem ; and that is the strange divergence in regard to him between Chinese and Japanese tradition. The Japanese tradition attributes to him a number of paintings of Arhats, magnificent alike in colour and design. Such are the series of sixteen paintings in the Freer collection, one of which is here reproduced. It is on this type of picture represented also in the Boston Museum by ten paintings out of a set of a hundred from the Daitokuji Temple at Tokio, that Fenollosa founded his enthusiastic estimate of the master as one of the supreme names in pictorial art. These last paintings are now known to be by two other artists, but this type of Arhat picture may perhaps have originated with Li Lung-mien. According to Chinese records, however, that master never painted in colour except when copying older pictures ; and the paintings which pass under his

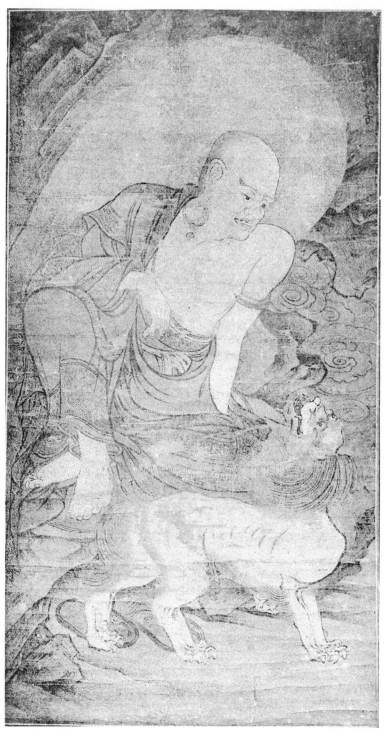

Plate XVII. An Arhat with a Lion. Artist unknown.
Sung dynasty. Formerly attributed to Li Lung-mien.
Freer Collection.

name in China are of a totally different type. They are ink-paintings, in fine, sensitive line, small in scale, somewhat intricate often, rather than broad and telling in composition. The subjects are generally Arhats in landscape surroundings; but a favourite theme for a series of designs, existing in many versions, is " The Tribute Bearers," in which diverse types of the more western nations of Asia are depicted. Liveliness and humour are more salient features than intensity or grandeur. Mr. Freer collected in China a considerable number of paintings of this type, works of varying quality, one or two possibly originals, but mostly copies. We cannot doubt that in this type of work we find the authentic vestiges of Li Lung-mien. In the *Kokka*, No. 380, are reproduced two ink-paintings of men leading horses which seem to be originals, and are masterly work. A roll of Dancers in the National Museum, Peking, is reproduced by Siren (Vol. II, pl. 25, 26). The type is represented also in European collections. A roll, representing groups of Arhats, is in the possession of Dr. Bone of Düsseldorf, who has published portions of it, with an essay, in the magazine devoted to Asiatic lore called *T'oung Pao*.* In the British Museum are two copies of a roll-picture of the " Sixteen Arhats crossing the Sea to Paradise," the original of which must obviously have been of strange beauty. In the same collection are two

* *T'oung Pao*, Série ii, vol. viii, No. 2.

variant copies derived from another original roll which represented a curious subject : demons attacking the bowl in which Buddha had placed the demon-mother's favourite child. The Musée Guimet in Paris has published another version of the same work. This type of Li Lung-mien's work is recognised in Japan. But side by side with this type the Japanese have for centuries placed, as also from the master's brush, the quite different type seen in the Freer series of Kakemono and in such pictures as the Arhats reproduced in the *Kokka*, Nos. 20 and 41.

These other pictures are certainly by great painters. They are works of great majesty, in which the force of the T'ang style is subdued and sweetened by the research for harmony of rhythmic line ; the kind of change we experience in passing from a Signorelli to a Raphael ; though the figures of the Arhats retain, in spite of the suavity of the artist's brush, a superhuman grandeur and impressiveness. These pictures are remarkable too for original and noble colour. To whatever masters are due these and other grand paintings of single Arhats, seated in their rocky haunts and alone in contemplative ecstasy, which belong to this era, though perhaps to a rather later time than Li Lung-mien, they are among the noblest creations of the Sung genius. Images of intense and concentrated thought, conceived in a rhythm of fluid lines, that play against

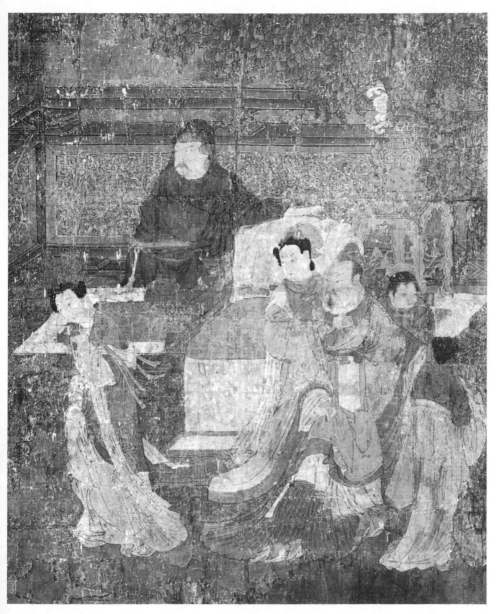

Plate XVIII. The Lady and the Bear. Sung dynasty.
British Museum.

severe or broken forms, they betoken an era of climax and culmination.

To this period we may assign a picture acquired by the British Museum in 1915, " The Lady and the Bear." This is the traditional subject which is treated in the Ku K'ai-chih and has already been described. But here we have a completely realised scene, in a colour-design of singular beauty. The brush-drawing recalls the vigorous line of those early Japanese masters who founded their style so closely on T'ang art. A secular subject like this is of great rarity. In the same collection is a more recently acquired short roll of a Buddhist subject (already mentioned) " Demons attacking the Bowl." This seems to be an original work of the twelfth century, and is executed in a miniature style, delicate and vigorous at once. Here, too, may be mentioned the " Portrait of the Lady Lien," also in the Museum, subtle and intimate in characterisation. This is of later date, but probably of the Sung period. But the special genius of the period is seen rather in landscape and in subjects allied to landscape, the pictures of birds and of flowers.

We have seen how even in the fourth century, though landscape art was in a primitive stage, it was a passion with the Chinese to escape from the city, its irksome conventions, its noise and dust, to forest, hill, and stream. The mysticism and the legends of Taoism gave to this native instinct a sort

of religious colour, which Buddhism, with its monasteries always built in mountain solitudes, further deepened. The romantic feeling for nature (escape from routine being of the essence of romance) developed with the Sung age into a more intimate emotion, such as we do not find paralleled in Europe till the coming of Wordsworth. The peculiar mode of thought which tinges the verse of the English poet is indeed thoroughly congenial to the poets and the artists of Sung. Them, too, the mountains " haunted like a passion." But instead of being part of a single writer's idiosyncrasy, the conception of nature was a permeating thought of the age, explicit in the doctrine of contemplation taught by the Zen sect. Under the reign of Sung this doctrine found, as I have said, its first great manifestation in art.

Kuo Hsi, one of the greatest of all Chinese landscape-painters, published an essay on landscape, in which we find side by side with the passionate feeling for nature a Confucian strain of thought. Though we may long, he says, to yield to our instinct and fly from cities to the woods and wilds, to the hills and the musical streams in which the soul of man delights, yet we ought not to disown society. Here is the boon of the painter's art, that in the midst of care and toil it can liberate the mind and bring it into the august presence of nature. Liberation was indeed the keynote of this Sung art. It

146

loved the " far-off effect." Kuo Hsi in his essay insists on this as necessary to unity. The painter must have varied experience, must build on incessant observation, he says, but above all things he must seize essentials and discard the trivial. He lays stress on the rendering of aerial phenomena and effects of gradual distance. The result of such researches produced a divorce between the hitherto associated arts of painting and calligraphy. The Sung landscape is built up of tones rather than of lines, though even now there is no attempt to suggest the solidity of objects otherwise than by forcible silhouette. The artists worked almost entirely in monochrome ; and they chose for subject all that is most elemental and august in nature, visions of peace or storm among the great peaks and immense distances of the mountains, plunging torrents, trembling reed-beds, moonrises over promontory and sea, the wild geese flying in the autumn sky, the willow loosening the soft streamers of its foliage to the warm winds of spring.

The method of presentation was what we now call impressionism. But we must distinguish between the impressionism of the East and the impressionism of Europe. In Europe the theory at least of impressionism is based on scientific fact. Our eyes, it is argued, are not capable of seeing any given scene in all its detail at once ; they are focussed on a single point of sight ; and in order

to render the whole field of vision in equally elaborate detail, as it is rendered in the Pre-Raphaelite pictures, the eye must travel from one point to another. It was characteristic of nineteenth-century Europe to appeal to the authority of science rather than to the artistic principle of unity. No such appeal was in the minds of the Chinese painters. Their method was the natural outcome of the conception of landscape as a means of expression for the artist's mood or emotion. Nothing matters but what concerns our own minds. In ourselves is the true reality. In the life of things the artist sought to illuminate and to realise his own soul.

In later times this strong bent of idealism brought about degeneration. But the Sung artists had not discarded the study of nature nor the inheritance of swift and strong draughtsmanship with the brush bequeathed by the T'ang masters ; their art was finely balanced ; and so it comes about that their pictures of landscape, birds, and flowers appeal to our eyes as marvels of vigorous and delicate naturalism, though we shall be far from understanding their whole import or true inspiration if we regard them as nature studies merely.

Landscape - painting, however popular, we in Europe conceive to belong to a category of less rank and importance than figure-painting. This is not merely a prejudice ; for, according to our Western conceptions, that type of art is the greatest which,

148

ceteris paribus, commands the fullest scope and is capable of widest range. Landscape in our view is less significant to humanity.

The Greeks divided poetry into epic, dramatic, lyric, and elegiac. Of these types the two former rank higher because they contain more ; they present life more adequately to its reality, richness, and variety. And we demand of the epic poet and the dramatist that his conceptions should accord with the main conceptions of life inherent in his race. For the lyric or elegiac poet it is enough if he express with power and sincerity a view of life quite personal to himself. In the domain of painting, landscape may be compared to lyric or elegy. The materials of landscape lend themselves more easily than any other materials to the control of an artist's mood ; they accept the impress of his feeling more readily.

Turner alone of European landscape-painters could give his themes a wider mental horizon and what we may call the epic tone ; but this was by the choice of themes in which national sentiment could be expressed or reflected, or scenes of sea and mountain made the actual theatre of momentous events.

The landscape art of China and Japan abstains from such interests ; and yet it has sources of vitality which have a nearly equivalent effect.

Just as in Chinese life, nourished by Confucian ideals, the constructive lines of the social order were, so to speak, vertical—the tie of father to son

and son to father being stronger than the tie of husband to wife—so in art a similar principle of continuity prevailed. The same subjects were treated again and again. In Europe this happened also, so long as the Church or the State demanded the treatment by artists of subjects answering to national or universal aspirations. But landscape subjects have never been so demanded, and the landscape art of Europe has no such standing themes as have provided masterpieces of religious or mythological painting. In China it was different. Many are the advantages for an artist bred to such traditions.

It is a great gain for him that his subject belongs to his race, and therefore to mankind. It partakes of the universal; it has been sifted by the choice of many generations; it has struck root in the imagination of a people; and so at once he is set in touch with the mind of his public, and can play upon a hundred associations and indefinable emotions. Again, he has to work within certain limits, and an artist is helped by limitations. For while they free him from the burdensome necessity of choosing among the vast and bewildering spectacle of the world, they concentrate his powers. The very fact that others, great and famous masters, have approached the same theme and handled it in their own way, inspires him with emulations, moves him with the necessity and the desire to make the subject his own—in a word, tests his originality

150

far more severely, and, if he is successful, disengages it far more effectively, than if he had set out on a road of his own with the deliberate quest of novelty. Thus successively refined upon, fed and refreshed continually by new life, the depths of a subject is proved, and the varying new conceptions it evokes are like flowers upon an ancient tree.

Wisely, then, did the old Chinese painters maintain this perpetual challenge of traditional subject, even in landscape. The most conspicuous example is the group of Eight Views of Hsiao and Hsiang, eight scenes about the shores of Lake Tung-t'ing. But " views " is really too topographical a word. Here is a list of the subjects :

The Evening Bell from a Distant Temple.
Sunset Glow over a Fishing Village.
Fine Weather after Storm at a Lonely Mountain Town.
Homeward-bound Boats off a Distant Coast.
The Autumn Moon over Lake Tung-t'ing.
Wild Geese alighting on a Sandy Plain.
Night Rain on the rivers Hsiao and Hsiang.
Evening Snow on the Hills.

These subjects are associated with the four seasons. And " Flowers of the Four Seasons " form another favourite set of subjects, generally landscapes. The Four Accomplishments, Writing Poetry, Playing

Music, Drinking Tea, and Playing Checkers, provide motives for sets of pictures in which we find happy sages in their mountain retreats, figures in great landscapes. Add to this the constant association of certain flowers with certain trees and certain animals, of the flight of the wild geese with autumn, of the willow with the spring, to name but obvious instances, and we see how immense a part order and tradition play in Chinese landscape. And this tradition was, at least while Chinese art remained vigorous, neither dead nor paralysing. For how free, after all, it left the individual artist, while at the same time it linked him with the common life of his countrymen, whose love of nature had been crystallised and consecrated for long generations in chosen themes.

This infinite linking of associations, these hundred sympathies, give to Chinese landscape a cohesion, a solidarity, a human interest which prove an animating power and remove it far from triviality and shallowness. Contrast the tendency in Europe which drives painters to Holland or Spain, to Hungary or Morocco, in search of something new in local colour to stimulate the jaded interest of a mostly indifferent public !

The great subjects of all art and poetry are commonplaces. Life, Love, Death ; these come to all of us, but to each one with a special revelation. It is by the new and original treatment—original, because profoundly felt—of matter that is fundamentally familiar, that great art comes into being.

152

Let us consider one of these traditional subjects in an existing example : " The Evening Bell from a Distant Temple," by Mu Ch'i. A range of mountains lifts its rugged outline in the twilight, the summits accentuated and distinct against the pale sky, the lower parts lost in mist, among which woods emerge or melt along the uneven slopes. Somewhere among those woods, on high ground, the curved roof of a temple is visible. It is just that silent hour when travellers say to themselves, " The day is done," and to their ears comes from the distance the expected sound of the evening bell. The subject is essentially the same as that which the poetic genius of Jean-François Millet conceived in the twilight of Barbizon, at the hour when the Angelus sounds over the plain from the distant church of Chailly. Well might such a subject become traditional in Europe. Yet our foolish and petty misconceptions of originality would cause all the critics to exclaim against any painter who took up the theme again as a trespasser on Millet's property.

Each of these works, the twelfth-century Chinese painting and the nineteenth-century French painting, is thoroughly characteristic of its continent. In the European picture human figures occupy the foreground, and in their attitude is concentrated the emotion which pervades the picture. The Chinese painter, on the other hand, uses no figures ;

for him the spectator supplies what Millet places in his foreground. He relies on a hint, a suggestion which the spectator must himself complete.

What a public for a painter, one cannot help exclaiming, when the artist could count on his work meeting with minds so prepared, so receptive! To what a prevalence of taste and imagination in the society of the day the very slightness of the Sung landscapes, which many will think a fault of insufficiency, bears witness.

Mu Ch'i (Mokkei in Japanese) was a Buddhist priest, whose work was thought capricious and unpleasing by Chinese critics of his day, but who is regarded as one of the greatest painters by the Japanese. The taste of the two countries does not always coincide. It is probable that most of Mu Ch'i's paintings are in Japan. He was certainly a great master of monochrome, but is less celebrated for landscape than for his wild geese, storks, monkeys, and Buddhist figures. The British Museum has a tiger ascribed to him (from the Morrison collection) with a wild background of torrent and tossing branches, which is splendidly conceived. Mu Ch'i belongs to the end of the Sung dynasty. In the earlier period of " Northern " Sung there was a phase of naturalism, encouraged in the academy of the Emperor Hui Tsung, himself a painter ; and small pictures of birds and flowers were in vogue. A beautiful example is the " Bird

154

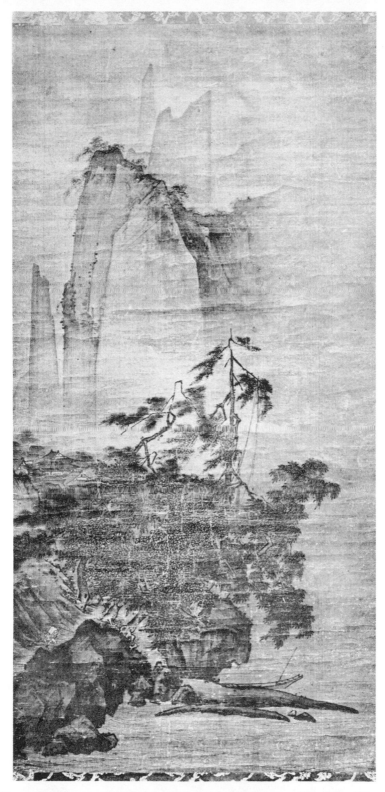

Plate XIX. Pines and Rocky Peaks. By Ma Yüan.
Collection of Baron Yanosuké Iwasaki, Tokio.
(From the *Shimbi Taikwan*.)

on a Bough," reproduced as frontispiece to this book, in the Eumorfopoulos collection. The "Two Geese" in the British Museum may perhaps belong to this period.

But even at the beginning of the Sung dynasty landscape art had reached a mastery and amplitude which are continued, with many individual variations of style, throughout the era. Tung Yüan's "Clear Day in the Valley" in the Boston Museum, now so rich in Sung painting, is already magnificent in spaciousness as in the lively handling of detail and the sense of light and atmosphere.

Besides Kuo Hsi, already mentioned, whose work is exceedingly rare, Hsia Kuei and Ma Yüan, famous in Japan as Kakei and Bayen, are the pre-eminent landscape masters of Sung. Of Ma Yüan especially many splendid works are extant in Japan and in America. The example reproduced nobly illustrates his style; yet the greatest work of the master now extant must surely be the magnificent roll now in the Freer collection, though officially described as a copy. Every motive of Chinese landscape art is there combined. We enter into this enchanted world and are played upon by every mood of nature. Now the sunlight steeps the distance, and soft ripples break at our feet; now we are climbing dizzy paths, the immense crags tower menacing above us; we are shut within the walls of a ravine, we are liberated with the opening glimpse of wide horizons;

155

sails gleam on winding waters ; villages sleep under the hills ; reeds tremble in the mist, tall pines drink the sun—it is a world in which, once entered, we can wander for ever, and find new springs of delight. The roll by Hsia Kuei in the same collection almost rivals the Ma Yüan. Less varied, less ample and genial, it has a dark force and passion like what we imagine of the wild torrents and the abrupt rock-ridges of the mountains.

The late Count Enrico Costa, who brought to the study of Oriental painting the same insight which made him so distinguished a connoisseur of the art of his own Italy, suggested to me that these great landscape rolls had their nearest counterpart in music, in the sonatas of Beethoven. The remark was made while we were looking at the great roll by Sesshiu, which was doubtless done in emulation of such Chinese masterpieces as are now in the Freer collection. Certainly the effect of these unfolding scrolls, with their continuous undertones of rhythm, their superb contrasts of plangent vehemence, remote majesty, and melting peace, evoke like music responsive moods of emotion in swift yet related changes. And the suppression of local colour enables the imagination to work freely, as if in touch with elements rather than features of nature.

Loftiness and simplicity, a deep feeling for solitary places, give their character to the art of these masters ; the Chinese term for landscape, " moun-

156

tain and water picture," indicates the elements of which it was habitually composed. Austere at times, with a sense of desolation in bare peak and blasted pine, yet often bathed in the mood of a serene and silent joy, the joy of the mountain-dweller gazing out on vast spaces of moon-flooded night, their art is never trivial, never pretty. The early landscape of Europe, conceived as a fair setting to the deeds of men and women, the earth a garden with soft verdure for their feet, trees to shade them, and rivers to refresh them, mountains on a blue horizon to repose their eyes upon; neither this, nor that sentiment of ownership associated with topography in which the independent art of land-scape in Europe had its root, has any reflection in the painting of Sung. It is true that we find now and then, especially, as already noted, in the art of Northern Sung, decided tendencies towards realism, always with an element of poetic choice, in such pictures as Li Ti's " Peasant returning Home," * with its leafless oak, a picture Ruysdael would have admired ; or Ma Lin's " Fisherman on a Wintry River," † with its vivid impression of December's bareness and the rustling of frozen sedge. And in Chao Ta-nien's " Lake in Winter," ‡ with its deli-cately outlined willow-boughs, its moor-fowl on the water, the bands of vapour stealing across the trees, and birds flocking through the dim haze, we find

* The *Kokka*, No. 71. † *Ibid.*, No. 162. ‡ *Ibid.*, No. 41.

157

much of that intimacy of feeling which charms us in a Corot. Do I exaggerate in speaking of the age which produced such things, over which there seems for us no veil of intervening time, as an age of modern character ?

To those artists already mentioned, one name (out of how many !) may be added, that of Mi Fei, since this painter, famous also as a critic, made a new departure in landscape. A number of existing paintings, in the Freer and other collections, are attributed to the master, and all have a common character. Mi Fei, who lived from A.D. 1051 to 1107, preferred, like Wang Wei, to work in monochrome. He loved to paint wooded peaks towering over mists, and with a fully charged brush dashed in his strokes, leaving effects of extraordinary richness and intensity of tone. An impetuous poetry, flooding from his emotional nature, pervades his work, which has a strongly personal character. His style was much imitated by artists of the Southern school in later times.

It cannot but be noticed that in the landscape art we are considering there is no marked preference for what is sunny and comfortable, nor, on the other hand, for what is savage and forbidding. We may say of these painters, as Walter Pater said of Wordsworth, " They raise physical nature to the level of human thought, giving it thereby a mystic power and expression ; they subdue man to the level of nature, but give him therewith a certain

158

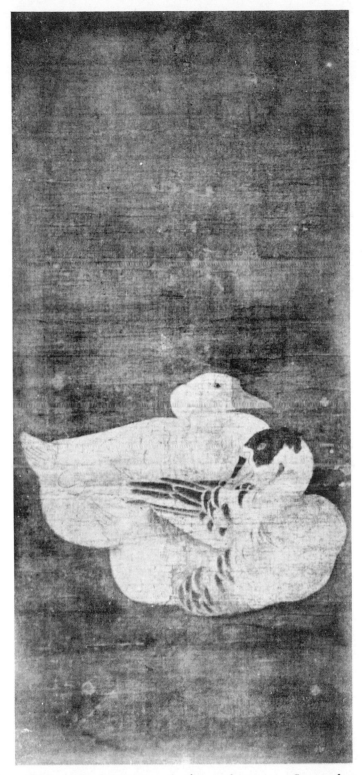

Plate XX. Two Geese. Artist unknown. Sung dynasty.
British Museum.

breadth and vastness and solemnity." To many spirits of the nineteenth century in Europe the Sung painting would have seemed, had they known it, the very expression of their own minds : * that is why it is of such living interest to us now.

In the Sung period the system of competitive examination had become by long use frigid and academic. The great economic reformer, Wang An-shih, introduced into the system a more flexible spirit, testing character, and bringing it more into relation with the reality of life. Wang An-shih, though no professional poet, has left a little poem, the sense of which is as follows : It is midnight ; all is silent in the house ; the water-clock has stopped. But I am unable to sleep because of the beauty of the trembling shapes of the spring flowers, thrown by the moon upon the blind.

In this little poem we get vividly expressed the old Chinese feeling for the beauty of flowers. I know not where in European literature or art we shall find a parallel to this peculiar poignancy of impression, this extreme sensitiveness. It is not merely voluptuous eye-pleasure ; it is not the feeling of Keats's lover who seeks narcotic joy by glutting his sorrow

> On the rainbow of the salt sand-wave,
> Or on the wealth of globèd peonies.

* Compare such sayings as that of Amiel : " Every landscape is, as it were, a state of the soul."

Nor is it the sheer overpowering of the senses which Shelley celebrates in " arrowy odours " darting through the brain. It is more akin to the emotion of Wordsworth's " Daffodils." But in the general art and literature of Europe it is the beauty of the human form and face which alone arouses a poignancy of emotion which is comparable.

In his delightful " Book of Tea," Okakura tells us of the extraordinary devotion to flowers prevailing from early ages among the Chinese. I have already mentioned the poet of the fourth century who shook off the irksome pomp of official life to cultivate the chrysanthemum in his retirement. Okakura reminds us how the T'ang emperor, Ming Huang, hung tiny golden bells on his favourite plants to frighten away the birds ; he tells us how it was thought that the peony should be watered by a fair maiden in rich attire, the winter plum by " a pale slender monk." With the Sung dynasty and the ascendancy of Zen thought, a tinge of mystic feeling is infused into this passion for flowers. It is no longer such keen sensuous delight and understanding as inspired Perdita's matchless words :

> Daffodils
> That come before the swallow dares, and take
> The winds of March with beauty ; violets dim,
> But sweeter than the lids of Juno's eyes
> Or Cytherea's breath.

It is the consciousness of a living soul in the world

of nature, parallel to the soul in humanity, making in these sensitive brief blossoms its manifestation, and touching the mind with

> Thoughts that do often lie too deep for tears.

Nothing to the contemplative spirit was mean or insignificant ; the fullness of life was more surely apprehended in small things than in great, in the power of a hint to the imagination than in the satiety of completed forms.

One of those sets of associated subjects which I have already mentioned is " Snow, Moon, Flowers," in each case conceived as an apparition of beauty from the unknown. The flowers are most often the flowers of blossoming trees, appearing at winter's end on the dark, leafless branches. And always it is the flower in its growth, in its life, that is painted. In the Sung age, for the first time, blossoming plum branches were painted in ink, without colour ; * the sensuous appeal of tint and texture detached as unessential or disturbing to the spirit of contemplation. Yet colour was often used, in subdued tones, with a noble harmony. Look at Li Ti's " Rose Mallow " † (the *Kokka*, No. 95). It is just two or three blossoms and opening buds on a

* See the *Kokka*, No. 195 ; article by K. Hamada.

† The rose mallow (Jap. *fuyo*), a kind of hibiscus, is often confused by European writers with the peony. I have been told that a plant of it was presented to one of our sovereigns by a Chinese emperor, and was placed in Kensington Gardens, but I have had no leisure to verify this information.

leafy stalk, but it trembles in leaf and petal to the air as the wind blows and bends the stems upon its root unseen. The spacing is perfect, the colour beautiful; but when we have said, " This is fine colour and design," we are still outside the secret of the picture : and I cannot find any words to describe the peculiar emotion it produces, though I know it is different from that which any European flower painting evokes, deeper and rarer. Before a masterpiece in this kind by Fantin Latour we feel that the flowers have been taken from field or garden to be grouped before us, a feast for the eye; but the Chinese artist brings us to the flower, that we may contemplate it and take from it into our souls something of the beauty of life which neither sows nor spins. That which Li Ti felt in painting his picture still emanates from it, eluding words.

Lou Kuan has painted rose mallows (the *Kokka*, No. 84) reflected in water. A bloom hangs into the picture from above, and a faint image of it colours the running water below, hinting at far more than we see. The Chinese say of poetry, " The sound stops short, the sense flows on "; and the same principle is in this painting.

Flowers, Moon, Snow; these three beauties of earth and air have a peculiar glory and consecration in the art of the Far East.

A Japanese friend of mine told me that when he was in Paris he woke one morning to find that

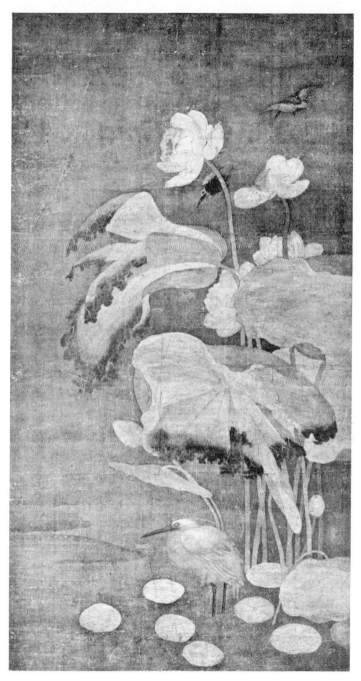

Plate XXI. Lotus, White Heron and Kingfisher.
Sung dynasty. British Museum.

snow had fallen in the night. As a matter of course, he took his way to the Bois de Boulogne to admire the beauty of the snow upon the trees. What was his astonishment when, with his friend, another Japanese, he arrived in the Bois, to find it totally solitary and deserted! The two companions paid their vows to beauty in the whiteness and the stillness, and at last beheld in the distance two other figures approaching. They were comforted. " We are not quite alone," they said to themselves. There were at least two other " just men " in that city of the indifferent and the blind. The figures drew nearer. They also were Japanese!

We in Europe are not blind to the beauty of the snow and " the radiant shapes of frost," but certainly we are far from having that kind of religious feeling which prompts the Japanese to go out and contemplate its freshly fallen splendour. We do not regard it as a visible manifestation of beauty, the apparition of a power from the unseen, at whose coming it behoves them to be present. I am not sure that we are not more conscious of the inconveniences of a snowfall than of its loveliness.

It was in China, in the Sung age, that this attitude of mind I speak of first found mature expression. There is no longer any element of dread or discomfort in the Sung artists' and poets' feeling for wild nature, storms and rain and snow ; nothing of the horror of mountains which survived till

nearly a century ago in cultivated Europeans. The life of nature and of all non-human things is regarded in itself ; its character contemplated and its beauty cherished for its own sake, not for its use and service in the life of man. There is no infusion of human sentiment into the pictures of birds and beasts, of the tiger roaring in the solitudes, of the hawk and eagle on the rocky crag ; rarely is there any touch of the sportsman's interest which has inspired most European pictures of this kind. If an artist painted a bird with such emotions as were Shelley's when he wrote his " Skylark " we should have something comparable to the Sung painting, though different. These men painted birds and flowers as they were in nature, with no explicit symbolism, with nothing factitious added, and yet the inspiring thought, the sensitive feeling, that was in their minds as they worked has wrought its effect and still finds a response in the minds of those who understand.

> To see the world in a grain of sand
> And a heaven in a wild flower.

The words of our own Blake crystallise more aptly than any language of mine what was at the heart of the poet-painters of Sung.

CHAPTER X. THE MONGOL EMPIRE : PAINTING IN TIBET AND PERSIA

CHINA, during the reign of the House of Sung, suffered continual pressure from the encroaching Tartars of the north. Two rival Tartar dynasties in succession held sway over her northern territories, and the later of these was contesting power with the weakened Sung empire of the south, when a new and mightier force arose in the Mongolian conquerors, who swept southward from the regions now known as the Transbaikal provinces of Russia, and first overthrowing the Nü-chēn Tartars, at last put an end to the House of Sung.

In 1264, Kublai Khan fixed his capital at Pekin. Kublai was no mere barbarian : the arts and literature flourished under his wise rule. The Mongols, like other conquerors, went to school with those whom they conquered, and became absorbed into Chinese civilisation. The new dynasty, Yüan, as it is called, lasted a little over a century.

Chao Mēng-fu is the most celebrated painter of this period. Born in 1254, he retired into private life on the final downfall of the House of Sung, from the founder of which he was himself descended ; but in 1286 he was summoned to court, and became a favourite of the Mongol emperor.

165

Chao Mēng-fu was famous for his horses. They were said to rival those of Han Kan. A famous picture of his was the " Eight Horses in the Park of Kublai Khan," copies of which are extant. The horses are seen disporting themselves in freedom on the grassy slopes of the park, down which a stream comes tumbling over rocks ; one of them is rolling on the grass. Two fragments of a similar painting are in the Louvre, and are of fine workmanship. In the British Museum is a picture of two tethered horses, which is a grand design. Most collections in Europe and America have acquired during recent years paintings attributed to this master. But no signature is more frequently forged than his, unless it be that of the Ming painter, Ch'iu Ying. I confess that among the great number of Chao Mēng-fu paintings of horses and hunters that I have seen, varying greatly both in quality and style of workmanship, I have found it impossible to choose one which could serve as an indubitable starting-point for the study of his work. At present we have to content ourselves with a general impression founded on what are in most cases Ming or later copies. Jēn Jēn-fa was one of the most famous painters of the time ; and a fine, rather austere example of his work is the " Feeding Horses in a Moonlit Garden " in the Eumorfopoulos collection.

In the British Museum is a small drawing of

landscape in ink by or after Ni Tsan, also known as Yün Lin, another Yüan painter, which recalls the studies of Claude in its truth and tender feeling, unalloyed by any mannerism ; a charming example of the Southern style. The Fogg Museum of Harvard University has a beautiful painting by this painter. But in the main this period is marked by the naturalism to˙which the later Sung art was tending, and by a certain hardening and loss of the delicate vibration of life, the beginnings of an academic preoccupation with method and material.

A painter of individual style, known and appreciated, like Mu Ch'i, more in Japan than in his own country, is Yen Hui (Ganki in Japanese). He painted chiefly figures from Taoist and Buddhist legend, and is famed especially for his pictures of Li T'ieh-kuai, the Taoist wizard of the hills, breathing out his spiritual essence toward the sacred mount of the Immortals. He is represented as a beggar with ragged garments and gourd hanging at his girdle of oak-leaves ; one hand grasps a crutch, the other props his chin, and his eyes look out from the picture under his black matted hair with the smile of a magician. Li T'ieh-kuai's brother wizard-sage, who made a great toad his companion, was also a favourite subject of Yen Hui's brush.

In the *Kokka* (No. 66) is the coloured reproduction of a portrait of a flute-player by Ch'ien Shun-chü. It is the whole-length figure in profile

of a gentle youth, who appears to be placing a sheath upon his finger-nail. He wears a cap, and a long robe, hiding the feet, of a dull rose-colour, with a girdle of blue, in which a flute is stuck. If we compare this portrait with one of the figures of the Ku K'ai-chih roll, we are conscious of a loss of vitality in the bounding-line which must play an all-important part in work of this simplicity of convention. Yet it is a painting of singular beauty. Ch'ien Shun-chü was also a famous painter of flowers and fruit. In the art of this time we note a stronger naturalism, and in the flower-pieces a greater solidity of treatment. Wang Jo-shui was very distinguished for his flower-and-bird pieces (an example is in the British Museum), though he also painted landscape and figures. Two damaged but beautiful pictures of Flowers and Insects in the British Museum, of uncertain authorship (Nos. 19 and 20), are interesting examples of the period. In the same collection is a winter landscape by Shēng Mou, remarkable for its structural drawing of rocks and crags rising from water, and leafless trees, no less than for its evocation of still and biting air. To the same eminent artist is attributed, though the actual painting must be of later date, the charming pair of leafy landscapes with a happy sage forming one composition, which we reproduce on Plate XXII.

Kublai Khan was a devoted Buddhist. But the form of Buddhism which he adopted as the state

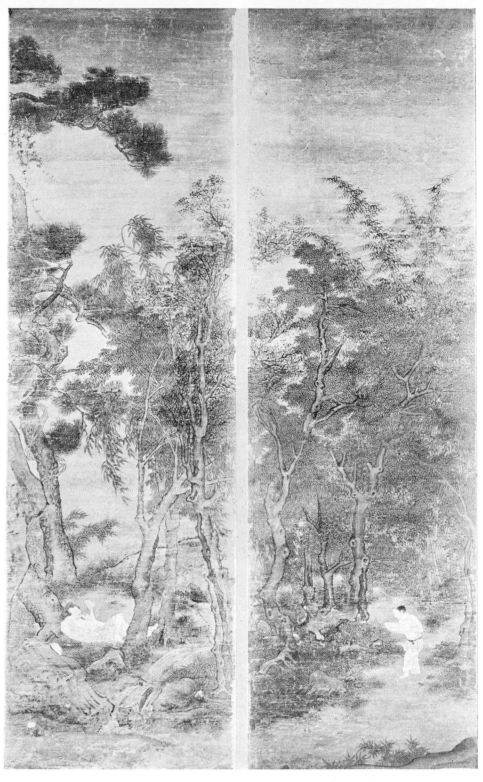

Plate XXII. The Sage in the Forest. A pair of paintings attributed to Shēng Mou. Yüan dynasty. British Museum.

religion of China was a form which had acquired its distinctive character in Tibet and was called Lamaism.

In the seventh century the Emperor of Tibet was converted to Buddhism by his two wives, one a princess of China, the other a princess of Nepal. In the native religion the worship of demons and the practice of magic predominated ; and it was not long before the countless Tibetan deities were incorporated into the new religion, in the guise of defenders of the Buddhist Church. The Lamas were an order of priestly exorcists, and a priest-kingship was established in the country by Kublai, which lasts to this day, though the title of Dalai Lama dates from a seventeenth-century usurper.

Tibetan painting, at which we may here briefly glance, reflects the monstrous and lurid features of the Lamaist religion. How much of its technical character is due to Chinese example we do not know, but the influence was doubtless considerable, and in early times Pekin was probably the centre of Lamaist art. Among the pictures brought by Sir Aurel Stein from Tun-huang is a picture of the goddess Tara which is on canvas and in the well-defined Tibetan style as we find it in later ages. The colouring is rich and sombre. If this picture dates, as we may presume it does, from the tenth century, it is probably the oldest Tibetan picture

now extant. The specimens which have been brought to Europe from Tibet in recent years are mostly of the last two or three centuries. But a hieratic style of painting, as we know from Byzantine art, keeps a fixed character, and it is difficult to date these paintings with any certainty.

The Tibetan pictures I have seen vary little in type so far as technique is concerned. They are painted on a kind of canvas, in body-colour, sometimes on a black ground. The drawing of the finest examples is vigorous and rhythmical, the colour glowing and rich. Yet in neither respect are they comparable with the classic painting of China. Moreover, for the most part the subjects, though impressive from fantastic power of imaginative treatment, are in essence savage and horrible. Flames writhe and twist in backgrounds of gloom ; rivers turn to blood at the approaching presence of infernal goddesses ; the Eight Demons trample on human victims ; fire-wreathed fiends drink from human skulls ; the green boar, the blue bull, the white elephant crush miserable mortals under them. The atmosphere of torment and terror is relieved at times by brief glimpses of fair, verdant landscape ; single passages, individual figures, may be found that have grace or beauty, but the general impression left is that of terrible and obscene nightmares in a burning gloom. When the subjects are milder the art, if more agreeable, is as a rule less forcible

and interesting. A good deal of later Lamaistic painting, light in tone, rather gay in colour, rather coarse in handling, seems to have no independent character, and may be classed merely as provincial Chinese art.

From this epoch also dates a considerable influence of China on Persian painting, as we know it in the beautiful miniatures of the Middle Ages.

The conquest of Persia by the armies of Genghis and Kublai Khan set up once more a quickened current of communication between the east and west of Asia. And the succeeding conquests of Timur (Tamerlane) at the end of the fourteenth century provoked yet further a stimulating intercourse and fusion of ideas, in spite of all the havoc and slaughter which they caused. Under Timur himself and his successors a flourishing school of art arose in the heart of Asia, at Samarcand and at Herat.

The relations between China and the Muhammadan world date from the very beginning of the Muhammadan era. But though China is only one of several influences which went to mould Mesopotamian art under the Caliphate, it becomes predominant after the fall of Baghdad and the new ascendancy of the Mongols. True Persian painting only begins, as Dr. Martin says, from this time.

Of the few surviving paintings of the Mongol period in Persia, those in the Persian manuscript

History of the World belonging partly to Edinburgh University and partly to the Royal Asiatic Society, and dated A.D. 1306–1314, are the most important. Here Mongol types and fashion of drapery, and a decided reminiscence of the Chinese manner of drawing, are manifestly visible. Of even greater interest from an æsthetic point of view are the paintings in a superb manuscript, generally known as " the Demotte MS.," now dispersed among various European and American collections, and dating from about A.D. 1340. A page of " A Troop of Horsemen " in the Louvre strongly recalls the contemporary Yüan painters. These miniatures, powerfully coloured, are notable for drama and vigorous movement.

The Chinese element was soon assimilated, and a new native school arose which gradually matured into the sumptuous art of the fifteenth and sixteenth centuries. But to Chinese influence again was due the formation of a style which relied on a pen outline of exquisite quality, with either no colour at all or a few discreet touches of red and blue or gold. It began under Timur. No Persian MS. shows this influence so directly as the marginal paintings in a manuscript belonging to Mr. Jacob Hirsch of Geneva, lent to the Persian Exhibition at Burlington House in 1931, and reproduced entire by F. R. Martin, in " Miniatures from the time of Timur," 1926. This style was practised in later times ; exquisite

172

examples exist : but Persian taste was decidedly for colour.

Bihzād is the most famous of Persian masters, and the creation of the Persian style of painting in its maturely developed and independent form is associated with his name, though he was no innovator and accepted the conventions of picture-making which had gradually grown up before his time. Bihzād worked at Herat and later at Tabriz, in the latter part of the fifteenth and early part of the sixteenth century. The names of Bihzād and of other great masters like Mirak are often found on miniatures, but in most cases are later additions. Most of the Persian miniature paintings in European collections show the influence of Bihzād and his school. In this mature school of Persian art an exquisite charm of colour is the chief attraction. Design becomes weaker, less coherent and unified with the progress of time, and in later periods decorative conventions tend to usurp vitality and expressiveness of drawing ; even the colouring at last loses quality, and coarsens. But there is abundance of painting of the sixteenth and even the seventeenth century, which is remarkable for sensitive delicacy of drawing no less than for singular beauty of colour, heightened and enriched by the exquisite mountings. After about 1550, however, a lack of creative ideas, apparent in the limited range of subject and the endless and servile repetitions,

accounts for a general languor of design contrasting strongly with the painting of China. Dependency on the taste of patrons in this court or that, and the condemnation of figure-painting by the orthodox Muslim had an inevitably restricting effect. Yet Persian painting will often refresh us by its naïve and unstudied design ; it repeats itself as craftsmen do, with pleasure ; it is saved from the coldness of academic formula. If it is less central and signifi-cant than Chinese painting, and if we may fancy Wu Tao-tzǔ, had he lived later, speaking of it in much the same terms that Michelangelo uses of Flemish art, we may also find in it the same sort of exhilarating contrast, after too much of the later academic painting of China, that we find in Altdorfer or Memling after too much Pontormo or Parmegiano. So we do not soon tire of a certain monotony, inher-ent less in subject than in design, of those scenes from poetry and romance, where horsemen ride up to ruined palaces among solitary hills, or chase with Bahram the lion and the wild ass ; where Laila finds her lover Majnun, a youthful wasted figure, among the wild animals in the desert ; where fair ladies bathe in garden pools under flowering trees, or a princess listens to a story-teller, surrounded by her maids ; where sages sit teaching wisdom to their disciples, or a king rides to visit a dervish in the wilderness. Whatever the theme, or the mood implied in the theme, the artist never remits the

delighted patience with which he supplies his
exquisite setting of the scene, painting over and
over again the rocks of fantastic tinges of pink or
purple or dove-colour, which rise to the high horizon
against a sky of gold or blue, the crimson mallows
and irises tufting the banks of streams, the slender-
tipped cypresses, and the magnificent plane-trees,
showing their pale under-leaves. It is a world
bathed in golden air of supernatural clearness,
spotless and distinct with gem-like colours. In no
art has the painter used his materials with so refined
a luxury. And this sensuous beauty, almost intoxi-
cating in intensity, and having its root sometimes in
a deep religious mysticism, makes us forget the
comparative lack of inner movement in this art, its
contentment with a piecemeal vision of things, the
absence of any compelling tendency to unify and
hit home. Even in those splendid pages which
depict Muhammad riding among the starry worlds,
attended by rushing angels, the atmosphere still has
a sort of sensuous perfume. On the other hand,
how enchanting are the portraits, especially the
portraits of youth, just because of this peculiar
temperament !

The scope of this volume precludes anything
but a glimpse at this fascinating chapter of Asian
painting. I have wished here merely to indicate
the kind of relation in which, so far as we can ascer-
tain, Persian painting stands to the art of Asia in

general. Though it had neither the free growth of Chinese painting, nor its capacity for rising to impassioned loftiness as an expression of thought and religious ideals, though it is less central and significant, yet its entrancing day-dream, its unique gift for colour, and a sometimes surprising element of drama, hold us with a peculiar spell.

CHAPTER XI. THE ASHIKAGA PERIOD IN JAPAN

WE saw how the arts in Japan came into existence by contact with the fertilising civilisation of China; how in the eighth century a national style had been formed in painting, grafting, we may infer from the very few examples that survive, on the traditions of the continent the Japanese quality of delicacy, buoyancy, and sweetness; how a great school of sculpture had been established; how in the ninth century a new wave of direct influence from the masters of the T'ang dynasty bore on its crest the great achievement of Kanaoka; how the Kosé line which Kanaoka founded sent out branches which developed more purely Japanese art in the Kasuga and Tosa schools; how in the twelfth century Toba Sojo inaugurated the virile and dramatic painting, saturated with Japanese character, which Mitsunaga and Keion carried to a climax, and which was continued by a host of powerful draughtsmen and splendid colourists through the fourteenth century; how finally the Tosa school began to fail, and a new revival from China rose into predominance.

From 1335 to 1573 extends the period of Japanese history known as the Ashikaga period. The power

of the Hojo family, which had succeeded the Minamoto in the Shogunate, was destroyed by Takauji, the founder of the Ashikaga line. He removed the capital from Kamakura and restored it to Kyoto.

Ashikaga Yoshimitsu, third of the line, was a contemporary of the first Ming emperor, and under his rule there was intimate communication with the empire of the continent. Yet it was not from the contemporary Ming painting, but from the classic art of Sung, that the Ashikaga style took all its inspiration. Now, instead of the gorgeous coloured scroll, instead of the representation of ceremonious manners or heroic action, Japanese painters turned with that whole-hearted fervour and intensity which is in the character of their race, to the bold and simple ink-sketch of landscape, birds, and flowers. The Zen doctrine, which had been a pervading influence in the active life of the Kamakura warriors, had ripened on the philosophic side in the contemplative retirement of the monasteries, and now flowered afresh as an æsthetic inspiration. Nearly all of the Ashikaga painters were priests or monks.

This Chinese Renaissance in Japanese art coincided nearly in date with the Renaissance in Italian painting. The close of the fifteenth century found it in full flood. But its beginnings were of earlier date. Nen Kao, who died in 1345, produced ink-sketches of sages in the genial temper and with the rapid freedom of Mu Ch'i. Gukei and Tesshiu

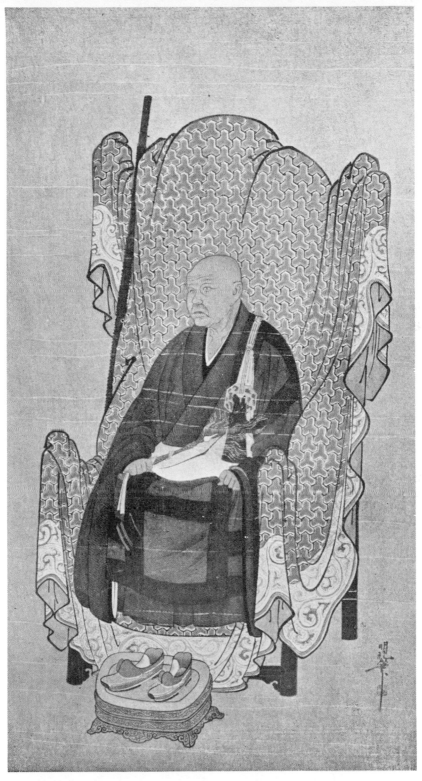

Plate XXIII. Portrait of Shoichi Kokushi. By Cho Densu.
(From the *Shimbi Taikwan*.) Tofukuji Temple, Kioto.

were others who still in the fourteenth century anticipated the coming revival of the Sung style.

But the greatest of these precursors of the Chinese Renaissance is famous less for his monochrome paintings than for his pictures in colour. This is Cho Densu, known also as Meicho or Mincho. Born in 1351, he died in 1427. He was a priest, and has been compared to Fra Angelico for his union of art and devotion. In this respect, however, he was only one of a host of painters. It is recorded that his absorption in painting drew on him a rebuke from his superior. He is famous as the painter of groups of Arhats, founded on Chinese models.

But the summit of his art is to be found rather in the portrait of Shoichi Kokushi, reproduced in this volume, a masterpiece of portraiture, of colour, and of design. The aged priest, with wrinkled austere features—how like some portrait by Ghirlandajo!—sits in a high chair over which a great cloth of green and white pattern has been thrown. The tip of his long staff resting on the chair makes a single note of red in the picture.

Of his religious painting a fine example is the picture reproduced in the *Kokka* of Kwannon, the Goddess of Loving-kindness, of whom a Buddhist text says that he who prays to her, even though his soul be in fire, shall feel the flames turn into a fountain of fresh water. She sits, a majestic figure,

beside the fountain which ripples past her feet,
while a votary kneels on the brink of the healing
stream.

Cho Densu also practised the ink-sketch. And
here I must guard the reader against a misconception which has received some support in Europe.
Dr. Anderson has classified certain painters as
forming the Buddhist school. But there is really
no such thing. " School " in Japanese means a
traditional style. An artist of any one school could
work, if he chose, and in later periods often did work,
in the style of a different school. The Buddhist
picture (*butsugwa*) was richly coloured, with lavish
use of gold. But I doubt if any Japanese artist
painted Buddhist pictures and nothing else. The
misconception has arisen simply because the temples
have preserved religious paintings of the early
schools, while all the secular pictures which are
known to have been produced by Kanaoka and other
masters have perished.

The Buddhist picture was painted alike by Cho
Densu and by the fifteenth-century masters of the
Tosa school, though the style of each in secular
subjects was totally different. The great period of
the Tosa school was coming to an end ; Mitsunobu
retained much of the power and all the rich colouring of the earlier epoch ; Yukihide was a worthy
rival. But before the fifteenth century was turned
a galaxy of artists had arisen, all working in the

Chinese manner, all followers of the free style of Sung : the Tosas were outshone, and their work disesteemed.

An impetus came from the outside. A Chinese artist settled in Japan and adopted the name Soga Shubun. A magnificent pair of snowy landscape screens in the Freer collection has been with some probability attributed to him : and in the British Museum (Morrison collection) is an upright landscape bearing his seal. But it is as a teacher that he is chiefly important, and his son Soga Jasŏku became one of the greatest masters of the time. Meanwhile another influential teacher was attracting many followers. This was Josetsu, by some said to be a Chinese, but more probably a Japanese who had studied in China. Only one genuine work by him is known. A fine landscape in the Boston Museum has hitherto gone under his name, but has recently been shown by Mr. R. Fukui * to be by a younger contemporary Bunsei, now identified also as the author of some fine portraits. Most famous among Josetsu's pupils is Shubun, the Priest (to be distinguished from Soga Shubun), who is regarded as the founder of what is called the Chinese school of Japan. His work is very rare. Native critics praise his landscapes for their " lofty tone," their mildness and serenity. Pre-eminent among his pupils are Oguri Sotan, especially famous for his

* In the *Burlington Magazine*, November 1922.

pictures of hawks and eagles, and No-ami, poet, critic, and courtier, renowned for his paintings of tigers. The son of No-ami, Gei-ami, and his grandson, So-ami, played a distinguished part in the history of the revival.

By the middle of the fifteenth century there had arisen a greater than any of these, a master whom the Japanese venerate as perhaps their greatest name in painting, certainly among the very greatest —Sesshu. He was born in 1420. Having studied and worked with the painters of his own country, at the age of forty he determined to visit China and renew his inspiration at the fountain-head of art. To his surprise, he found that he had more to teach than to learn. The Chinese acknowledged his great originality ; he became famous ; and the Emperor of China himself commissioned him to paint a set of landscapes on his palace walls. Among these was a painting of Fuji, a memory of his own land. This signal and unique honour for a Japanese set the seal on his renown. Sesshu returned to Japan, and continued to paint till his death at a ripe age in 1506. A painting in the British Museum, made when he was eighty-three, of the merry fat god Hotei pulled along the ground by children, shows that old age had not dimmed his eye nor relaxed the vigour of his hand.

It is not easy for Europeans to understand quite all the admiration accorded to Sesshu in Japan ;

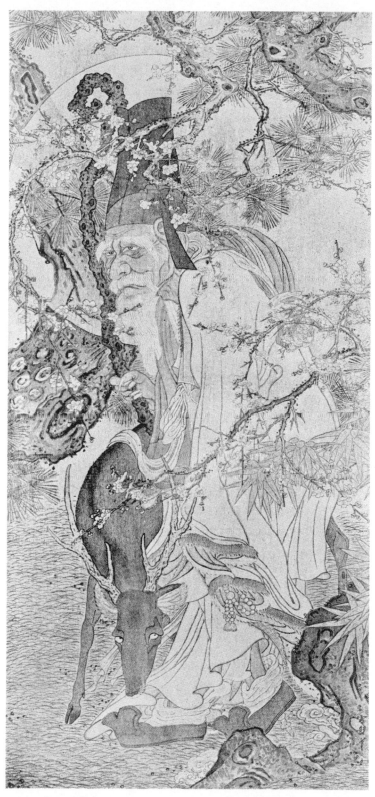

Plate XXIV. Jurojin. By Sesshiu. (From the *Kokka*.)

we are indeed inclined to wonder, at first, at the
enthusiasm evoked by this whole phase of Ashikaga
painting, in which Sesshu is the greatest figure.
It seems to us so limited, so narrow in its range.
It is content with landscape, birds and flowers,
adding only a few figures from religious history
or legend, and these not as actors in any human
drama, but as types of contemplation or spiritual
desire. It is an art that is almost wholly subjective.
Again, on the technical side we shall, most of us,
be more struck with its limitations than with its
powers. It eschews colour almost entirely, though
only those who have seen and studied some of the
light-coloured paintings of a Sesshu or a Sotan
can realise what exquisite harmonies can be attained
with tawny and russet, or pale emerald green,
against the miraculous range, from silver grey to
velvet black, that brush and Chinese ink are capable
of in the hand of a Japanese master. How slight,
too, seems the workmanship! Even those unused
to Oriental art can appreciate such a painting as
Sesshu's " Jurojin," the genius of immortal old age,
a hoary figure, bowed with the weight and wise with
the wisdom of uncounted years, gazing out from
among the intricate branches of blossoming spring
trees, while the mysterious fawn that companions
his solitude rubs its head across his knee. No one
can fail to be impressed by the sense of significance
and sublimity in this imaginative conception, by

the majesty of design and power of execution. This
is indeed one of the central masterpieces of the art
of Japan. Yet it is on his landscapes that the fame
of Sesshu chiefly rests ; landscape, according to his
own confession, was the most difficult province of
art. And although we may begin by thinking that
we know better than the Japanese, and that tradi-
tional idolatry has set Sesshu too high, yet when I
recall the landscape sketches of Rembrandt, I feel
that in Sesshu Rembrandt himself would have
welcomed a peer. For just as Rembrandt with a
blunt reed-point and sepia could conjure up in a
few seemingly careless strokes the essentials of a
scene, everything in its right place and at its due
degree of distance, so Sesshu amazes us by his power
with the brush. His strokes are sudden, strong,
and vehement, he seems careless of modulating them :
and yet how magically all falls into place—the masts
of the fishing-vessels beyond the rocks, the clumps
of trees, the towering promontories ! It is this
extraordinary mastery of forcible brush-stroke which
gives Sesshu his supremacy with the Japanese ; this,
and the intensity and directness which he combines
with unsurpassed greatness of spirit. As the " The-
ban eagle " among the poets of Greece, so is Sesshu
among the painters of his country.

But we shall only half understand these Ashikaga
masters if we regard their technical achievements
only. As I have said already in writing of the
184

Sung artists of China, we must firmly grasp the intention of their work. A painting was as a communicating spark between mind and mind; we must not judge it, as we with our Western notions are too apt to do, for its achievement as a completed piece of workmanship, dwelling on the artist's skill and science. Skill and science in a work of art are, let us never forget, utterly valueless in themselves except as a means to awake emotion of worth and power in ourselves, the spectators. And these painters found that mind could speak to mind by suggestion more intimately than by elaboration. All their art, too, was but one expression of a pervading ideal of life. To find one's own soul, the real substantial soul, beyond and behind not only the passions and unruly inclinations of nature, but also the semblances with which even knowledge, even religion, may cloud reality by imagery, form, ritual—this was the aim of Ashikaga culture; liberation, enlightenment, self-conquest. For the Zen ideal, which had inspired so much of the Chinese art in the Sung age, impregnated even more profoundly, if possible, the Ashikaga painters, though we must admit that in comparison with the Chinese works of Sung their art shows something, if not all, of the difference between the classic drama of the French and the Greek originals on which that was founded.

It was now, under Zen influence, that the Cha-no-yu, the Tea-ceremony, was elaborated; and I

must devote a few words to this singular institution, which was to exert an incalculable influence on the Japanese mind and character.

Tea of choice quality was not known till the twelfth century, when a priest of the Zen sect brought back some plants from China. The wakeful properties of the leaf caused it to be prized as an aid to meditation, and in course of time the tea, at first so valued for its rarity that small quantities of it were given as a reward for heroism in battle, came to be associated in a ceremonial manner with the doctrine of contemplation.

A priest, Shuko, and the painter So-ami, founded the Tea-ceremony, as it is practised in Japan. Acting on their counsels, the Shogun of the day, Yoshimasa, eighth of the Ashikaga line, built the first tea-chamber in his famous Silver Pavilion. Yoshimasa retired in 1472, and gathering round him the finest artists of the time, devoted himself to æsthetic pursuits, setting a fashion to the nobles which was of far-reaching influence on the whole nation. Nothing ornate was suffered in the tea-chamber : its small proportions, its severe furniture, were strictly prescribed ; even the garden seen without must harmonise, and show no gaudy tone, no luxuriant detail ; and in conversation all tittle-tattle was to be abhorred. At these meetings a single painting would be shown ; and when we look at one of the ink-sketches of this period, and remember

186

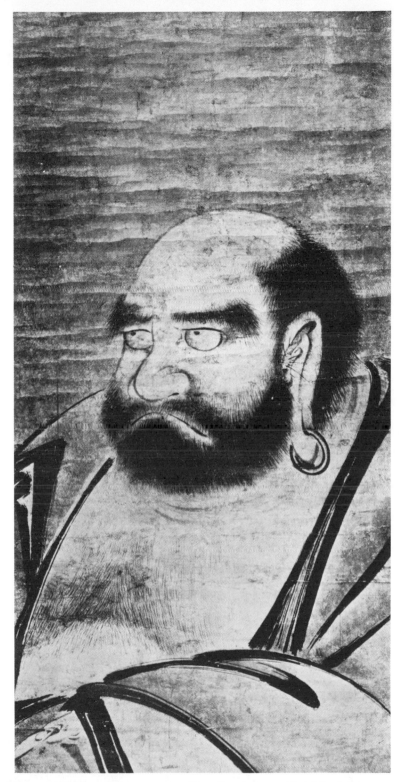

Plate XXV. Daruma. By Soami. British Museum.

the world of thought in which it was produced, we shall understand better its peculiar qualities, its disdain of all emphasis, loudness, and richness, its suggestive slightness and refined simplicity. Austerity is so rarely cultivated by the human spirit, save at the cost of harshness, that we must recognise as a thing of rare felicity the light, flexible, and gracious temper which is infused into the severe aim of the Ashikaga masters. The secret lay in the discovery that beauty has most power on the imagination when not completely revealed ; perhaps the statues of antiquity that Time has mutilated are those which move us most ; hence the choice of subjects which to us often seem trivial or insignificant, but which to the prepared mood are sufficing hints towards one supreme idea. Okakura has written some eloquent pages on this theme.*

With the name of So-ami is associated the elaboration not only of the Tea-ceremony, but of the art of landscape-gardening, another art of Chinese origin. Buddhist monks had been ever careful in their choice of a site for their temples, so that beauty should reside in the whole surrounding, in the genius of the place, rather than in the building merely. By So-ami the features and component parts of such surroundings were analysed and catalogued, and infinite thought was spent on the refinements of an art which aimed at a definite influence on the

* " Ideals of the East," pp. 168–180.

beholder's mind, at the evocation of certain emotions by the aid of inherent character or associations in the features of a scene. The art of flower arrangement, concerned above all with the interpretation of the life and growth of the flower, not with harmonious colour effects, was another of the studies of the circle of the Silver Pavilion, no less than the old pastime of " listening to incense," an exercise in literary knowledge and taste, even more than in discrimination of the senses.

So-ami, that painter of space and solitude, of great mounded hills and misty marshes where the wild-fowl cry, remained in the purely Chinese tradition which Shubun inaugurated. But though all the painters of this revival worked in a common spirit and with one ideal, more than one distinct style was grafted on the original stem. Thus the style of Sesshu was followed by a group of powerful talents, among whom Sesson, Keishoki, and Shugetsu were the most illustrious. Sesson indeed is almost the rival of Sesshu. The British Museum is fortunate in possessing a precious set of eight sketches by Sesson, landscapes which show to admiration the special qualities of the Sesshu style, its power of suggesting space, atmosphere, aerial distance, by swift and forcible strokes. A portrait of Vimalakirti by Shugetsu in the same collection is interesting as being painted, not in the Sung style, but in the contemporary Ming style, which the artist had

Plate XXVI. The Haunt of the Wild Geese. One of a set of eight.
By Sesson. British Museum.

the opportunity of studying at first hand, since he accompanied his master to China.

A third tradition was formed by Masanobu, the first of the Kano family. It was in this Kano family that the Chinese style was to be assimilated most thoroughly with the Japanese character ; and the Kano style, when fully developed, formed a powerful and persistent tradition, lasting even to this day, and rivalled only by the long line of Tosa in its centuries of fame.

Masanobu, born in 1453, died young, according to the most trustworthy tradition, in 1490. Hence his works are rare, but enough survive to reveal a painter of poetic imagination, the delicate modulation of whose brush contrasts strongly with the vehement force of Sesshu's strokes. One of the most beautiful pictures of the time is Masanobu's picture, shown in London in 1910, of a Chinese sage, whose retirement was dedicated to contemplation of the water-lily, musing in his boat on a lake over which feathery willow branches droop, while on the water blossoms of the opening flower shine in the still morning air, hung with veils of tender haze. An old version of this painting was bought some years ago by the Louvre. In our own national collection are two landscapes, attributed to him, in the lightly coloured style.

The gentleness of Masanobu's nature was reinforced by a commanding strength in the genius

of his son. Motonobu, if he lacks something of the rarity and loftiness of his father, is the most vigorous and various of the whole Kano school. Few names in Japanese painting stand higher than his. The force and firmness of his brush are controlled by that calligraphic element which is of the essence of the pure Kano style ; its supple beauty of stroke adapts itself to every subject, unlike that of Sesshu, whose imperious freedom of spirit accommodates all things in nature to his own energy and daring. The clean strength of Motonobu's handling is magnificently seen in a painting in the British Museum of the sage Shoriken crossing the sea on a floating sword, defying the rage of the foaming waves and winds that blow his hair and toss his garments. A set of three pictures in the same collection, though not of the finest brushwork and probably early copies, have much beauty. The Chinese and Japanese are fond of these sets of three, in which, as in some of the triptychs of Italian and Flemish art, the subjects are distinct, though the paintings are related in one scheme of design. Here the central subject is a crane : on one side are birds and a flowering tree on rocks against which a wave breaks in foam ; on the other a small bird poises beating against the wind, which bends the strong stalks of a rose-mallow beneath and flutters the petals of its flowers. These are coloured paintings upon paper of a mellow golden tone, harmonising

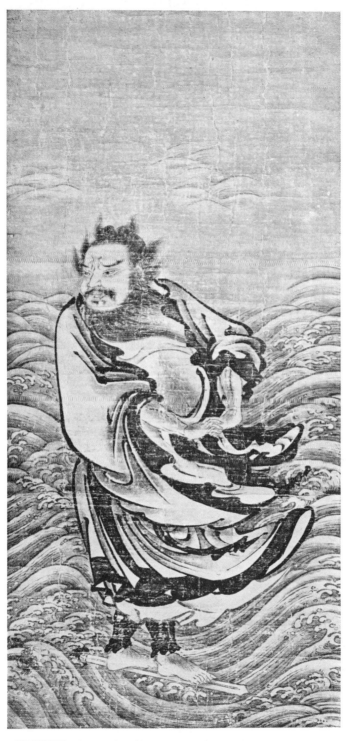

Plate XXVII. Shoriken crossing the sea on a Sword.
By Motonobu. British Museum.

with the rich gold of the brocade silk mount. They are entirely modelled on the art of Sung. But Motonobu's art is eminent in variety and versatility. In landscape, though he keeps mainly to Chinese tradition, he exchanges the solemn dream and poetic reverie of the great Chinese for a wider range of observation, for a more alert and buoyant spirit, a livelier and a swifter touch. Nor did he confine himself to the Chinese style. He married a daughter of Tosa Mitsunobu, and the alliance had effect on his art. He painted several scrolls in the Tosa manner and with the Tosa conventions, though the Kano character of drawing is apparent in details, especially in the figures. One such scroll depicts the adventures of the hero Raiko, the slayer of an ogre called the Shiuten Doji. A copy of this in the British Museum was catalogued by Dr. Anderson as the work of a Tosa painter. Motonobu was, in fact, the first to adopt an eclectic principle which in later centuries inspired many of the greatest artists of Japan. Born in 1476, he lived on to 1559. His brother Utanosuke emulated him in painting, being especially distinguished for his flower-and-bird pieces, while his son Shoyei also followed in Motonobu's footsteps with much ability. During the next few generations the Kano family was still to dominate the world of painting. But the style passed through successive phases, not unmodified by outward events. To these I must return. Meanwhile in China the

191

arts had been greatly flourishing under the first Ming emperors, and it was from the developed style of Ming that the second great generation of the Kanos took some of its chief features.

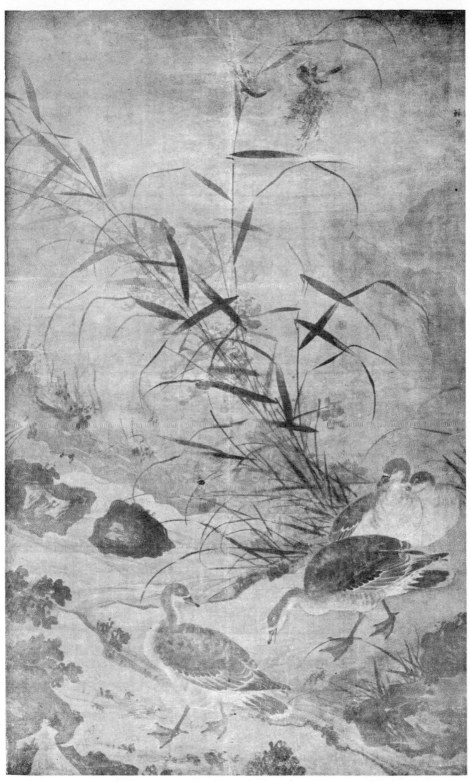

Plate XXVIII. Wild Geese by a Mountain Stream.
By Lin Liang. British Museum.

CHAPTER XII. THE MING PERIOD IN CHINA

PEDANTRY and conservatism, the ingrained weakness of the Chinese genius, begin to show their paralysing power on painting in the Ming epoch. Yet the period opened with splendour.

In 1368 the Mongols were expelled, and the first Ming emperor mounted the throne. The Chinese themselves divide the period of this dynasty into two ; and the first half, down to the end of the fifteenth century, constitutes, for painting, an age of production hardly less important than that of Sung. There is, however, a change of mood ; a change from the lofty idealism of the eleventh and twelfth centuries to a more luxurious temper, delighting in external magnificence. The ink-sketch, beloved of the Sung masters, a mode of art in which the materials of expression could almost merge themselves in the artist's thought or emotion, yielded to the sensuous charm of colour. It is true that at the opening of the period we are met by a few masters like Lin Liang (Jap. Rinriō) who still remain in the Sung tradition and prefer to work in monochrome. The British Museum possesses a large painting by this artist, which is almost worthy

to rank with the Sung masterpieces. It is a picture of wild geese on the banks of a mountain torrent, among tall reeds. The mastery with which the ink-charged brush has expressed the forms, even to the pressure of the birds' webbed feet upon the ground, and the sense of distance in the planes, is consummate. It is an admirable lesson in the possibility of giving reality and atmosphere without the aid of shadow. Only a certain loss of grandeur and simplicity in the design removes it from the heights of Sung art. A pair of paintings of wild geese, lotus, and millet in the same collection, though inferior to this and belonging to the school of Lin Liang, are also vigorous examples of monochrome work.

Another great master of ink-painting is Wu Wei. A magnificent example of his brush passed into the Museum from the Morrison collection. It represents a goddess or fairy attended by a phœnix, the long tail of the bird sweeping up behind her head to complete a design of singular dignity. This painting is in ink lightly coloured. But Wu Wei is best known by his pure monochromes. A less-known painter, Wang Li-pēn, is the author of an ink-landscape, " Valley and Mountain," in the same collection, which still retains much of the Sung feeling and has a certain severity of style.

The new Ming style is found at its finest in another fifteenth-century master, Lü Ch'i, to whose brush

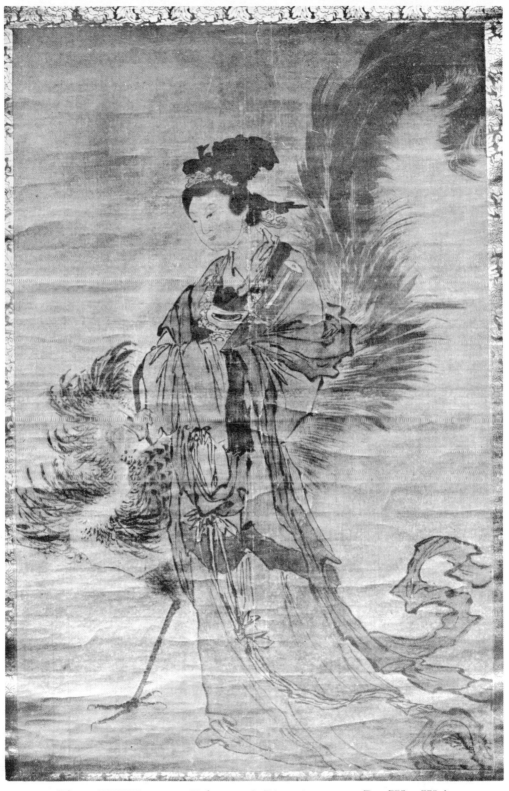

Plate XXIX. Fairy and Phœnix. By Wu Wei.
British Museum.

are ascribed a beautiful pair of paintings in the British Museum. These are works in the lightly coloured style, of morning mist by a river with ducks and blossoming trees, and pheasants by a mountain stream. Fenollosa considered this pair the finest examples of the master that he had seen. Flowers and birds with a landscape background were Lü Ch'i's favourite subjects; but there is a splendid pouncing cat reproduced in the *Kokka*, No. 78. In his typical work the colouring, rich and opaque, is concentrated in a few strong notes—red camellia blossoms, it may be, or pale blue convolvulus—contrasting with the warm brown of the silk ground. With the greater stress on the external appearance, texture, and colour of objects, there is less modulation of tone, less atmosphere. Decorative aims assert themselves; the artist is not so sensitive to reality, as conceived in wholeness by an interior mood of the mind.

Wēn Chēng-ming, whom the Japanese call Bun-chomei, is one of the great masters of Ming land-scape. Born in 1522, he died in 1567. In the British Museum (Morrison collection) is an upright landscape, with a very high horizon; mountain heights with falling torrents and green woods and winding wreaths of mist. It is a dreamy and romantic work, carrying our thoughts now back to the eighth century and Wang Wei, now forward to the early nineteenth century and Tani Buncho

in Japan. The Museum also possesses, through the gift of Mr. George Veitch, a beautiful large painting called " The Hundred Stags." Down a gorge below cloudy peaks troop the thronging herd of deer, where no voice or foot of man intrudes upon the dewy forest solitudes. In the centre a royal stag, the patriarch of the herd, proudly emerges between two trees.

What is now to be noted is that Chinese painting begins to be more remote and less near to us than it was in the Sung masterpieces. That peculiar intimacy with nature which strikes us as so modern in the Sung painters yields to a romantic feeling in landscape ; and that fine simplicity, the mark both of the manners and the art of a high civilisation, is exchanged for elaboration and ornateness.

The art of Ch'iu Ying (Kiu Yei in Japanese) crystallises these tendencies. He is an extremely popular painter in China, and imitations of his work abound. His favourite subjects were taken from the life of the court or the illustration of romances, but he also painted landscapes. One of his most famous pictures was a long roll, the original of which is lost, or at any rate not at present known, but numerous copies exist, and one of these is in the British Museum. It depicts the occupations of court ladies. Here they are watering flowers in the garden, there in a pavilion is a group dancing and playing musical instruments ; some are reading, others are gathered

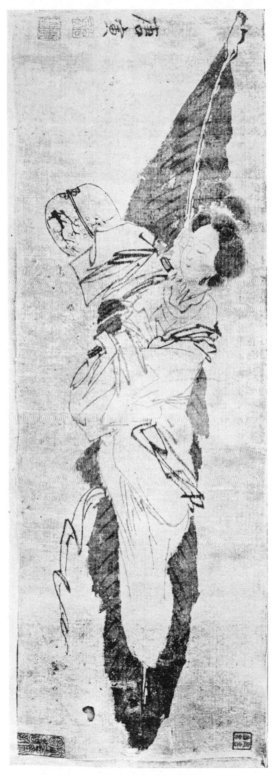

Plate XXX. Lady asleep on a Leaf. By T'ang Yin.
A. W. Bahr Collection.

PLATE XXX. Fabrication on a cliff. (By Walter Stein.
By Mark Stenographers.

round a princess whose portrait is being painted. It has pretty motives, such as the bird which alights on a low bough and dips it in the surface of the moat ; it is charming in gay colour, it is full of graceful figures. But if we compare it for a moment with the Ku K'ai-chih picture, we feel how far the art of China has fallen. The contrast between the feminine types in the two pictures is worth remarking. As in the case of Chao Mēng-fu, it is difficult to single out any one of the numberless pictures bearing Ch'iu Ying's name as an undoubted original by his hand. A small circular painting in the Museum of a lady at her window looking out on a moonlit landscape, seems to me to have more claim than most to be original. Its exquisite quality of handling places it far above the great majority of pictures claimed for the master. With this may be ranked a fine *makimono* acquired for the Museum with the Morrison collection.

T'ang Yin, who flourished about 1500, was a contemporary of Ch'iu Ying, and rivals him in popular esteem. He was famous for his pictures of fair ladies, and also for his excellent landscapes.

Genre-painting begins to be prominent in this period. Such subjects as the " winding-water fête," when cups were set afloat on a winding stream, and competitors, handicapped according to talent, had to compose a poem before their cup came to

the point where they were stationed ; games of polo ; pedlars with trays of toys and ornaments (an occasion for revelry in jewelled colours) ; ladies looking at bowls of gold-fish, girls letting off fireworks ; the occupations of children ; such subjects as these, taken from familiar life, are frequent in Ming art, and anticipate the Ukiyoyé of Japan. Of one such subject, " The Hundred Children," there is a delightful example in the British Museum : we see the roguish urchins at play, with bows and arrows and with hobby-horses, scuffling together, trying their hands at painting, enjoying a marionette theatre, and finally saying their prayers on little mats before going to bed.

Some fine portraits have come down to us from the Ming period : seated figures, seen in full-face, designed with simple breadth and with a subtle suggestion of modelling in the calm features. Two good examples are in the British Museum collection. The memorial portrait-group, of which we reproduce a part, is probably Korean.

At the same time the traditional subjects were not neglected, sages, landscapes, birds, and flowers, only, as I have said, with an ebb of the inspiring glow which had animated earlier and greater times, though such a painting as the roll of " Lychees and Birds " in the British Museum (to take one example out of hundreds) is a truly masterly work of intimate observation and fine colour. A significant symptom

198

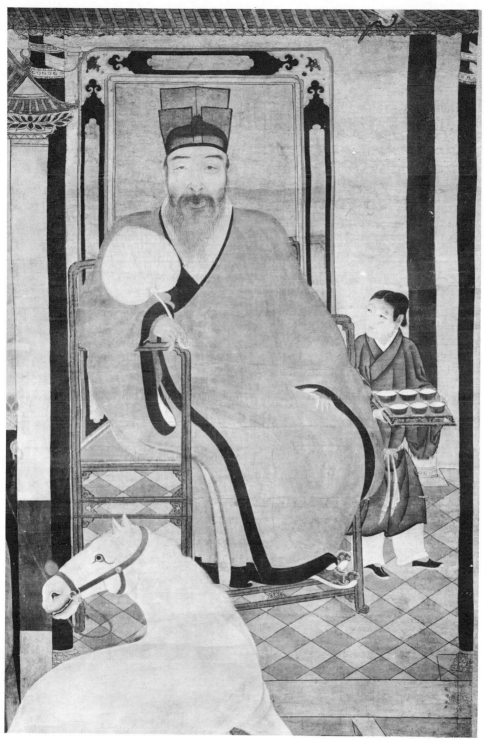

Plate XXXI. Portrait of a Philosopher. Probably
Korean, 15th century. British Museum.

Plate LXXI Portrait of a Widow-woman. Paschalis
Kazan, 1612 (?). The Berlin Museum.

of decaying vitality is the progressive increase in
the copying of old masters by accomplished artists,
the growing loss of independence.

Not till the Ming era can we study the painting
of China with anything like adequacy of material.
The remnants that survive of early epochs suffice
to put the art of Ming into a secondary place. Yet
how many works of beauty and of splendour the
dynasty can claim ! Hitherto attention has been so
much concentrated on painting which claims to be
of the Sung or earlier periods that Ming art has been
little explored. In the future we shall probably
appreciate more justly its rich achievement.

The large painting formerly in the Olga Wegener
collection and now in the British Museum called
" The Earthly Paradise " sums up the matured
characteristics of Ming art with great charm and
completeness. Compared with Sung or T'ang
painting, we are forced to admit that the workman-
ship lacks fibre and fineness, the mood of its con-
ception lacks intensity and loftiness : but in itself
how delightful it is ! The joyous rhythm which
unites the figures, the harmony of rare colours,
the animation, the atmosphere of romance and
discovery, of youth and experience at once, the
suggested perfume of flowers upon the air, all
combine to make what is, in its own kind, a
masterpiece.

In 1644 the weakened empire, corrupted by the

199

court ascendancy of eunuchs, and threatened by a rebel army, called to its aid the Manchu Tartars, wild tribes of herdsmen who had long hovered dangerously on the northern frontier. The Manchus came, and they came to remain. They put an end to the Ming rule, possessed themselves of Peking, and enforced on the Chinese the wearing of the pig-tail in token of subjection.

CHAPTER XIII. THE KANO SCHOOL IN THE SIXTEENTH AND SEVENTEENTH CENTURIES

THE sixteenth century in Japan was a reign of war and chaos. Once again the great family which had seized the sovereign power and held it for two hundred years fell into impotence and decline. The fate which had overtaken the Fujiwara in the earlier day overtook the Ashikaga in their turn. As their sway grew feebler, so the strength of the feudal barons increased. But each was against his neighbour ; fighting was incessant ; the country was devastated, no man was secure. The once magnificent city of Kyoto lay half ruined : grass grew in the streets ; the common people made their tea in the precincts of the palace, where, in miserable seclusion and real poverty, the ladies of the court passed their forlorn and empty days. The Emperor himself supported a precarious existence by selling his autograph.

It is to be noted that now, as always, there was no thought of abolishing the Emperor ; his person was too sacred, his power too shadowy. But the ambition of the great barons was to obtain possession of Kyoto, and with it the custody of the Mikado. The purpose was achieved, and anarchy

arrested, by three remarkable men. Nobunaga, a man of genius for war, subdued the rival chiefs, deposed the last Ashikaga Shogun in 1573, and became military dictator in his place. Nobunaga's lieutenant, Hideyoshi, famed as Japan's greatest man of action, succeeded to his power, and brought the whole country under one rule. Not content with this achievement, Hideyoshi, who had risen, like Napoleon, from obscurity, aspired to further conquest. He dreamed of conquering China also ; he invaded and laid waste Korea ; but his grandiose schemes were frustrated by his death, two years before the century closed, and his troops were recalled to Japan. The third of these commanding historic figures is Iyeyasu, the inscrutable strong statesman who consolidated the work of Nobunaga and Hideyoshi, kept the feudal barons under strict control by his politic measures, made a new capital in Yedo, on the eastern coast, and founded the line of Tokugawa Shoguns which held power till the revolution of 1868.

The invasion of Korea revived intercourse with the continent, and the severe simplicity of Ashikaga taste was supplanted by the vogue of the now mature Ming style of China, with its rich colour and ornament. The style appealed to the new nobility who had risen to power with Hideyoshi. Untrained in the fine culture of Zen philosophy, they could appreciate gorgeous decoration, but were

indifferent to the subtle beauties of an ink-sketch by So-ami or Sesshu. Kano Motonobu died in 1559. But he left a successor of genius in his grandson Yeitoku ; and it was Yeitoku whom Hideyoshi commissioned to decorate his newly built vast stone castle of Osaka. It was an age of castles. The most renowned for its splendour was the castle of Momoyama, near Kyoto, on the decoration of which the finest art of the age was concentrated. The daimios followed Hideyoshi's example, and all through the country rose castles, furnished in the same gorgeous style.

Yeitoku was trained in Motonobu's school, and inherited the lofty traditions of Ashikaga painting. Hence a style that might easily have fallen into vulgarity and parade preserved in his hands weight and grandeur. This second phase of the Kano school appeals perhaps more to European taste than either the earlier or the succeeding phases. The typical masterpieces of Yeitoku and his pupils were immense screens, decorations on walls or sliding panels, painted in opaque pigments of rich colour on gold leaf. The effect was one of extraordinary magnificence. When Hideyoshi made a public procession, screens were set up along the road for miles together ; and Momoyama castle was famed for its " hundred sets " of them. Like Rubens, Yeitoku worked with a large light brush and rejoiced in the designing of huge pictures,

with gigantic pine-trees and more than life-size figures. Like Rubens, he supervised the work of a crowd of pupils, and even so the demands of the nobles could hardly be supplied. There was a fever of decoration. Yet nothing could surpass the stately impressiveness of Yeitoku at his best. He painted horses in their stalls or in the freedom of the solitary hills, tigers menacing and irresistible, fabulous lions of strange but royal aspect, birds of rich plumage on forest boughs, fawns flying from the retreat of tall waving grasses, heroes and princesses of old Chinese legend, and superb landscapes. It is significant how fond he is of portraying scenes from the story of the T'ang Emperor, Ming Huang, and the lovely and ill-fated Yang Kuei-fei. It is as if he hungered to recall that time when, for a brief moment, Beauty, not riches, empire, conduct, or conquest, was the supreme passion, and poetry, painting, and music were of more account than statesmanship, war, or commerce. Many screens, by the master or his pupils, depicting scenes of that old court and its poetic revels, are in the Boston Museum and in the Freer collection. Boston also has a splendid pair in monochrome of dragon and tiger. But finest of all and most typical of Yeitoku's grave force and monumental design is the Pines in the Freer collection, here reproduced. How simple are the elements that compose this picture ; the great pines, the

204

Plate XXXII. Pines in Wintry Mountains. By Yeitoku. Freer
Collection.

mountains, the snow ; but what a sense of vastness, of majesty, of solitude ! A certain solidity of effect allies such work as this to the masterpieces of Europe ; and in its own kind I do not know where we shall find painting to surpass it, whether in Japan or in the West.

Yeitoku's greatest pupil, Sanraku, came near his master, but is perhaps less famous for his rich screen-painting than for his work in the pure Kano style, lightly tinted or in monochrome. For the style of Momoyama—the name of the palatial castle has been given to the period—was to last for no long time. The art of the Kano family, still gloriously persisting, began to revert to its earlier tradition, and refreshed its strength in the next generation with the advent of its third sovereign master, Yeitoku's grandson, Tanyu.

Sanraku, as we shall see later, helped to inaugurate, in certain paintings of popular life which he did not sign, the beginnings of that school of genre, called Ukiyoyé, which was to flourish so exceedingly in the eighteenth century.

One of his pupils, Sansetsu, who died at the age of sixty-three in 1652, must be mentioned. Sanraku adopted him as his son, and he proved worthy of the finest traditions of Kano. Something of antique simplicity gives character to his work, and links him with the older masters rather than with the looser swing and dash coming into Kano style

during his lifetime with Tanyu's ascendancy. A fine example in the British Museum, here reproduced, is a masterpiece of impressionist rendering of a downpour of rain drenching the lake shore and blotting the mountain peaks.

Tanyu was born in 1602. And now with the seventeenth century Japan enters on the long and profound peace which lasted under the Tokugawa rule for more than two centuries and a half. As before in the days of the Fujiwara, this singular nation again closed itself to the outer world. Foreign intercourse was prohibited. By an order of the third of the Tokugawas, Iyemitsu, all large ships on the coast of Japan were destroyed. War and politics were no longer the predominant interests. Amusement in every form became more and more the engrossing occupation. The policy of the Tokugawas was to promote unity of government; the power of the feudal lords was to be restricted; and to this end each of the great daimios was required to spend half of the year in the new capital of Yedo in attendance on the Shogun. As a consequence the city grew swiftly in size and in splendour. The populace woke to consciousness of their part in the nation, and the industrial arts flourished as never before.

The seventeenth century was remarkable in painting chiefly for the new movements which were being originated, both in regard to subject and to

206

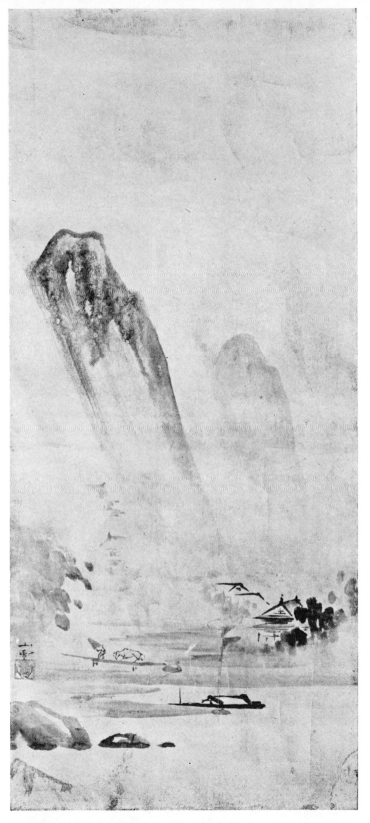

Plate XXXIII. Rain. By Sansetsu. British Museum.

style. It saw the beginning of genre-painting in Matabei, founder of that school which in the next two centuries became the special art of Yedo, and produced that marvellous mass of colour-prints so prized by the collectors of Europe. It saw also the rise of the magnificent school of decorative painting and lacquer design culminating in Korin. But before considering these new movements, let us see how the Kano tradition was being upheld by the successors of Masanobu, Motonobu, and Yeitoku.

In Tanyu and his school the long line of Kano enjoyed its last period of glory, only to fade into academic futility with the advent of the eighteenth century.

The ideal of Iyeyasu, the great founder of the Tokugawa dynasty of Shoguns, was simplicity. And this ideal partly explains the reaction in Kano painting from the gorgeousness of Momoyama. But though Iyeyasu may have desired a return to the refined severity of Ashikaga culture, the temper of the times was against him. The nation gained in awakening consciousness of unity. But the very policy of the Tokugawas, which obtained peace at last for the long-devastated country by vigorous exertion of authority, promoted a state of things inimical to the austere art which Zen teaching had inspired in times of material peril and disaster. Before the end of the century, in the famous period

of Genroku (1688–1704), the life of Yedo was a sort of carnival of amusement and luxury for a people no longer allowed by circumstance to participate in the strenuous interest of politics and war.

The mood of Ashikaga times was not to be recovered. That exquisite fabric of art and manners, which only a long tradition of study and religious thought could have prepared, could not survive the great upheaval through which Japan had passed without some inner change. We feel the change when we pass from a painting of Masanobu to a painting by Tanyu. There is a loss of spirituality, an element of display.

Tanyu is a painter born, a master of the brush who exults in his mastery. The virtuosity which displays itself in much of his painting may lead us into thinking of him too exclusively as a marvellous executant, lacking in the rarer emotional and imaginative qualities. Yet he can touch lofty heights. Few have evoked a nobler image from that poetic subject dear to the painters of Japan, Kwannon, the goddess of love and mercy, seated by the wild sea-shore on a rock where the water breaks in foam tossed up even to the hem of her garment ; an image of heavenly serenity throned above the tides of trouble and of passion ; or Monju, the deity of wisdom, a face inscrutable, a gaze profound with the intensity of thought, rising tranquil, with dark, smooth hair, as if from mists

208

of contemplation. But it is in landscape that Tanyu achieves his peculiar triumphs. A well-known early masterpiece in a Japanese collection is the " Fuji from Kiyomi Bay." Still finer is the grand pair of screens in the Freer collection, where Fuji towers up remote in the distance, while in the foreground a solitary reed-bed shivers in the wind. The growing national spirit shows itself in the choice of a Japanese landscape by a painter of the school which had repeated for generations themes borrowed from the classic landscape of China, and disdained the beauties of their native land, much as the Roman Campagna imposed itself, after Claude's example, on the imagination of those landscape-painters of Northern Europe who aspired to a classic style. Of Tanyu's Chinese landscape no better example could be found than the fine *makimono*, acquired with the Morrison collection by the British Museum. This seems to have been painted in emulation of Sesshu's most famous landscape roll, and betrays that master's influence in the tremendous boldness of the strokes, contrasted with great spaces of empty air and flowing water.

Even more magical is the painter's use of Chinese ink on the screens in the same collection where immense distances of mountain, shore and sea retreat in impalpable veils of air ; on nearer heights a clump of trees has been created with a swift and sudden turn of the wet brush—shapeless it seems,

yet it is there, a living thing : out of a misty hollow rises a temple from which the bell, one knows, is sounding in mellow tones ; over remote reed-beds come wild geese in trailing flight ; a whole panel is blank except for a pale round glimmer—the moon. The materials used—the expanse of absorbent, self-toned paper ; the ink, now melted into the surface in faint wide washes, now flung in vivid blot or splash, now shaping a mountain's contour with exquisite certainty—these materials seem to have merged themselves into mere expression as words fit thoughts. How large, how liberating the effect ! What exhilaration in this sense of ease, this joy of mastery !

It was this easy, fluid confidence of Tanyu's brush which enchanted succeeding generations and seduced them to their ruin.

Tanyu was the eldest of three brothers. The other two, Naonobu and Yasunobu, were both distinguished painters. Naonobu especially, a gentler nature than Tanyu's, is a master of monochrome and the art of reticent suggestion, admirably seen in a set of three paintings, of Hotei with a bird on either side, now in the British Museum. Yasunobu represents the Kano school in a more academic vein. Naonobu's son, Tsunenobu, ranks as the ablest follower of Tanyu, and has left many accomplished pictures, though they betray less original force of mind.

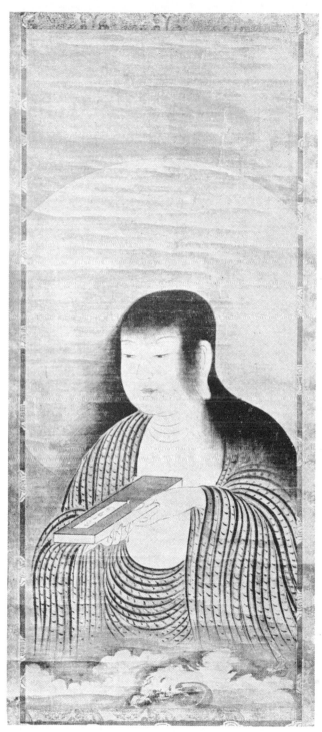

Plate XXXIV. Monjiu. By Tanyu. British Museum.

A pupil of Tanyu who rose to independent rank was Morikage. Little is known of him save that he was poor and had little popularity. His instinct for delicacy and refinement of workmanship marks him out in an age that loved splendour and bold execution.

Among the pupils of Yasunobu was a still more remarkable painter, Hanabusa Itcho (1652–1724). His originality soon declared itself, and caused a rupture with his masters. Itcho, though he always retained the traces of his Kano training, created a style of his own, in which he gave rein to his strong sense of humour and a vein of mocking wit. In 1698 a painting of his gave offence to the Shogun, and he was sentenced to banishment for twelve years. Even in landscape subjects Itcho reveals the light and witty handling congenial to his temperament. But the significance of his art lies rather in his preference for subjects from popular life, which was beginning to be illustrated in such profusion and with so much charm by the artisan school of Yedo. That school, however, derived its first inspiration from an offshoot of the aristocratic schools, and its origin goes back to painting of much earlier times.

CHAPTER XIV. MATABEI AND THE BEGINNINGS OF GENRE

THE close of the fifteenth century in Europe saw the beginning in Italian art of the painting of scenes from daily life which we call genre. Before that time painters had confined themselves to the set subjects of religion, allegory, war, mythology, portraiture.

The inventor of genre-painting for Southern Europe—in the North certain lost pictures by Van Eyck created a similar tradition—was Giorgione. An atmosphere of mystery and fascination haunts the name of the poetic Venetian, to whom so few works can actually be assigned, though so many have passed under his name—a fact testifying to the peculiar fruitfulness of his genius, which, though not eminently productive in quantity of work, was yet so rich in inspiration both for contemporaries and for the future. Those themes of beauty which Giorgione discovered in the favourite pleasures of his own Venetians—their summer picnics among the wooded hills, to which music lent a heightened charm of feeling or of reverie—were the Italian prototype of all the long array of Dutch genre pieces, where the sunny open-air pleasures of the South have given way to the interiors of the North,

212

with stray beams of sunshine adding some touch
of pensive charm and suggestion to shadowy corners
and familiar furniture, some glorifying caress to
the common things of home. In Watteau and his
followers, again, the same type of art is born anew
under different conditions, and removed by one
degree from actuality ; while in Chardin it reverts
to homeliness, infused with a refined and heightened
sense for beauty.

Ukiyoyé is the Japanese equivalent of genre.
" Pictures of the fleeting world " it means, a term
of Buddhist origin, coloured with the Buddhist
reproach of all that appeals to the senses and belongs
to the transitoriness of miserable mortality. But in
time the word lost this colour. Applied originally
to painters of daily life, on account of the subjects
they preferred, it came to mean a recognised style,
and the artists of the school were known by that
style even when they painted landscapes, flowers,
battle scenes, on any of the recognised subjects of
the older schools.

Matabei, the originator of Ukiyoyé, holds a place
in the art of Japan analogous in more than one
respect to that of Giorgione in Europe. Numbers
of paintings pass under his name, but very few
can really be claimed for his brush, and scarcely
any are authenticated. Various and contradictory
accounts of him have been handed down, and there
have not been wanting native critics to deny his

very existence. Quite recently, however, the real facts of his career * have been brought to light, and his identity fully established. Matabei's family name was Araki. His father was a lieutenant of Nobunaga, and having rebelled against his master was forced to commit suicide. Matabei, who was born in 1578, was then a baby of two, and was carried off in safety by his nurse to Kyoto, where she procured his adoption into the related family of Iwasa. He became known as a painter, and as his reputation grew he was summoned to Yedo, and worked there for the Shogun. He died at Yedo in 1650. His eldest son, Katsushige Gembei (d. 1673), also painted ; and Gembei's son, Koreshige, continued the family tradition in a weaker style. There were other followers who painted genre. To the productions of all of these the name of Matabei has been vaguely attached. The genuine work of the master has, however, decided characteristics of its own. He affected, especially in his women, a peculiar type of face, short in the nose, but with long, full cheeks and rounded chin. His design is notable for the simplicity of its contours, his brush outlining the figure with sweeping lines which are yet supple, sensitive, and expressive of the form within them. With great naturalness of pose and gesture he has a profound sense of style, and swiftly seizes essentials. There is something rare about

* First published by Mr. Arthur Morrison in the *Monthly Review*.

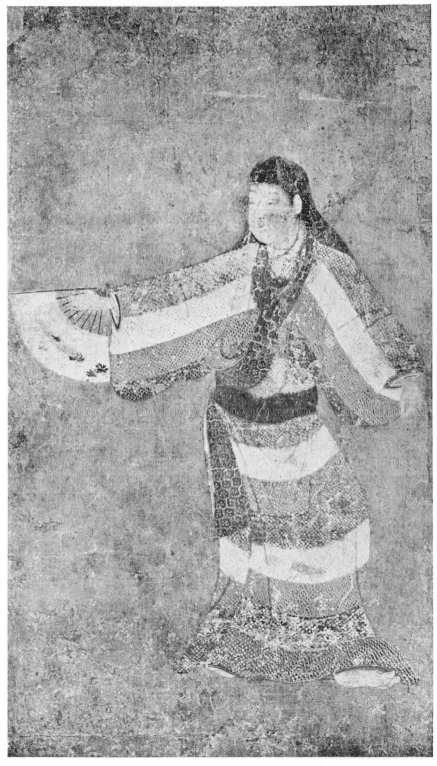

Plate XXXV. Dancer. By Matabei. British Museum.

his art which matches the scarcity of his productions. Of these, some of the best authenticated are a set of paintings of the Thirty-six Poets, signed on the back and dated 1640. Here the painter describes himself as " belonging to the lower stream of Tosa Mitsunobu," a description which indicates how he regarded himself, as a painter of the Tosa tradition who applied the Yamato style to a lower kind of subject than the artists of the court. These Thirty-six Poets followed, indeed, the Tosa treatment of such portraiture, though with a new vitality supplanting the old stiffness. But Matabei's distinctive genius is far better seen in a set of four pictures of men and women playing games, painted on a screen, as a part of the wedding portion of a Tokugawa princess. One of these was shown among the Japanese treasures in London in 1910. Here we see what a powerful originator he really was. The Tosa style, long ago in the thirteenth century, when Keion and Mitsunaga wielded the brush, so apt and free in depicting groups from the actual life of Japan, had frozen into utter formalism. The Chinese style, on the other hand, with its vigorous brush-work— never more vigorous than in the hands of Matabei's younger contemporary, Tanyu—was ill adapted for Japanese subjects. Matabei had learnt both styles. He could paint goddesses with the long flowing lines and soft light tints of the classic masters ; he could sketch legendary heroes in washes of ink.

But in fusing the two elements into a manner of his own Matabei escaped the ordinary fate of eclectics. There is nothing in him of the tameness that so often attends the calculated attempt to blend a variety of qualities, such as we find in the Carracci. On the contrary, there is a sort of primitive fire in his painting. All his qualities are native to him ; there is nothing taken on from outside. Nor was he tempted, as many leaders of revolt have been, into the violence of reaction from accepted type. There is the centred strength of balance in his art. His was a truly original genius, in that what he expressed in his painting was entirely his own : had there been no novelty in his art, his originality would not have been less. Nothing is more entirely Japanese in its beauty than the beauty discovered in life by Matabei. Perhaps these may seem extravagant words when we contemplate the artist's few extant works. But it is with him as with Giorgione ; we feel him a power working in the life of art, perhaps even more in the production of others than in his own.

Matabei was called Ukiyo Matabei by his contemporaries, from the subjects of his pictures. But though he was the first to devote all his powers to genre, there were painters before him of the aristocratic schools, both Kano and Tosa, who had painted genre subjects occasionally. The earliest known example is a screen by Hideyori, a son of

the great Motonobu. Kano Sanraku is known to have painted in this style, and some have suggested that he is the author of an unsigned work, called the Hikone Screen, which is at any rate the work of a master. This is, in a sense, the most important of all the productions of the first phase of Ukiyoyé, and rivals in beauty the work of Matabei, under whose name it has long been known, though the types of face, with strongly marked lines and small chins, are totally distinct from his. It is painted on a gold ground, like the screens of Yeitoku and Sanraku. It represents men, women, and children amusing themselves : some are painting, some reading, some playing on musical instruments, others playing " Go." The figures are full of life and character—note especially the face of the blind man playing the samisen—yet at the same time it is a wonderful piece of decoration, finely spaced, and with a rare sense of beauty in silhouette.

Tosa artists also painted genre, though nothing could show more clearly the feebleness into which that school had declined than its inability to take up a mode of art so suited to its genius and traditions. The work was left for a new school, for painters of the people, painting no longer for an aristocracy, but for their own class. To them we must return in time. For the present we must see what other movements were taking place, and what changes were working among the older schools.

CHAPTER XV. THE GREAT DECORATORS

AS the power of Michelangelo proved the ruin of the Florentine school, which could not match his force yet could not help following in his wake, so the power of Tanyu dissolved the art of Kano, though in the school of Tsunenobu the great tradition was for a time not ingloriously prolonged. The Kano family continued to hold official rank in the Shogun's court, while at Kyoto the Imperial house fostered the line of Tosa. But the old inherited styles tended to break up or merge in one another. Mitsuoki (1617–1691) revived something of the old fame of Tosa in his delicate and distinguished art, but his subjects were taken often from the themes of Chinese art ; he was specially renowned for his paintings of quails. The same tendencies appear in a branch of the Tosa school, the Sumiyoshi, which had come into prominence. More significant for the future, however, was the work of independent artists. Among those who remained at Kyoto when the new capital was founded was a remarkable man who inaugurated a new style in decorative work. This was Koyetsu. His family, the Honnami, were experts in all that relates to the manufacture of swords. The sword is more than a mere weapon in Japan. It is " the

soul of the samurai," and by far the most valued
of his possessions. The sword-smith must be a
man of high character and pure life ; the forging of
the steel was done with religious rite and ceremony,
and the sword itself came to be regarded as a sort
of other conscience, an ideal by which a man should
test his life. Blades by one of the most famous
makers are priceless. Forgeries have always
abounded ; and Koyetsu is known as the first
expert whose authority on a question of genuine-
ness was universally accepted as final. In painting,
Koyetsu was a pupil of Yusho, chief of a branch of
the Kano school. Then he studied the old Tosa
masterpieces. His own style is an independent one.
It is not as a painter that he acquired his greatest
fame ; it is as a lacquerer and as a master of calli-
graphy. He created a new mode of lacquer-work
by the employment of lead, tin, and shells in decora-
tion, and interested himself in wood engraving and
printing. He was a student of the Zen doctrine,
was an adept in the Tea-ceremony and in landscape
gardening, and lived a life of lofty seclusion. He
died in 1643.

Though his painting is so rare and the works
ascribed to him often disputed, his design is
intensely original. Fenollosa was the first to recog-
nise its high importance, to vindicate Koyetsu's claim
to be the greatest of the wonderful group of artists
we are now to consider. If it were only by this

group, Japanese painting would take rank among the supreme achievements of pictorial design. In the hands of Korin and his followers, the peculiar design evolved by the school takes on a more abstract character ; but in its earlier phases, as seen in the screen from the Freer collection which is here reproduced, there is an exuberance of sap and growth which gives it a richer savour. It is full of the suggestion of the depth and luxuriance of Nature. And of even greater beauty are the pair of screens once in the Gillot collection and now in the Metropolitan Museum, New York. One of these especially, which has a large-leaved sapling in the foreground, is extremely original in design : it seems to me one of the most fascinating pictures in the world. As to the actual authorship of these works there seems to be no settled opinion.

With Koyetsu is associated another man of genius, his friend Sotatsu, each perhaps deriving an element of inspiration from the other. The two sometimes worked together on a single *makimono*, Koyetsu adding specimens of his beautiful writing to Sotatsu's paintings. Little is known of Sotatsu's life. But his works reveal a consummate gift for design, as well as a marvellous delicacy of touch and feeling. The significance of the achievement of Sotatsu and Koyetsu lies in their revival of the glory of colour which had been an integral part of the old Yamato painting. The now decaying Tosa line was no longer

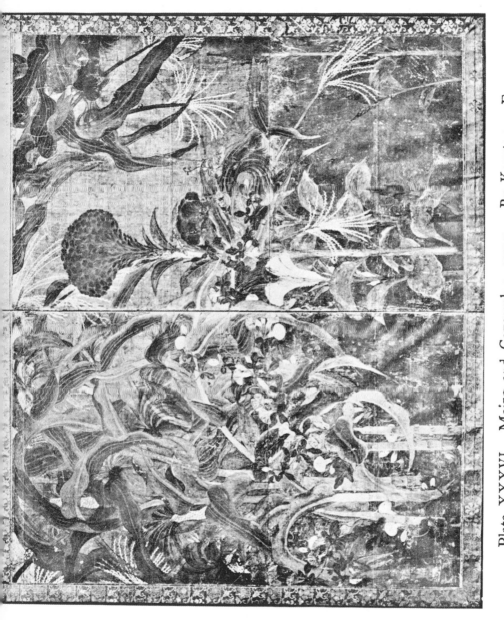

Plate XXXVI. Maize and Cozcomb ; screen. By Koyetsu. Freer Collection.

capable of expressing ideas by colour. Mitsuoki was deserting the rich colour-schemes of Tosa for the light tints of Kano. Sotatsu and Koyetsu, who had studied both styles, evolved a style which has its roots in Tosa principles of design and keeps the rich Tosa colour, but their brush-work has the nervous force of the Chinese tradition, and their art breathes the pure and lofty tone of Ashikaga. Technically, Sotatsu was an innovator. He mixed gold with his Chinese ink, adding a hidden lustre and rare gleam to grey and black. The leaves of his flowers are often veined with gold. As in the old Tosa scroll-paintings, his flowers are simplified, detached, almost symbolic, yet full of life and sap. He was fond of effacing the ground ; we see shoots of bamboo and young fern-fronds springing up from space. The tendency of his design was to modify the old linear method, and to work less by line than by mass. His typical masterpieces are screens overlaid with gold or silver leaf, on which the pigment is gorgeously encrusted. Poppies blazing on a broad golden field of quivering sunlight, or flowers that glimmer with colours dipped in beams of a moon of unearthly splendour, are made into designs that fill their space as majestically as the great figure-compositions of Europe. Sotatsu's magnificence of colour, which loves broad spaces of lapis blue and exults in crimsons, emerald, and purple, keeps always a stately dignity ; a marvellous sense of measure

221

holds all the elements of his art in balance. What strange masterpieces he could make of simplest things we see in a pair of screens which have for subject nothing but clothes-horses. True, the clothes which hang on them are of sumptuous brocade ; but it is the spacing above all which shows the master and makes beauty unexpectedly to appear. He painted also in monochrome ; and there is a fine screen by him in the British Museum, painted in ink, representing the Thunder-God threatening the Palace of the Fujiwara.

The fame of Sotatsu and Koyetsu has been unduly overshadowed by the fame of their follower, Korin. Korin is one of the few artists of Japan who is known in Europe ; known, it must be said, chiefly by the innumerable imitations and forgeries which pass under his name. But in our admiration for this wonderful master we must not forget how vast a debt he owes to Sotatsu and to Koyetsu both in painting and in lacquer-work. The peculiarities in design and brush-work which mark the painting of Sotatsu are all found again in Korin, though in him the style has become more conscious and more concentrated. His temperament is less grave ; it has something defiant in it. Sotatsu's art had its roots in the old art of Tosa, the national style of Japan, but was developed by him into freedom, breadth, and suppleness. Korin carries the style to climax and extreme, so that in him we see the distinctive

222

essence of the Japanese genius in final flower. He is perhaps the most Japanese of all the artists of Japan. It is because his art sums up so much that the style which actually was originated by Koyetsu and Sotatsu bears the name of Korin.

The decorative genius that flowers in the painting and in the lacquer of this school was perhaps the boldest and most fertile that the world has seen. " Decorative " is a term that carries with it to our ears associations of what is abstract, systematised, restful in art ; it does not suggest the stimulating qualities, the energy and daring, of Korin.

In Europe we talk of decorative art as different in kind from pictorial art, but in Japan the division is hardly apparent. Decoration must always be governed in idea by architecture. Now in Japanese architecture it is a group of forms rather than a single form, and the whole surroundings of a building rather than the building alone, which is considered. Not only is a harmonious site carefully chosen, but the material surroundings may be artificially altered to harmonise with the building. It is, so to speak, a landscape conception of architecture, just as a landscape idea controls the figure-painting of Japan. Thus, while our architecture triumphs in massiveness and concentration, and controls thereby the instinct of designers towards the rigid and symmetrical, the lightness of Japanese buildings, which are made to belong as if by right

223

of natural growth to their surroundings, and to melt their beauty into the beauty of the groves and hills, this lightness of structure—not wholly to be explained by the frequency of earthquakes —invites and fosters the designer's instinct towards delicacy and naturalism in decoration. We have seen that when for the first time massive stone castles were erected by Hideyoshi and his barons, a decorative style of painting arose which is more massive in character than anything else in the pictorial art of Japan, and begins to have affinity with the art of Europe.

In the Korin school we find the same style of design used both in painting and applied art. But Japanese decoration never hesitates to use pictorial motives. We know from experience that European decoration is rarely able to dispense with symmetry or a geometrical basis, whereas the Japanese will decorate a lacquer box with a moonlit landscape, and wild geese flying across the sky, and we feel that it is in perfect taste. The truth is, that European painting since the Renaissance has been so much occupied with the problem of representing depth and relief that pictorial motives have to a great measure lost touch with the primary motive of decorative design. We now associate decorative art with design from which the representative and imaginative elements have been almost discarded. In Japan there has never been this divorce, because the

224

cast shadow has never been admitted into painting, and illusion never aimed at. Hence the decorative motive has never been absent from Japanese pictorial art. Decoration does not confront the Japanese with a new and different problem from painting. They have been able to discard symmetry as a geometric basis, and to found their decoration on the same subtle principles of balance which underlie European painting. People often talk and write as if Japanese design was mere felicitous caprice and irregularity. On the contrary, it has science as well as taste behind it. The national cult of *ikebana*, or flower arrangement, shows us how intense has been the Japanese study of balance in the living growth of plants. Rodin, who says, " Balance is the pivot of art," had studied both natural forms and the human body from the same point of view. Japanese design inherits the training, bred to instinct, of centuries of study and observation, and the efforts of modern artists in Europe to achieve the effects of a Korin merely by imitation from the outside expose to ludicrous result their total insufficiency.

To the special qualities of buoyancy, clearness, delicacy, which belong to the character of the Japanese and are inherent in their art, Korin adds something more : a frank audacity, a gaiety that is almost arrogant, a confident challenging note. He satisfies the eye, but he stimulates and stirs rather than soothes. His art is conceived in the

Dorian mood. His brush has the trenchant movement of a sword held in a nervous grip. Something fiery and abrupt informs his design and gives strangeness to its beauty. He has a way of getting to the bare elements of expression. His figures, like Daumier's, will sometimes be concentrated into one great gesture. Like all his countrymen, in painting flowers he is interested above all in their growth, the charm of their springing lines, careful neither to pervert them nor to tame them into adumbrations of, or embroideries upon, a geometrical pattern. But more than this : his genius seizes and expresses the force of their growth, the force of the straight-shooting iris blades, of the bamboo shoots which burst up even through the frozen sod. Thus the irises of a famous screen standing sharp against the gold ground impress us at once with a sort of architectural quality as decoration, and with a vivid sense of life and the power of life. He was fond of painting wild waves—blue, rearing, crested waves tossed up on a gold background : decorative again, superbly decorative, and conventional if you will ; but, looked at long, they seem to grow into a strange and formidable reality of their own, such as might haunt the midnight visions of one whose life had tasted deeply of the terror and the beauty of the sea.

In his half-humorous painting of the Thirty-six Poets, grouped together in a single picture, one

226

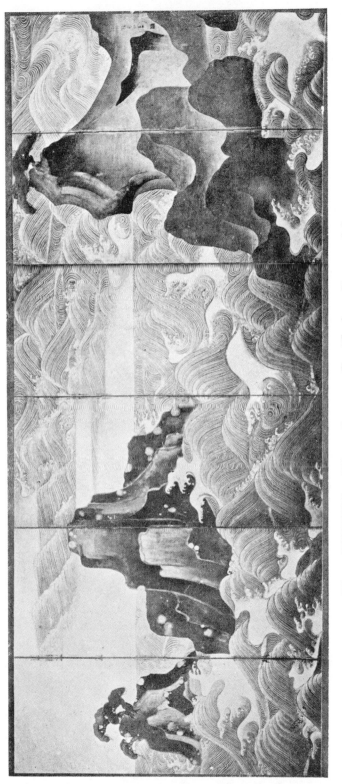

Plate XXXXVII. Wave Screen. By Korin. Boston Museum.

notes the extraordinary skill of arrangement, and also the characteristically Japanese composition, held together by the play of relations between the figures, no one of them forming a centre or focus.

As a painter, Korin must yield to the greater Koyetsu and Sotatsu. His supreme triumphs, perhaps, are certain lacquer boxes of classic fame, decorated with lead and mother-of-pearl. Simple, rude, and careless may seem the design at first blush, yet how it continues more and more, as we look, to attract and impress! There is something quintessential about the art which with such bare elements as these—a leafing spray, a temple gateway and its grove of pines, shown in rudiment and symbol—has power at once to stimulate, surprise, and satisfy like a medal by Pisanello.

The influence, through Korin, of the style of design originated by Koyetsu upon applied art has been immense. Not less distinguished than Korin's work on lacquer was that of his brother Kenzan on pottery. Kenzan's design is allied to that of Korin, but he is often fond of pliant twisted sprays where his brother prefers more massive and straight growths. Kenzan was also a fine painter, though his pictures are rare.

The splendid hollyhocks of our illustration, though it does not betray his special idiosyncrasies, may stand as a typical example of the flower-painting of the school.

Korin and Kenzan were sons of Soken, a pupil of one of Koyetsu's pupils, and their family was connected with that of Koyetsu ; but Korin was not, as has been asserted, himself trained under the older artist, who died, in fact, in 1643, whereas Korin was not born till 1661. Korin was a pupil in painting of Kano Tsunenobu (or, as some say, Yasunobu) and of Gukei, a painter of that branch of the Tosa school which is called Sumiyoshi. He worked in Kyoto, but was expelled from the city on account of what was thought his wasteful luxury. The occasion was this. The artist accompanied two bankers of Kyoto on an excursion to view the cherry-blossom. At noon the bankers brought out their luncheon from beautifully decorated luncheon-boxes. Korin produced his, wrapped in fibrous sheathing of bamboo ; but the wrapper was covered with gold-leaf on which was an exquisite design. Having finished his luncheon, Korin threw the wrapper away. The shocked men of business reported the incident, and the artist was bidden to leave Kyoto. He took up his abode in Yedo, but in time returned to the old capital. He built a tea-room for the Tea-ceremony in a garden which he filled with curious and beautiful plants, and used to spend entire days watching the unfolding of the buds or the falling of the leaves.

The Genroku era, in which Korin lived, was one of unparalleled luxury and magnificence. New

228

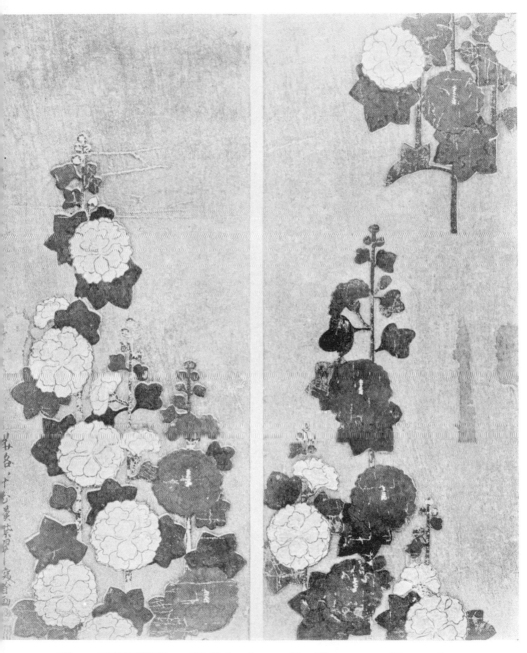

Plate XXXVIII. Hollyhocks. By Kenzan. (From the *Kokka*.)

designs and patterns for stuffs and dresses were in continual request, and Korin delighted to improvise some novel idea in decoration for the dresses of fair women. We read of parties at which the ladies withdrew and returned seven or eight times, appearing each time with a different dress, always of the same colour, but always with a new design.

Never, perhaps, in history has there been a time so rich in fantastic gorgeousness. And over it all, disseminating the seed of its strange beauty, played the fire of Korin's genius.

CHAPTER XVI. NEW MOVEMENTS IN THE EIGHTEENTH AND NINETEENTH CENTURIES

THE slow, gradual, but steady ebb of animating glow and vigour, which had set in on Chinese art during the Ming period, continued into the eighteenth century, and has continued apparently to the present day. Not that admirable pictures were not produced in great numbers ; what was wanting was not skill or taste, but the fresh transforming impulse which inspires men to see earth and heaven with new eyes, an impulse needing, perhaps, to come from some deeper movement in the nation's life ; and no such movement came.

The weakness of Confucianism, its inclination to fixity and to establish over the mind a despotism

Heavy as frost and deep almost as life,

became more and more visible ; and no new stirring from without, such as Buddhism had brought, was at hand to rescue the degenerating genius of the nation from itself. Admiration of the past had become idolatry. When a man achieves distinction in China, and is ennobled, the honour does not descend to his posterity, but is conferred on so many generations of his dead ancestors. So too in paint-

ing men's faces turned to what was gone before, careless of what was to come after. Want of faith in the future paralysed to a great extent the energies of the present. With aspirations thus turned backward, it was remarkable that China could still produce so many artists and so much good work.

When our knowledge of the art of the Manchu dynasty has become more definite and tangible, it may be possible to distinguish the influence of outstanding personalities and to gauge their worth. Prof. Hirth has collected a great deal of information about these painters, and from him we learn something of certain individual men whose names stand high in the esteem of their countrymen. Such are the four landscape painters called Wang, who flourished at the beginning of the dynasty. But in a book of the present scope we are concerned less with individual names than with general movements. And this period was the reign of the Southern school.

Far back in the eighth century and the great times of the T'ang dynasty, the poetic artist Wang Wei, we saw, originated the Southern style in landscape, of which a later phase was the so-called Literary Style. The votaries of this school ranked the inspired and careless sketch of a literary amateur above the finest technical mastery. Subjective merits only counted. It was in a sense a return to the ideas with which the famous Zen sect had inspired the slight ink-painting of the Sung period in China

231

and the Ashikaga period in Japan. But it was a return which pushed those ideas to caricature ; and at the back of it was no longer the lofty atmosphere of religious aspiration, having its counterpart in life and conduct, but a dilettantist spirit not averse to fostering a fashionable craze.

The movement has its interest and significance as being a last effort of the Chinese genius to throw off the yoke of too rigid academic formula and prescription. But, deriving no fresh element to support and nourish it from without, it took the curious form of depreciating everything in a painting which had obvious technical power. It not only encouraged excessive slightness of execution, but affected weakness and incoherence in brush-work, in revolt from the accepted supremacy of the strong and rhythmic line of the classic schools. Something parallel may be found in recent phases of Western painting, where an effort towards sincerity and reaction from the formulated style of academic drawing shows itself in a calculated roughness and clumsiness of touch, and a horror of beauty in pigment. But, in the West this movement has aimed at form and colour for their own sake, divorced as far as possible from human associations. In China, on the contrary, the movement allied itself with the association of literature. Europeans, therefore, are hardly capable of appreciating whatever charm this kind of painting possesses.

NEW MOVEMENTS

It is probable that, from want of knowledge, we underrate the Chinese artists of the eighteenth century. Certain it is that from them their Japanese contemporaries received no insignificant stimulus.

At the close of the Ming dynasty many a refugee from China, mostly scholars and priests, refusing to accept the Tartar rule, found a home in Japan, where the study of the Chinese classics was now a reviving enthusiasm. Chinese painters also arrived, bringing with them both the literary style and the decorative coloured style of the later Ming. They worked at Nagasaki, the one open port, and Japanese artists flocked to learn from them. The most important of these men was Chen Nan-Ping, a painter not, it is said, uninfluenced by the realism of European art, whose vigorous and graceful pictures of birds and flowers evoked enormous admiration and were greatly imitated. Chen Nan-Ping arrived at Nagasaki in 1731. The literary style, too, was introduced, and was able to renew itself by an alliance with the movement towards naturalism now prevalent.

What were the conditions of art and society in Japan at the time of this invasion from China?

On the one hand, there was the teeming city of Yedo, dominated by the vast castle of the Shogun, with its many moats, as its population was dominated by the rigid Tokugawa rule. Yedo art was sharply divided. The official Kano painters of the court,

233

whose mode of work was prescribed by fixed author-
ity, starved on lifeless academic formula and routine,
and produced little that was not merely an imita-
tion, more or less clever, of Tanyu or Tsunenobu.
Despised by these feeble representatives of an old
and great tradition, the multitude of Ukiyoyé painters
and colour-print designers, men of the artisan
class, were illustrating, in innumerable woodcuts,
the life of the populace and the drama of the popular
stage. Cut off from the life of the nobles and the
samurai, they created a world of art, beautiful in
its kind, which is self-enclosed, and has but little
relation with the ideals of the older schools. This
thriving popular school we will leave for a while
and turn to the ancient capital of the Mikados—
to Kyoto. Here the power of the Shoguns was less
openly exercised ; and as the growing elements of
revolt against the Tokugawa policy and discipline,
even against the Shogunate itself, gathered at Kyoto,
so too at Kyoto we find the most vigorous and
independent artists.

It was the painters of Kyoto who responded to
the new current of ideas flowing through Nagasaki
from China.

Thus we find Ryurikyo refining on the decora-
tive colour of later Ming, while his pupil, Ikeno
Taigado, takes up the light, loose, faintly tinted style
of the Southern school. Buson also works in the
Southern style, painting Chinese landscapes or deer

in mountain solitudes, but with an added force of naturalism. And in Buson's pupil, Goshun, the strain of naturalism becomes predominant. This was only in accordance with the temper of the time. Goshun, dissatisfied with Buson's teaching, betook himself to another master, who gave him advice, though he did not actually admit him as a pupil. This other master was Maruyama Okyo, the most famous painter of the age.

Okyo was born in 1733. He was the son of a farmer, and as a child showed a passion for drawing. He studied the styles of all the older schools, and some of his best paintings are inspired by the ancient masters ; but his mature and characteristic work is in the style which he himself invented. He copied European engravings with his brush, and aspired to infuse a greater spirit of realism into the art of his own country. Compared with what we call realism in the West, Okyo's innovations seem to have little claim to such a title. Yet we recognise in his art, along with acceptance of the conventions which Asiatic painting had never discarded, a new particularity and precision. He observed nature keenly ; and no painter surely was ever gifted with sight more sensitive or more searching. A hand which had almost miraculous control of the brush was at the service of a vision of exquisite lucidity.

" Nature nerveuse, fine, et froide," he is happily characterised by M. Hovelaque. In his detach-

235

ment, his marvellous eyesight, his fine taste, he reminds us of Velazquez. Not without that coldness of temperament, perhaps, could Okyo have achieved his singularly unruffled masterpieces. A sweet playfulness comes out in him when he paints his delightful pictures of puppies, a favourite subject ; but he rarely communicates his mood. He is capable of grandiose conceptions, as in a celebrated pair of screens depicting the River Hodzu, a torrent pouring down a rocky valley, or as in the series of " The Seven Calamities," in which the elemental terrors of flood and earthquake are depicted with immense power. A famous Waterfall, with fragile green boughs contrasted with the plunging mass of water shattered on rocks below, was shown in London in 1910. But the finest specimen of Okyo's art that I have seen is the monochrome sixfold screen in the Freer collection, where two wild geese are winging out to the pale empty distance over a sea that ripples on solitary sands and is lost in a vast horizon. Yet Okyo never affects us as the masters of the Ashikaga period affect us : we feel the difference of import, of all that lics behind a work of art in the recesses of thought, reverie, spiritual ardour, and desire. Okyo is too absolute a master of his means : he is no longer the wooer of beauty, but the sovereign, dispassionate observer who can do with his brush all he wills, to the utmost limits, so it seems, of his ambition.

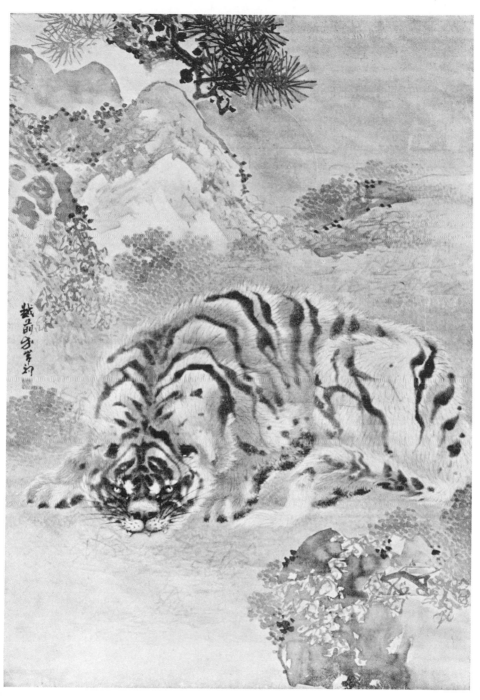

Plate XXXIX.　Tiger.　By Ganku.　British Museum.

And so we prize him most in those wonderful pictures of carp gliding and swerving through water, of great pine branches powdered with snow, of willow or maple spreading their faultless tracery against a serene space of sky, of birds in flight seen as we might see them if we had an eagle's eye to follow them through the air : all such themes of nature his art seems to hold and image for us as if with the heightened purity of a mirror's reflection. There is nothing blurred, nothing violent, nothing troubled in this unerring art, clean in vision as it is clean in touch. Far removed as Okyo's painting is from mere naturalism—for a profound science in composition and a supremely fastidious taste are of its essence—yet it was the realistic effort in which it had most influence on the century. A similar effort is not absent from the work of Ganku, a painter of temperament strongly contrasting with Okyo. Ganku, who was Okyo's junior by sixteen years, and survived him by more than forty—he lived on to 1838—comes nearest of the modern masters to the freedom, fire, and grandeur of the Ashikaga times. His brush-work has a vibrant quality which makes Okyo's beside it seem cold and almost dry. He is especially famous for his tigers, and painted them in his youth with a patient realism, though his opportunities for study from nature must have been exceedingly limited. Apparently he never saw a living tiger, though he imagined

the fierce beast with remarkable insight as is manifest in a large early painting (Pl. XXXIX) recently acquired by the British Museum. He excelled in other subjects, too. His paintings of deer and of peacocks are impressive in a way the Shijo pictures very rarely are; they communicate the dignity of the painter's nature. In these, and still more in his Chinese heroes and sages, he allies himself with the inspired masters of classic times. Ganku is ranked by his countrymen as the founder of a school bearing his name.

While Okyo enjoyed fame and prosperity, surrounded by eager disciples, a singular artist led a life of poverty and seclusion in the same city of Kyoto. Soga Shohaku came of the old Soga family which in Ashikaga days had been eminent in art, and himself claimed to be a reincarnation of Soga Jasoku. In his life and in his art he reminds us often of William Blake, who was working at the same time in London. He was thought mad by his neighbours. He poured scorn on the successful Okyo, as Blake poured scorn on the successful Reynolds. He turned away from the art of his own time, and sought to recapture the strength and fire of the fifteenth-century masters. As with Blake, the aspiration was only half realised, and begot a strain of the fantastic and grotesque, but Shohaku at his best is a great painter and a very interesting artist. An admirable pair of ink-paintings by him are in the British Museum.

238

Jakuchu was another contemporary of marked independence, also not without his eccentricities. He too was poor and careless of worldly success. He painted birds and fish, and was especially fond of cocks and hens, rejoicing in their vigorous plumage and variegated mottlings. His colouring, rich and opaque, reminds one of some of the earlier Ming painters, such as Liu Ch'i. His design is not quite like that of any other Japanese, though it has certain affinities with that of Korin.

Korin himself found a follower in a man of great gift, Watanabe Shiko. It has been sometimes asserted in European books that the Korin style was not revived till the end of the eighteenth century, when Hoitsu took it up and attracted some accomplished pupils. Shiko, however, if not an actual pupil, was a very near disciple. His manner is distinct from his master's, though the difference is hardly to be put into words. The Chinese element is rather stronger in his painting than in Korin's. The British Museum has acquired with the Morrison collection one of his finest works, a pair of sixfold screens of the Four Seasons. Summer flushes and fades into autumn, winter melts into spring, and a group of white herons about a snow-covered willow seem to feel the awakening of the year, as the flowers begin to put forth their blossoms in the air under the soft cold mists.

Although these various masters were working in

Kyoto on their own independent lines, the main current of Kyoto painting appears in the growth of the naturalistic school, called, from a street in the city, the Fourth Street or Shijo school. The Japanese count Goshun as its founder, while the school of Okyo is distinguished as the Maruyama school. But the two schools are the outcome of one movement, of which Okyo is undoubtedly the originator. Goshun, as we saw, began as a follower of Buson's style, then fell under Okyo's influence. His graceful brush has less fineness and precision than that master's. His followers and successors developed a style in which light, harmonious colouring and an unforced, flexible handling were pursued, in avoidance of the ruggedness and looseness which the Chinese manner was apt to affect. The subjective idealism of the classic schools was discarded, and instead we find Mori Sosen, the incomparable painter of animals, living for months together on fruit and nuts in the woods of Osaka to learn by patient observation the life of the forest monkeys that he loved to paint. Peerless as a painter of monkeys, whether in the rough broad style or in his other minuter manner, in which their hairy coats are rendered with the fidelity and much more than the sensitive life of Dürer's animal studies, Sosen is equally happy in his pictures of shy, delicate-footed deer, of which there is an exquisite example in the British Museum, while at South

240

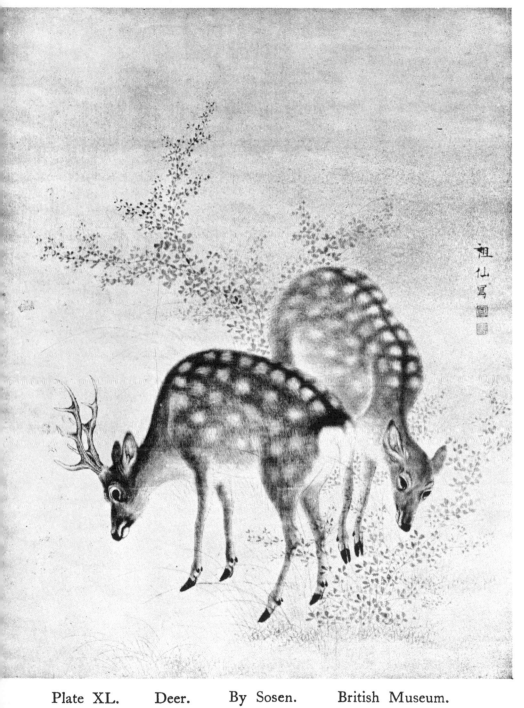

Plate XL. Deer. By Sosen. British Museum.

Kensington is a fine picture of peacocks from his brush.

Hoyen is another delightful animal painter, with a humour of his own. Rosetsu puts a touch of oddness and unexpectedness into his animal designs. Mori Ippo is famed for his birds and for his landscapes.

It is sometimes said that the Shijo school avoided the subjects of heroes and sages, and all the legendary lore of the Chinese and Kano schools. They did not often choose these subjects, it is true, but they are by no means unknown to their art. The typical Shijo picture is, however, a nature study ; still keeping the singleness of pictorial idea, the charm of design, but emptied of that inner purpose of alliance to a spiritual conception, interpretation, or lofty mood, which was the life of the older schools, and which made their work impressive. We feel some such change as there is between the painting of seventeenth-century Holland and of fifteenth-century Italy.

But meanwhile the Chinese school, which since Ashikaga times had shown but fitful life, had not only received a new impetus from China itself with the advent of Chen Nan-Ping, but was now reinvigorated and transformed by a master of Japanese birth.

Tani Buncho was the son of a poet in Yedo. Born in 1768, he lived to 1840. Like Matabei and Sotatsu,

he created a style of his own by fusing elements from more than one of the established schools. To the romantic feeling of the Southern school of China he added the nervous, masculine brush-line of the North. And as Yeitoku had infused into the Kano style the strong, opaque colour of Ming, Buncho could at times enrich his art with colour effects which seem influenced by a study of the Tosa classics. Buncho painted birds and flowers, and is famous for his romantic mountain landscapes painted in tones of blue and green alone. Fine as these are, they lacked something of the dream-like spaciousness and lofty air of the old Chinese. Buncho is at his finest in his rare pictures of sages and heroes. His painting of Shoki, the demon-queller of Chinese legend, standing on a white floor of cloud in the deep blue spaces of heaven, is nobly conceived and splendid in colour. The variety of his style, manifest in a special exhibition of his work held a few years ago in Tokyo, is astonishing. A large and splendid Dragon in ink has quite recently been acquired by the British Museum.

The school which Buncho founded tended to coalesce with the Shijo style. But his favourite pupil, Watanabe Kwazan (1793–1841), has a place apart. Kwazan had in his nature no little of the heroic idealism of an earlier and a greater time. In him we recognise one of those devoted spirits who founded the new Japan of our own day. Like

other earnest and thoughtful men of his time, he was deeply persuaded of the evil effects on his country of the Tokugawa policy of isolation. He learnt Dutch, and published a book advocating the renewal of foreign intercourse. The book brought down on him the Shogun's displeasure. " Fearing lest his conduct might invite some misfortune to the lord whom he served, he put an end to his life." The grief of his devoted band of pupils at his death bears witness to the charm and nobility of his nature.

I have already spoken of Hoitsu, Buncho's contemporary, who at the beginning of the nineteenth century revived with brilliant success the style of Korin. Hoitsu was of noble family, and entered the priesthood, but lived most of his life in retirement dedicated to painting. He studied under more than one master, and tried various styles, but in the end chose that of Korin, in which, indeed, he found a natural affinity. When all allowance is made for the immense debt to a predecessor followed so closely, Hoitsu must be credited with real originality to have retained his own spontaneous gift. As a colourist he almost equals Korin, though it is perhaps inevitable that his choice and delicate art should strike us as a little cold. A twofold screen of young fir and red acacia on a silver ground, acquired some years ago by the British Museum, is exquisite in its contrasts and harmonies.

The early nineteenth century saw also a rather

remarkable revival of the old Tosa style in the hands of a little group of painters, Tanaka Totsugen (d. 1823), Ukita Ikkei (1795–1859), and Reizei Tameyasu (1821–1862). These artists, who have been neglected and ignored by most European writers, are highly esteemed by their countrymen. Their work is no mere affectation of archaism ; it is full of vigour, and, especially that of Tameyasu, splendid in colour. The movement is of interest and significance, too, in its witness to the strong reaction towards the ancient national ideals of pre-Tokugawa days.

One great painter remains to be mentioned—Yosai, best known by his fine book of portraits of celebrated heroes, " Zenken Kojitsu." Yosai was born in 1787, and died at a great age in 1878. He was of noble family, and after a training in the Kano style made a prolonged study of all the schools, on which he founded his own independent manner. As a figure-painter he has had extraordinary influence. A Fukurokujiu by him, in the British Museum, is a noble and original conception of the old sage ascending into Paradise and mounting through the mists of heaven. In the same collection are some ten paintings of heroic subjects.

Zeshin, famous for his lacquer, was also an admirable painter, often using lacquer with his pigments. A choice series of his paintings, mainly the bequest of the late James Orange, is in the British Museum.

He died in 1891, aged eighty-five. Kyosai (b. 1831, d. 1889) is famed for his humorous invention, but he excelled in more than the comic vein ; as may be seen in Mr. Conder's book on his art, he was a various and vigorous master who brought fresh imagination and real dignity to the treatment of classic themes.

Since the restoration of 1868 there have been a number of painters who have deserted their native tradition, working more or less in the Western style and using the medium of oil. A kind of oil-painting has been known in Japan from quite early times, but has found scarcely any practitioners. In the seventeenth century a certain artist, called Yamada Emosaku, learnt the European method from the Dutch. He was a Christian, and during the persecution of the Christians in that period he distinguished himself by his heroic defence of a fortress. He would have been put to death, but his bravery and his skill as a painter saved his life. A screen * by his hand is extant, which seems to be adapted from a European print. It represents two princes on horseback on a terrace. On the caparison of the horse of one of them is a shield with the arms of France and Navarre, which identifies the rider almost certainly as Antoine de Bourbon, father of Henri IV. The other is probably François, Duc de Guise.

* Reproduced in the *Kokka*, No. 138. I am indebted for the identification to the late Mr. Max Rosenheim.

But the oil medium has never proved congenial. The hybrid productions of artists of the recent era of Meiji have no real felicity. And in later years a return has been made by the more gifted artists to the old native style, even when treating European subjects. In the Morrison collection, now in the British Museum, is a striking picture of Diogenes in his tub by a painter who died quite recently, Shimomura Kanzan, in which the head of the sage, with a suggestion of the tub from which he gazes, is treated like that of some Daruma or Jurojin of Eastern legend. Among living painters Yokoyama Taikwan is a master who need fear no comparison with the great men of the past. For the future of Japanese painting I will venture no prophecy. Hard as it may be to withstand in art the Western influences which have transformed to so great an extent the external conditions of life, I fervently hope that those influences will be withstood, and that the artists of Japan will realise how it is only by being true to its own ancient and inbred traditions that their art can worthily rival the art of Europe.

CHAPTER XVII. UKIYOYÉ AND THE COLOUR-PRINT

UKIYOYÉ in its later phases, as we know it in the manifold productions of the colour-print designers, was an art made by artisans for the people. But it had its origin, as we have seen, in the aristocratic schools. For the early days of the Tokugawa rule were days of liberation, when for the first time the nobles took part in the common life and shared the pleasures of the people. Events had, to a certain extent, remoulded society. During the desolating civil wars the court had known poverty and wretchedness ; humanity had invaded its seclusion, with its suffering and its pity. Again, Hideyoshi had risen from low origin to be Regent of the empire, and among his captains were many of obscure rank and birth. When, therefore, under the power of Tokugawa Iyeyasu, peace was consolidated, a single current of ideas could pervade the whole nation. A genial influence melted for the moment old barriers of caste. Relief from the long strain of war and danger brought about an extravagant reaction. It was an age of joy and festival. The new capital of Yedo grew fast ; commerce thrived in her streets with the sense of security gained ; the middle and lower

247

classes of the nation woke to a consciousness of national life and to a sense of the pleasures of art. So arose Ukiyoyé, a mirror of popular life in all its freedom and variety such as the art of no other country in the world can show.

Under the later Tokugawa Shoguns conditions changed again, and class distinctions became once more rigid—so rigid, in fact, that the populace were cut off from the samurai and the nobles, and lived a life absolutely their own and apart. Ukiyoyé became more and more confined to the artisan ; and in spite of Hokusai and Hiroshige, the nineteenth century is in the main a record of its degeneracy.

Matabei was of samurai family, and his subjects were drawn from the middle classes rather than the populace. But only a few years after his death in 1650 there arose an artist who was to be typical of the men of Ukiyoyé as we know it, and who ranks as the second founder of the school. This was Hishikawa Moronobu.* He was the son of an embroiderer, and began life as a pattern designer. He then studied painting, and became an admirable master of the brush. As a painter he was considerably influenced by that brilliant and unorthodox Kano painter, Hanabusa Itcho. But for the future his importance lay rather in his discovery

* The date of Moronobu's death used to be given as 1714, but it is now certain that he died in 1694.

of the uses of the woodcut in popular art. Wood-cut native images of deities and saints had from early times served the same purpose as the prints of Helgen in fifteenth-century Germany. There had been, too, woodcut illustrations to books. Moronobu's innovation was the issue of picture-books (*E-hon*), in which the text was quite subsidiary to the illustration, and of single-sheet prints. And whereas Matabei was unconscious that his work was to form the foundation of a new tradition, Moronobu claimed to be the originator of a school, and styled himself Yamato artist. During the years that he was designing, from about 1660 onwards, and no doubt owing to his influence, the competence of the woodcutters increased enormously.

An event which was of enormous consequence as a factor in the productions of this popular school was the establishment of the regular theatre, dis-tinguished from the old lyrical drama called *No*, archaic in its severe conventions as early Greek tragedy, which alone found favour with the aristo-cratic class. In the theatre, to which Japan's first great actor, Danjuro, ancestor of a line of actors flourishing into our own time, gave lustre, the Uki-yoyé artists found endless material, not only in scenes from famous plays, but in the portraits of famous actors. These latter were sold in their thousands, as photographs and picture postcards in Europe of to-day. And competing with these were the por-

traits of famous beauties of the Yoshiwara, the courtesan-city without the gates of Yedo, women who, like the hetairæ of Periclean Athens, were sometimes among the most accomplished of their day, versed in poetry and music.

The history of Ukiyoyé reflects within itself the history of Japanese art as a whole. It is the history of a number of artist families, each keeping mainly to one class of subject; but it is continually complicated by the fact that when one family line was enfeebled or exhausted, the tradition was often taken up and revived by a man from an opposed school; or, again, the power of a particular master in one school would attract to his style the pupils of many other schools.

We must at the outset distinguish between two main streams : between those who were chiefly or exclusively painters and those who were chiefly print-designers. The painters were the more fastidious in their subjects, and notably avoided the stage. Of these the first was Miyagawa Choshun, ranked by native critics as the best of all Ukiyoyé painters. He was certainly a charming colourist. Born in 1682, he was a younger contemporary of Moronobu. He designed no prints.

Following up the school of Moronobu, we trace step by step the evolution of the colour-print. Brocade-print, *nishiki-yé*, is the Japanese name.

Moronobu's follower, Kiyonobu, the first of the

Torii line, a family which for several generations played a strong part in Ukiyoyé, used to be credited with the first advance from the hand-coloured proof to the print in which colour was applied by pressure from the wood block. But Kiyonobu died in 1729, and the colour-prints bearing his signature are by the Second Kiyonobu (whoever he was). The invention of the colour-print seems to have been due to a publisher, and the first specimens were put on the market in 1743. At first two colours only besides the black outline, a rose * and a green tint, were employed ; and a wonderful variety of harmonies was developed within this simple scale. Next a third block was added, and other colours used as well as or instead of the green and rose. At last in 1764 a further step was taken ; the number of blocks was increased, so as to complete the design with background and atmosphere, and the colour-print in its full splendour was evolved. Harunobu was the first master to exploit the discovery, and during the next five years, till his death in 1770, poured out an astonishing quantity of exquisitely coloured prints. It is difficult to understand why the Japanese were so slow in arriving at the complete print, when the Chinese had produced examples, not less elaborate than those of Harunobu, in the century preceding. Little is known about Chinese prints, but there are colour-printed books

* Called *beni* ; it is identical with the " rouge " used in Europe.

dating from as early as 1625, and some years ago I had the good fortune to discover in the MSS. department of the British Museum a number of colour woodcuts which were in the Sloane collection, and have therefore been in the Museum since its foundation. Of these the most remarkable are a set of prints of flower arrangements, flowers and birds, &c., printed from many blocks, with all the refinements of embossing and superposition of tints which we associate with the final stage of colour-printing in Japan. These were brought home by Kaempfer, the historian of Japan, in 1692, and as there is no record of his touching anywhere in China on his voyage, it seems likely that these woodcuts came from Japan, though certainly of Chinese workmanship. Still more recently some Chinese colour-prints of " Ukiyo-yé " subjects, girls, women and children, illustrations to stories, &c., have been discovered in the Sloane collection in the Museum. These seem to be quite unique. It is hard to believe, then, that the Chinese invention was not known in Japan ; we have, in fact, evidence that Chinese colour-prints were known to the Japanese before the middle of the eighteenth century, since Shunboku published in 1746 a book printed in several colours which is a copy of a Chinese book published in 1701. An almost unique copy of the first edition of Shunboku's book has been presented to the British Museum by Mr. Arthur Morrison. More than this, Mrs. Norton

Brown in her learned work, " Block-printing and Book-Illustration in Japan," describes a tentative experiment in two-colour printing dating as early as 1627.

The fact remains that in Yedo at any rate, whether the process was known or not, it was not taken advantage of. After 1764 we find a number of prints produced by Harunobu, Koryusai and others which are directly imitated from Chinese prototypes. But the invention of the colour-print in Japan seems to have been made quite independently. The stages by which it was reached may seem to us strangely long and slow. But the history of human inventions is full of similar singularities. How many discoveries, now in universal practical use, were made in principle centuries ago, yet left unutilised ! We may illustrate even from the history of colour-printing in Europe. In Germany, the home of the woodcut, the idea of colour-printing was brought to practice at the beginning of the sixteenth century. Yet very few colour-prints were made, though the existence of one cut printed in eight colours shows that the possibilities of the process were not ignored. In Italy, about the same time, colour blocks were also used, but Ugo da Carpi did not go beyond two or three tints ; the process was dropped for a century, and only revived sporadically in Europe before the nineteenth century.

But it is time to return to the Ukiyoyé artists.

We have, then, during the first half of the century, Kiyonobu and his pupils devoting themselves to theatrical prints ; Okumura Masanobu and his pupils beginning to explore the field of daily life, while not neglecting the fame of noted actors or Yoshi-wara beauties ; the school of Choshun proudly confining itself to painting ; while a few, like Sukenobu, worked almost entirely for picture-books, for which the occupations of women—girls, all sweetness and innocence, to look upon, at any rate —provided endless and monotonous material. With Harunobu (1718–1770) we arrive at the complete colour-print. But we arrive also at one of the most seductive artists of Japan. Avoiding the stage, Harunobu charms us at once by his subjects. Who can paint more delightfully than he the maidens of his native land ? He has a passion for the shyness, the sweetness, the slimness of adolescence ; for fragile figures sensitive to the finger-tips of little hands on wrists as slender as stalks of autumn crocus, and even when swaying and bent with emotion, showing hardly more in their soft small faces than flowers do in the wind. We seem to hear the delicate clatter of their pattens as they walk among the irises or the lespedeza bushes, or cross some snow-covered garden bridge, the close skirts clinging round their knees as they take their short, tripping steps. Young lovers, too, Harunobu understands, and is intimate with their moods. Many of his prints bear verses

inscribed at the top, which interpret them. We see the tea-house girl, pausing in her work to think of the youth who has come once or twice and captured her heart, but has had no thought of her (she fears) —gone like the cuckoo's cry, one moment near and the next far away. We see the maid blowing soap-bubbles for the delight of her dancing baby brother ; and though her will be set to withstand the magic of love (says the verse), yet the wind from the blossom-ing plum boughs will not suffer her to be at peace, and her white thoughts are flushed and perfumed. We see young lovers in the moonlit garden saying farewell. " I have broken off a flowering branch," the youth whispers, " and now that I have broken it, it is dearer than ever." The young mother, too, half hidden under the folds of the green mos-quito-net, playing with her baby ; the young mis-tress parting the sliding-door of her room in the early morning, the delicate ankles showing under her white night-dress to find her little waiting-maid huddled asleep on the floor ; geisha-girls gazing out to sea, where the distant sails are, or watching the gay boats on the Sumida river from the verandah ; a damsel humorously regarding the pretty shape that the shadow * of herself and her umbrella make on the snow ; merry children wrestling, playing games, or making a huge snow-dog ; all these are

* An instance of the way in which the Oriental artist uses the cast shadow for his own purpose, in spite of traditional convention.

of Harunobu's spring-time world. And with all this delicacy and feminine charm, what power is in Harunobu's design ! What force and variety in his colour ! He loves the tender tones of grey, and rose, and soft yellow ; but he strikes in a rich apple-green, a crimson, a chocolate-red, with confident success. His colour-schemes are matter for perpetual study, his designs not less so. His faculty seems inexhaustible in its freshness. It is rarely that one finds more than two or three copies of the same print in going through half a dozen collections, containing thirty to fifty examples each. Could we see his entire production we should be astounded.

Harunobu's work was continued by Koryusai, who followed in his steps so closely that at times the prints of the two are scarcely distinguishable. Koryusai excelled in the tall narrow prints made for the posts of houses (*hashirakaké*), and designed some splendid prints of landscape, birds, and flowers.

Meanwhile a young artist from the painter-school of Choshun had come to invade the declining Torii school of theatrical print design. This was Shunsho. Using Harunobu's methods, Shunsho re-created the actor print, and produced an infinite array of portraits of actors in character—playing both male and female parts, for the Japanese theatre, like the Elizabethan, had no actresses—and if inevitably monotonous in subject, displayed within these set limits great freshness and masterly draughtsmanship.

UKIYOYÉ AND COLOUR-PRINT

With the seventh decade of the century a yet greater figure comes into view, and soon establishes an undisputed sovereignty—Kiyonaga, a scion by adoption of the old Torii line. No kind of Ukiyoyé subject was untouched by Kiyonaga: the actor print, the domestic genre of Harunobu, scenes and figures from the heroic periods, and above all the rich, gay outdoor life of Yedo, its processions, its festivals, all the countless ceremonies of the New Year, picnics and excursions to view the cherry-blossom on green knolls above the Sumida banks, the loiterers in temple precincts, groups in restaurant gardens, music parties in house-boats on the river, visits to the sea-shore at the favourite rocky islet of Enoshima, to which at low tide a pathway crosses the sando. Kiyonaga is wonderful in his night scenes. He excels in two-sheet and three-sheet prints, with figures large in proportion to the frame. In his strength of sweeping line, he is without a rival; and his tall figures, beautiful in their stately attitudes, are of a noble type. A certain aristocracy of temper pervades his designs, of whatever subject.

The triumphant power of Kiyonaga attracted followers from all the schools of Ukiyoyé. Shuncho was a fine artist who merged his own individuality almost wholly in the master's style. Shunman also came under the spell, though he retained a poetic and wayward character of his own. But three men who fell more or less under the same sway rose to

independent mastery, and worked as rivals in the next following period ; these are Yeishi, a deserter from the Kano school of painting, Utamaro, and Toyokuni. Fine as Yeishi can be—and the best of his singularly graceful prints, such as the series that illustrate the Genji Monogatari, rank with the masterpieces of Ukiyoyé—he was not the potent personality that Utamaro proved. Utamaro, it is true, did not dominate Ukiyoyé as Harunobu and Kiyonaga had done, and he worked on into a time when taste was perceptibly and progressively decaying. Historically he may be reckoned as belonging to the decline. But, judged as one of the world's artists for the intrinsic qualities of his genius, he stands out as the greatest of all the figure-designers of the school. If he has not the serene beauty of Kiyonaga's humanity, if he introduces an intensity that seems at times almost sinister, he has a stronger sense for the dynamic in figure-drawing, and far greater resource of composition. His felicities of unexpected invention are endless. He should be an inexhaustible study to figure-designers. And his versatility was great. His early book of flowers and insects is an exquisite work, delicately drawn with the finest observation ; yet in the groups of one or two figures, whole-length or half-length, or heads only, how large is his boldness, what force is in his style ! How magnificent is his treatment of the masses of black hair ! How expressive his line is of living

258

flesh and blood ! In the sets of prints illustrating that favourite subject of his, the life of the strong boy Kintoki and his wild mother of the mountains, Utamaro is at his most original, soars highest above the common world of Ukiyoyé. His famous triptych of Awabi Fishers (" Les Plongeuses ") is one of the great and rare classics of colour-printing. It holds its own with Greek design.

Contemporary with Utamaro's prime is the brief but tremendous production of Sharaku. No actor-portraits are so incisive, so big in design as Sharaku's, and he was a most original colourist, ranking with the greatest of the school. He makes the actor-prints of all the other masters look pale and small by comparison. Before he published his prints (1794–1795), the favourite actors of Yedo had always been more or less idealised. Sharaku drew them as they really were, incisively and unforgettably. His realism was disliked by the public, but his mastery was keenly appreciated by his fellow-artists, and he had great influence. But his imitators lacked his greatness of style, and the influence worked mostly for the bad.

For, in spite of the extreme brilliance of the decade 1790–1800, it is true that we have passed the meridian of Ukiyoyé. Toyokuni, a lesser man than Utamaro, an artist of strong gift but a nature of no fine fibre, easily yielding to popular demands, was in the main current of the decline and degradation. He, too,

at his best, can hold his own with greater men for vigour ; his earlier actor-prints are splendid ; but after Utamaro's death he seemed to fall headlong.

The two most eminent of Toyokuni's pupils were Kunisada and Kuniyoshi. Of these, Kunisada is the more celebrated, but unjustly. Kunisada did much extremely able work, though the mass of his prints, especially after he took Toyokuni's name in 1844, is disfigured by over-emphasis of every kind. Kuniyoshi, on the other hand, stands by himself ; in his best work, which is not theatrical, he breaks free from his school, and in his own province, the dramatic, rises to great heights. His preferred subjects are heroic : the feats of old Chinese warriors, the deeds of the Forty-seven Ronins, above all the fierce combats, the sieges, the ambushes, of the civil wars of the Middle Ages, the triumphs and disasters of Yoshitsune, of Nitta, of Masashige, of Takauji.

Such subjects as the slain hosts of Taira rising from the waves about the ship of Yoshitsune ; or the defence of the Emperor's person in the barricaded temple of Rokuhara ; or the last fight of Masatsura, when he and his two friends take the bodies of the slain upon their shoulders to shield them from the thick storm of arrows ; such subjects as these are after Kuniyoshi's own heart. Whatever faults these prints have—and they are not, of course, to be compared with the battles of Keion and Korehisa—they

show astonishing powers of design. And in the rare print of Nichiren, the famous exiled saint in a snowy landscape, Kuniyoshi rises to nobility.

In this realm of dramatic imagination only one man of Ukiyoyé could match Kuniyoshi, and even he has not left us such splendid dramatic pages—I mean the greatest, most various, and most puissant spirit of them all, Hokusai.

With Hokusai we move away from the main tradition of Ukiyoyé, now hastening to its riot of decay, into an ampler, wider world. It was in landscape, with Hokusai and with Hiroshige, that Ukiyoyé was to renew itself and complete the round of its achievement. Not that Hokusai was not a great master of the figure. But with all his knowledge of humanity, all his mastery of the human form, all his immense resource in composition, he has left few figure-subjects in which the essential powers of his genius are concentrated into the unity and perfection that make a classic, as compared with the masterpiece on masterpiece that overwhelm us in his landscapes.

The story of his life has been often told. Born in 1760, he was a pupil of Shunsho, and under the name Shunro produced graceful prints in his master's style. But his independent spirit asserted itself ; the two quarrelled, and the pupil was expelled. Hokusai was driven to various shifts to make a living, and was at one time a pedlar in the

Yedo streets. Then he procured work as a book-illustrator and designed a vast number of *surimono*, those messages of good luck, invitations, or announcements sent by the Japanese to their friends, chiefly at the New Year ; small woodcuts printed with especial care and daintiness. Inexhaustible in fancy and full of charm as these *surimono* are, they give but a hint of the mature strength of the artist. Hokusai reminds us of Rembrandt in the steady ripening of his powers from youth to age ; of Turner in the means he took to found his art on a basis of infinite and untiring observation. Hokusai surpassed even Turner in his industry. He could hardly stop drawing to take a meal ; he had no time to untie the packets of money with which he was paid, but handed one of them unopened to the tradesmen whose bills were due. They came back for more if the sum proved not enough ; not otherwise. No wonder that in spite of raging industry he was always poor. Unlike his countrymen, he was careless of his surroundings. When his lodgings grew intolerably dirty he could not stay to tidy them, but hired others. He moved house ninety-three times in the course of his ninety years. At seventy-five his thoughts were all of the future. He had learnt something of the structure of nature and her works, he wrote ; " but when I am eighty I shall know more ; at ninety I shall have got to the heart of things ; at a hundred I shall be a marvel ; at a

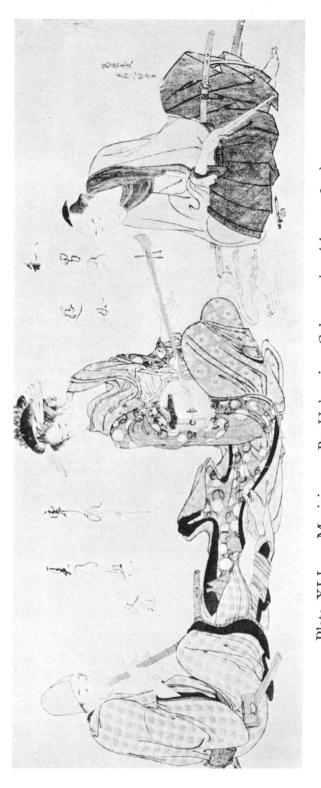

Plate XLI. Musicians. By Hokusai. Colour print (about 1800). The masterpieces of Hokusai being so well known, this rare print has been chosen to illustrate the range of his gift. A. D. Hall Collection.

hundred and ten every line, every blot of my brush will be alive!" He now signed his work "The Old Man with a Mania for Drawing." On his death-bed he sighed: "If Heaven had given me ten more years!" and at the very end, "Five more years, and I should have indeed become a painter!" It was May 1849. It is the custom with the Japanese, even with criminals condemned to execution, to make a little poem before dying. Hokusai's was this: "Now my soul, a will o' the wisp, can flit at ease over the summer fields!"

Greatly was this great artist rewarded for his unceasing and laborious cultivation of his gift. His paintings, fine as some of them are, represent him less truly and far less adequately than the wood-cuts made from his designs. In the "Mangwa," or collection of studies and sketches, a series published in fifteen volumes, the first of which appeared in 1817 or earlier, the vast range of his observation is displayed. Nothing in nature escapes his "devouring eye and portraying hand": mountains, rivers, trees, birds, fishes, animals, insects; the forms of breaking waves, flowers, rocks, and ships, buildings, utensils; men and women in every kind of occupation—all workaday Japan; comic and fantastic figures; even gods, saints, heroes, warriors, dragons, and fabulous beasts; all take life under his restless brush. The "Hundred Views of Fuji," printed in black and grey, appeared

in 1834; while to the twenties and thirties belong
the sets of colour-prints on which Hokusai's fame
chiefly rests, the " Thirty-six Views of Fuji," the
" Bridges," the " Waterfalls," the " Hundred Poems
explained by the Nurse," the " Flowers," the " Ten
Poets of China and Japan "; this last set, which
is very rare, being in some ways the crown and
climax of them all.

I have said that Hokusai reminds us of Turner
in the unweariable industry of his eye and hand.
He was like Turner in his effort to realise the quan-
tity of fact in nature, an effort corresponding to the
genius of the times in Europe, and symptomatic
even in Japan of the new spirit which was to come
to its own in our day. Hokusai allowed no such
profusion of accumulated material in the great land-
scapes of his maturity as Turner did ; yet in some
of Turner's noblest water-colours, in the " Blue
Righi " and the " Red Righi," for instance, we find
a curious parallel in simplicity of design and choice
of colour-scheme to some of the famous prints of
this unknown and unguessed-at contemporary. Who
that has seen a fine impression of the " Fuji in
Fine Weather," the vast ruddy cone sweeping up
from fringes of dim forest into a sky of clear blue
barred with white cloud, or " Fuji from the Hollow
of the Wave," with its monstrous billow toppling
heavy-crested over the rowers huddling in their
boat below (to name two alone of the famous Fuji

series), or the " Waterfalls," or the book called
" Hokusai Gwashiki," with its marvellous desolate
snow scenes, or the finest of the " Bridges " and the
" Hundred Poems Interpreted "—who can doubt
that the creator of these designs is among the greatest
landscape artists of the world ? The audacity with
which he eliminates whatever weakens or distracts
from the central interest of the design is superb.
He brings in a cloud of the old Tosa convention,
a solid band with neatly defined edges, where he
chooses. The intricacy and profusion of nature's
forms and hues are reduced to a scheme of definite
outlines and definite colours, vivid tones of blue,
green, yellow, relieved by white, and frequently
opposed by masses of light red. The limitations
of the wood block conditioned his designs, and by
an enthusiastic acceptance of those limitations he
achieves a marvellous success. These landscapes
are something quite new in Oriental art. The
effect is one of strangeness, a shock of beauty and
surprise at once. We feel that the world holds
more wonders than we dreamed of, sources of
power and exhilaration which Hokusai has revealed,
and which we may go on to discover for ourselves.
These prints are far removed indeed from the
majestic reverie, the aerial vista, the lofty con-
templation of the great landscape art of China, if
at times he emulates it in bold simplicity of design.
The spirit which informs his work is no longer the

spirit of fastidious choice, but of frank acceptance of the world as it is. Nothing is common to him; the incongruous stimulates instead of displeasing him. In one of his views of Fuji, the distant mountain is seen through the vast hoop of a cask which a cooper is busily making; in another the huge stacks of a timber yard form the foreground; in another, the plight of travellers on a windy road, with their clothes blown in their faces and their hats flying off, is depicted with the enjoyment of a Rowlandson. Hokusai finds nothing in nature or mankind irrelevant to the purposes of what, after all, becomes a design of real grandeur. I have no doubt that in our day he would have made of the poles and wires of electric trams material for beauty.

It was this frank and joyous acceptance of the world as it is which attracted modern Europe to Hokusai. Yet if we turn back to an earlier page of art, to Yeitoku, to So-ami, to Nobuzane, we feel at once that something has been lost. Old and effete conventions, many will say, which it was Hokusai's glory to supersede. But no, the loss is much more than that. Hokusai broadens the bounds of Japanese art, but there are heights he never reaches, moods he is incapable of possessing. If he reminds us of Rembrandt by the breadth of his interest, he has little or none of the tragic insight, the pathos, and deep tenderness of the Dutchman, from whom also his vivid sense of fun and quick-

266

witted alertness are quite alien. The work of the older masters may seem slight and limited compared with his ; yet theirs is a world of finer senses, of subtler emotions, of more serious soul. The difference cannot be explained in words. M. Gonse had in his collection two paintings of a plum-branch, one by the fifteenth-century master, Soga Jasŏku, the other by Hokusai. One must have some such tangible comparison before one to understand what Japanese critics mean when they insist on nobility and " lofty tone " in a picture. It is like the difference in " accent " by which Matthew Arnold sought to distinguish among the great poets, but which he could only explain by examples. It is at bottom a difference in attitude of mind rather than of technique ; yet we can never really separate the two, and Hokusai's brush-work tells its tale also. His line is jagged and restless ; one may see in it a conscious revolt from the long curves and flowing rhythms of Kiyonaga and his peers. Admirably as his figures are placed in landscape, sometimes with real nobility, his figures in themselves are too often defaced by mannerism. He is fond of a strange type, with low, receding forehead and grinning jaw. In the British Museum is a picture of demons trying to bend the bow of the famous archer Tametomo ; and here the mannerism of Hokusai's figure-drawing is almost painful, while the pigment is coarse and the colouring hot. For all that, his figures are always alive.

It is necessary to understand Hokusai's deficiencies; for even though he may be thought a mightier artist than any of his predecessors, it is not true that he represents the climax of Japanese art, the final genius for whom all those predecessors were preparing. He represents rather a breaking away from those long-maintained traditions, as he lived in a society cut off from those old ideals. When we have followed the course of Japanese painting through the centuries, and become familiar with its aspirations and achievements, we can understand why the Japanese themselves deny a place among their very greatest to Hokusai, even though we can recognise that prejudice has something to do with that denial. But prejudice apart, let us confess that the Japanese have a right to be indignant when European writers announce to them that they don't understand their own art, that a mere habit of idolatry explains their admiration of Mitsunaga and Sesshu and Motonobu, and that Hokusai is their greatest master. This was at one time the European attitude. But since this book was first published, the older art of Japan and of China has become far more widely known in the West; the stage of opinion represented by the De Goncourt has passed; and Hokusai at the present day probably receives less than his due.

The invasion of landscape by Ukiyoyé in Hokusai was continued by Hiroshige. We must note as

significant a total change in attitude from that of the classic landscape-painters. The Ashikaga and later Kano masters painted landscape as the Chinese had done, in the spirit of a communion with the life in nature, as material for the expression of a mood or an emotion. Ukiyoyé landscape has its roots, like our own English landscape, in topography. The classic masters cared nothing for the individual place : it was the universal features of earth and air that moved them ; and, as we have seen, they preferred to paint the imagined scenery of China to that of their native land. But with the early nineteenth century came a passion on the populace of Yedo for pictures of the beauties of their own country ; a symptom of the thirst for facts, the knowledge of actualities, pervading the people, which was preparing the way for the overthrow of the Tokugawa policy of isolation, for the era of Meiji and the acceptance of Western science. Illus trated guide-books abounded. Hokusai's land- scapes, though so original and often bizarre in effect, were illustrations of renowned views and favourite resorts of the excursion-loving people. Hiroshige now took up the work, and produced an endless series of colour-prints depicting many times over views of Yedo, views of Kyoto, views on the famous high-roads, the Tokaido and the Kisokaido, and the inevitable views of Fuji.

After the audacities and heroic simplicities of

Hokusai's landscape, it is a fall to Hiroshige, who is interested in smaller things, and who has far less sense for the elemental forces in nature. And yet what a delightful art is his ! He is less concerned with the stable rudiments of earth than with the beauties of their veiling by the atmosphere and changing light. No one has revealed to us so freshly the beauty of rain ; rain showering like light javelins that shine in the returning sun, or mingling with the mist and with the wind that bends and tosses a long ridge of blotted pines, or descending in straight rods that hiss on ground or water, or trailing delicate threads that caress the trembling willows. It is incredible how, with four or five colours, crude rather than subtle in themselves, and with only such gradation of flat tint as wiping of the block is capable of, he can bring to our eyes so living an impression of the beauty of twilight, when the last glow fades on the horizon of vast prospects over coast and islands and sea of deepening blue, or of moonrise among great avenues of enormous pines, or of night and stars, or of the flush and sparkle of changing weather among the mountains, or of the falling snow on white knolls and steep slopes above blue gulfs of sea. Hiroshige loves to depict fireworks illuminating the night sky over the Sumida, the crowd of boats on the water, the thronged spectators on the great arch of the Riogoku Bridge. In pictures like the " Batter-

270

sea Bridge," now in the Tate Gallery, Whistler takes a Hiroshige motive, and even his method of composition, and translates it into a vision of his own. Of all Japanese artists Hiroshige is the one whose influence has been widest on the painting of the West.

CHAPTER XVIII. CONCLUSION

THE colour-prints of Ukiyoyé were the first revelation to Europe of the pictorial art of Japan. Ignorant of all that lay behind these strange, new, ravishing harmonies of line and colour, enthusiasts were prompted sometimes to imagine that here at last was an ideal art, produced by men who were concerned solely with problems of decorative design, indifferent to subject. And under this spell there were those in Europe who imagined that our artists should do likewise.

Yet I am convinced that the finest decorative design has never been produced by men whose conscious aim was solely directed to that end. Two powers are present in the forming of a work of art : creative instinct and conscious intelligence. Two aims are present also : the achievement of beauty in design and the realisation of the life and character in men and things. Success is likeliest when the design comes mainly of the creative instinct, and the conscious intelligence is devoted mainly to the realisation of life. With the Ukiyoyé artists this was the case. They were enormously interested in the life around them, not less so than the Dutchmen of the seventeenth century, and they set to work to mirror that life, at least the gay and sensuous

272

side of it, in all its detail and variety. But they had this great good fortune, that their path was prepared and their problem infinitely simplified. A strict convention was prescribed them, by which they were relieved from all the difficult and entangling complexities of light and shade. Their mode of design was an inheritance from long ages of production ; it was for the individual to refine and vary on themes of rhythm and balance already found for them by the race. This definite and accepted circumscription proved the artist's liberation. His energies were not absorbed in the intellectual effort of translating the common scene into pictorial terms, a problem which in Europe of to-day each painter must practically set about solving afresh for himself ; but, this translation having been effected for him by the inherited habit of his national art, he was free to invent new harmonies of line and colour on the old basis, and at the same time, within the given limits, to exercise his interest in life and character.

The Ukiyoyé artists were picturing a time with all the manners, occupations, and amusements of its men and women. The value of their work, as art, lies not in this, but in the infinite harmonies of line and colour they created ; yet their conscious motive, as I have said, was not to make decorative arrangements so much as to picture the life around them. The Japanese themselves have been in the

273

habit of despising the whole school of Ukiyoyé;
and though the causes of this contempt are com-
plex, and partly on the score of art, the main pre-
judice against the colour-prints is that they remind
Japan of a period of degradation, effeminacy, and
excess. To our eyes they seem to picture a fairy-
land of beauty, removed from gross realities, and
we scarcely concern ourselves with the conditions
of life underlying it. But to the Japanese, accus-
tomed to nothing more realistic than the pictorial
conventions that Ukiyoyé adheres to, the colour-
prints are as vivid a picture of an epoch as Dutch
genre is to us of seventeenth-century Holland.

And here I would like to ask a question. If we
compare Dutch genre-painting with Ukiyoyé, what
does the latter lack as a representation of the life
of a period which the former gives us? Ukiyoyé
does not give us effects of light and shade, but these
can be seen wherever the sun shines. It does not
give us the texture of stuffs and surfaces; it is
arbitrary in its types of face and proportions of
figure, which vary with each artist's ideal. But if
we regard its production from the standpoint of
historical interest, quite apart from its value as art,
we must confess that it presents us with a far com-
pleter picture of the life of a time than does the
genre-painting of the Dutchmen. But then we
must add that the life depicted by Ukiyoyé is far
richer and more beautiful in itself. It is a life in

274

which immemorial custom, ceremony, superstition, poetry, legend are like closely interwoven threads making up a many-coloured web. Take almost any print, search out the meanings implied in its subject and accessories, and you will find yourself tracking, by intricate association and allusion, some habit of thought consecrated by a thousand-year-old poem, or be brought back to contemplate the deed of a mediæval hero, or the saying of an Indian saint, or the precept of a Chinese sage. You cannot detach one of these prints from the life that produced it ; some tender filament or clinging root binds it to a nation's living heart.

Is it not here that our art of to-day fails in Europe ? Our art tends more and more to be detached from the common life, to be dissociated from things of use, to become an affair of museums and exhibitions. This is all part of a wide tendency. The Japanese do not seem to understand an ideal till they have put it into practice. We in the West seem, on the contrary, to think that an ideal practised is no longer an ideal ; it is regarded as too good for daily use and in danger of profanation. Is it not so with our religious ideals ? Just in the same spirit we hang on walls porcelain plates that are thought too beautiful to eat from, though made for no other purpose. We fill a museum with fine works from divers countries, and place it in the midst of streets that desolate eye and heart, without an effort to

make them part of the beauty we desire. Art is not an end in itself, but a means to beauty in life. This we forget.

I have been told that a certain Japanese artist, who was studying in London, entered one of our chief art schools. On one occasion the subject of Joan of Arc was set as a theme for competition among the students. What was his amazement to discover that, in attempting such a subject, all that was thought requisite was to pose a model and paint her in armour! To him it seemed that no one could embody in a picture even the least profound conception of a soul incomparable in loftiness and simplicity without weeks of solitary thought, without a strenuous inner preparation, if not with prayer and fasting. We know what is applauded as the " conscientious " treatment of such a subject. The painter studies the period, finds a suit of armour of the right date (which usually turns out to be a little wrong), journeys to Domrémy or Rouen to make careful studies for his scene, perhaps chooses a peasant girl of the Maid's own district for his model ; and what energy is left from these labours and the work of elaborating his design he devotes to his conception of a heroic soul. A genius of exceptional intensity may, indeed, build on such foundations to magnificent effect, but only one in ten thousand. It was not by such means that Giotto, that Rembrandt, went

to the heart of the Gospel stories. And for most the process means absolute defeat. The spirit sets out to conquer matter, and by matter it is conquered. Yet only in the victory of the spirit can art prevail.

The Oriental painter who desires to portray the image of a figure standing in the history of his own lands with such a radiance as Joan of Arc seeks not in outward relics of the past, but in his own heart.

The image of his painting will be perhaps the actual work of a few minutes, but he will not put brush to paper till his mind is saturated with his vision, till the intense emotion it is charged with can be contained no longer. Slight to appearance may be the result ; but what a man puts into his work is there, and will be felt by all capable of the feeling that possessed himself, though from the profane it keeps its secret.

In the art of Sung and Ashikaga, those flowering times of the Asian genius, the work of the painter's hand was not conceived of as something objectively complete. Like a drama on the stage which requires a responsive audience before its capacities can be known, it took perfect life only in the beholder's mind. Not to build a tangible monument to his own powers was the artist's dream, but to create a beauty in the lives of men. He looked, it may be, to that ideal state, never actually attainable, when men should no more talk of art than the healthy

talk of health, because the beauty that had been sought through many images had been found in life itself. But this implies a harmony between painter and spectator, which, alas! no painter can count on with us. The spell of science has corrupted us. We do not ask, before a work of art, " What does this do for me? what does it mean for me as an experience? " but we judge it as a finished, objective achievement, ask whether its anatomy and perspective are correct, attach a moral value to the amount of labour obviously put into it, exercise our intelligence over details—anything rather than let our minds be wisely passive to receive what a true work of art will never give out to those who demand that, without effort or preparation on their part, it shall say all it has to say at once. Masterpieces are fine distinguishers of persons; they will yield all they have to some, while to others they are mute.

If our art ails, it is because our life ails. We shall gain nothing much from the study of the art of China and Japan by trying to adopt, from the outside, beauties of pictorial convention alien to our own modes of vision. But Heaven preserve us from a sterile admiration having its outlet only in a facile and foolish contempt for the achievements of Europe. What we can learn is to regain clearness of mind, and dissolve some of the confusion and anarchy which undermine our art;

278

CONCLUSION

and this is an effort for the public even more than for the painter. If we look back over the whole course of that great Asian tradition of painting which we have been following through the centuries, the art impresses us as a whole by its cohesion, solidarity, order, and harmony. But these qualities are not truly perceived till we know something of the life out of which it flowered. We then see that paintings which in themselves seem slight, light, and wayward are not mere individual caprices, but answer to the common thoughts of men, symbolise some spiritual desire, have behind them the power of some cherished and heart-refreshing ideal, and are supported by links of infinite association with poetry, with religion, yet also with the lives of humble men and women. We shall study this art in vain if we are not moved to think more clearly, to feel more profoundly ; to realise in the unity of all art, the unity of life.

NOTES

NOTES

CHAPTER II. EARLY ART TRADITIONS IN ASIA

THE discoveries in Khotan are described in detail and illustrated in the two works by Sir Aurel Stein, " Sand-buried Ruins of Khotan " (London, 1903) and " Ancient Khotan " (Detailed Report ; 2 vols., Oxford, 1907). A number of the actual objects discovered are exhibited in the British Museum.

Grünwedel's " Buddhist Art in India " (the English translation edited and amplified by J. Burgess) and A. Foucher's more recent " Art gréco-bouddhique du Gandhara " are authoritative works dealing exhaustively with the Gandhara sculptures, many specimens of which are in the museums of Calcutta and Lahore, in the British Museum, and at Berlin.

Full material for the study of the paintings found at Turfan is to be found in Grünwedel's " Altbuddhistische Kultstätten in Chinesisch-Turkistan " (Berlin, 1912), and in the superb colourplates of " Chotscho " by Von Le Coq (Berlin, 1913).

For a summary of the results of the various recent expeditions to Eastern Asia see the articles by Petrucci in the *Gazette des Beaux-Arts*, vol. vi. (4th period), p. 193, and in the *Burlington Magazine*, vol. xvii., p. 158.

As a supplement to " Serindia " the India Office has published a series of large reproductions of the Tun-huang paintings under the title of " The Thousand Buddhas," with descriptions by Sir A. Stein and introduction by L. Binyon. For the frescoes see Pelliot, " Les Grottes de Touen-Houang," Paris, 1920, etc.

CHAPTER III. CHINESE PAINTING IN THE FOURTH CENTURY

The " Admonitions " attributed to Ku K'ai-chih was first described by the present writer in the *Burlington Magazine*, January, 1904. Its previous history is discussed at length in Waley's

" Chinese Painting." A full account of the artist was given by Professor F. Chavannes in the magazine called *T'oung Pao*, Series II, vol. v., No. 3. See also the pages devoted to him by Giles, " Introduction to the History of Chinese Pictorial Art," and Hirth, " Scraps from a Collector's Note-book."

CHAPTER IV. ORIGINS AND EARLIEST PHASES OF CHINESE PAINTING

For the literary records of early art in China see Professor H. A. Giles, " Introduction, &c.," Chapter I ; for the trend of thought and development of ideals see Okakura, " Ideals of the East." For the painting of the Han period see O. Fischer's " Die Chinesische Malerei der Han Dynastie," Berlin, 1931.

The Wisdom of the East Series, published by Murray, includes the " Sayings of Confucius " and the " Sayings of Lao-tzŭ," both translated and edited by Lionel Giles.

CHAPTER V. CHINESE PAINTING FROM THE FOURTH TO THE EIGHTH CENTURY

The most famous of the masters who are recorded in the histories of this period is Chang Sēng-yu (Cho-so-yu in Japanese), who flourished early in the 6th century. He was renowned for his dragons and Buddhist pictures, but also painted hunting scenes and other secular subjects. Fame ranks him among the very greatest of Chinese artists, but no certain work of his is known to survive.

The Korean Tomb-paintings are reproduced in the Japanese publication, " Chosen Koseki Zu-fu."

For a fuller account of the subjects of Chinese and Japanese art see Anderson's Catalogue of Japanese and Chinese Paintings in the British Museum, Joly's " Legend in Japanese Art " (London, 1907), and " Mythologie Asiatique Illustrée " (ed. Hackin ; Paris, 1928).

For an account of the six Canons of Hsieh Ho, see S. Taki's " Three Essays on Oriental Painting," Petrucci's " Philosophie de la Nature dans l'Art d'Extrême Orient," and Waley's " Chinese Painting," pp. 72–73.

NOTES

CHAPTER VI.　THE T'ANG DYNASTY

The principal painters of the T'ang dynasty are :

Yen Li-tē (7th century).

Yen Li-pēn (7th century), brother of the preceding. See text. Both these painters were famous for pictures of foreigners. See text.

Wei-ch'ih I-sēng, of Khotan (b. 627). See text.

Chang Hsiao-shih. His picture of the Buddhist Hell was taken as a model by Wu Tao-tzŭ.

Li Ssu-hsün (651–716). See text.

Li Chao-tao, son of the preceding, whose style he followed. See text.

Yang Cheng (8th century). Painted portraits and landscapes.

Wu Tao-tzŭ. See text.

Lu Lēng-chia, pupil of Wu Tao-tzŭ.

Yang T'ing-kuang (8th century). Painted in the style of Wu Tao-tzŭ.

Wei Wu-t'ien (8th century). Famous for animals.

Chang Hsüan (8th century). Famous for pictures of women. See text.

Ch'ē Tao-chēng (8th century). Painted Buddhist subjects.

Wang Wei. See text.

Ts'ao Pa (8th century). Painted horses.

Han Kan. See text. Pupil of the preceding.

Ch'ēn Hung (8th century). Painted animals and portraits.

Wei Yen (8th century). Famous for pine-trees.

Chang Tsao (8th century). Painted landscapes in the Southern style.

Chou Fang (8th and 9th centuries). Painted genre, also Buddhist subjects, portraits, &c. See text.

Paintings in Japan attributed to T'ang masters are reproduced in the " Toyo Bijutsu Taikwan," vol. viii. Among these is the portrait of a priest by Li Chēn, which was brought to Japan from China by Kobo Daishi. See text.

PAINTING IN THE FAR EAST

CHAPTER VII. EARLY PERIODS OF PAINTING IN JAPAN

Principal painters :
 Kosé Kanaoka (9th to 10th century).
 Yeri Sozu (d. 935).
 Kosé Kintada (10th century).
 Kosé Hirotaka (10th to 11th century).
 Yeshin Sozu (942–1017).
 Takuma Tamenari (11th century).
 Kasuga Motomitsu (11th century).
 Takayoshi (11th century).
 Chinkai (12th century).

The chief works of the Fujiwara period preserved in Japan have been reproduced in " Toyo Bijutsu Taikwan," vols. i. and ii.

CHAPTER VIII. THE KAMAKURA PERIOD

Principal painters :
 Toba Sojo (1053–1140).
 Takuma Choga (12th century).
 Takuma Shoga (12th–13th centuries).
 Takanobu (12th century).
 Mitsunaga (12th century).
 Keion (13th century).
 Nobuzane (1177–1265).
 Nagataka (13th century).
 Yoshimitsu (14th century).
 Takakane (14th century).
 Mitsuhide (14th century).
 Korehisa (14th century).
 Mitsunobu (1434–1525).
 Yukihide (15th century).

Many famous *makimono* have been reproduced entire in Japan ; but apart from the Keion roll at Boston, the " Tenjin Engi " rolls in the Metropolitan Museum, New York, and a few other examples, the early painters of the Yamato school are hardly to be studied

286

in Western collections except in their Buddhist pictures. Numerous and fine examples of these are at Boston ; a few are in the British and other European Museums. An important painting is the portrait of a priest in the Louvre (reproduced in Fenollosa's " Epochs," frontispiece to vol. ii.).

CHAPTER IX. THE SUNG PERIOD IN CHINA

Principal painters :

Li Ch'ēng (late 10th century). Famous for landscapes.

Hsu Hsi (10th century). Painted flowers.

Fan Kuan (10th and 11th centuries). Famous for wintry landscapes. An example is in the Freer collection.

Tung Yüan (10th century). Painted landscapes, animals, &c. See text.

Chao Ch'ang (11th century). Painted flowers.

Kuo Hsi (11th century). See text. In the Freer collection are several paintings by and attributed to the master. A landscape roll is in the Metropolitan Museum, New York. Portions of Kuo Hsi's essay on landscape are translated in Waley's " Chinese Painting " : fuller extracts are given by Siren.

Li Lung-mien, or Li Kung-lin (d. 1106). See text, and " Chinese Painting as reflected in the Thought and Art of Li Lung mien," by Agnes Meyer (New York, 1923).

Chao Ta-nien, or Chao Ling-jang (11th to 12th century). See text.

Mi Fei (1051–1107). See text.

Hui Tsung (1082–1135), the Emperor, and founder of the Academy. See text. Paintings attributed to him, especially of falcons and eagles, are to be found in the British Museum and many other collections. A picture of " The Emperor instructing his Son " is in the Musée Guimet.

Li An-chung (12th century). Painted birds. An album picture by him is in the Eumorfopoulos collection.

Li Ti (12th century). See text.

Ma Yüan (12th and 13th centuries). See text.

Ma Lin, son of the preceding. A landscape with Rishi, by him, is in the Musée Guimet.

Hsia Kuei (12th and 13th centuries). See text.

Mu Ch'i (13th century). See text. *Cf.* Fenollosa, " Epochs,"
vol. ii, p. 47.

Liang K'ai (13th century). Painted sages, landscapes, &c.

Examples of most of these masters are reproduced in the *Kokka*
or in the Shimbi Shoin's publications. The Boston Museum has
a splendid series of Sung paintings. Fine examples are also in the
Berlin Museum.

CHAPTER X. THE MONGOL DYNASTY

Principal painters :

Chao Mēng-fu (b. 1254). Painted horses, huntsmen, land-
scapes.

Ma Kuei (13th century). Painted landscapes.

Ch'ien Shun-chü (13th century). Painted flowers, animals,
figures.

Wang Jo-shui (13th century). Painted flowers.

Chao Tan-lin (13th century). Painted animals.

Ni Tsan (14th century). Painted landscapes.

Yen Hui (14th century). Painted Rishi.

Jēn Jēn-fa (14th century). Painted landscapes with sages.

Shēng Mou (14th century). Painted landscapes.

Tibetan Paintings.

Of these a large number have come to Europe and America
in the last decades. A fairly representative collection is in
the British Museum. One found at Tun-huang by Sir Aurel
Stein is probably the oldest specimen known.

Persian Paintings.

These can best be studied in the illuminated manuscripts,
of which there are magnificent specimens in the British Museum
Library, in the Bibliothèque Nationale, Paris, and in American
collections. " Persian Miniature Painting," by L. Binyon,
J. V. S. Wilkinson and B. Gray (Oxford, 1933), is fully
illustrated from the Persian Exhibition held in London in
1931.

NOTES

CHAPTER XI. THE ASHIKAGA PERIOD IN JAPAN

Principal painters :

Chinese School.

 Nen Kao (d. 1345).
 Gukei (14th century).
 Tesshiu (14th century).
 Cho Densu (1352–1431). *B.M.*[1]
 Kan Densu (15th century). *B.M.*
 Shubun, the priest (15th century). *B.M.*
 Soga Shubun. *B.M.*
 Soga Jasoku (15th century).
 Kantei (15th century). *B.M.*
 Oguri Sotan (15th century). *B.M.*
 Keishoki (15th century).
 No-ami (15th century). *B.M.*
 Gei-ami (15th century).
 So-ami (15th century). *B.M.*
 Riukio (16th century). *B.M.*
 Yamada Doan (d. 1573). *B.M.*

Sesshu School.

 Sesshu (1420–1506). *B.M.*
 Shugetsu (15th century). *B.M.*
 Unpo (15th century).
 Shuko (15th century).
 Sesso (15th century).
 Sesson (16th century). *B.M.*
 Unkoku Togan (16th century). *B.M.*
 Hasegawa Tohaku (1539–1610).

Kano School.

 Masanobu (1453–1490). *B.M.*
 Motonobu (1476–1559). *B.M.*
 Utanosuke (d. 1575). *B.M.*
 Shoyei (1519–1592). *B.M.*
 Hideyori (16th century).

[1] In this and the following notes, *B.M.* after a painter's name indicates that work by him, or attributed to him, is in the British Museum collection.

All these masters are represented in the *Kokka* and the Shimbi Shoin publications. " Masterpieces of Sesshu " and " Master-pieces of Motonobu " have been published in separate volumes. The Shimbi Shoin has also issued an admirable facsimile of Sesshu's greatest landscape, the famous *makimono* belonging to Count Mori.

Many fine examples of the period are in the Boston Museum and in the Freer collection, and some of the masters are repre-sented in the Berlin Kunstgewerbe Museum, in the Ostasiatische Museum, Cologne, and in the Louvre.

CHAPTER XII. THE MING PERIOD IN CHINA

Principal painters :
 Lin Liang (15th century). *B.M.*
 Lü Ch'i (15th century). *B.M.*
 Tai Chin (15th century).
 Wang Li-pēn (15th century). *B.M.*
 Shēn Chou (1427–1507). *B.M.*
 T'ang Yin (1466–1524). *B.M.*
 Ch'iu Ying (15th century). *B.M.*
 Wu Wei (15th century). *B.M.*
 Wēn Chēng-ming (1522–1567). *B.M.*

An adequate conception of the various Ming styles can be got from the paintings in the British Museum, the Musée Guimet, the Louvre and American museums.

CHAPTER XIII. THE KANO SCHOOL IN THE SIXTEENTH AND SEVENTEENTH CENTURIES

Principal painters :

Kano School.

 Yeitoku (1543–1590). *B.M.*
 Sanraku (1573–1635). *B.M.*
 Kaihoku Yusho (1533–1610). *B.M.*
 Niten (1582–1645).
 Sansetsu (1589–1651). *B.M.*
 Tanyu (1602–1674). *B.M.*

Morikage (17th century). *B.M.*
Naonobu (1607–1680). *B.M.*
Yasunobu (1613–1685). *B.M.*
To-un (1623–1694). *B.M.*
Tsunenobu (1636–1713). *B.M.*
Itcho (1652–1725). *B.M.*

Chinese School (of the same period).

Chokuan (16th century). *B.M.*
Ni Chokuan (17th century). *B.M.*
Shokwado (1584–1639). *B.M.*

Tosa School.

Mitsunori (d. 1638). *B.M.*
Mitsuoki (1617–1691). *B.M.*
Mitsunari (1646 1710). *B.M.*
Sumiyoshi Jokei (1597–1668). *B.M.*
Sumiyoshi Gukei (1631–1705).

The Boston Museum and the Freer collection at Washington are exceptionally rich in Yeitoku, Sanraku, and their school.

CHAPTER XIV. MATABEI AND THE BEGINNINGS OF GENRE

The work of Matabei, as of his precursors and immediate followers, is best to be studied in the sumptuous first volume of "Masterpieces of the Ukiyoyé School," edited by S. Tajima (Tokyo, 1906).

CHAPTER XV. THE GREAT DECORATORS

Principal painters :

Koyetsu (1557–1637). *B.M.*
Koho (1601–1682).
Sotatsu (17th century). *B.M.*
Korin (1661–1716). *B.M.*
Kenzan (1663–1743). *B.M.*
Shiko (d. 1755). *B.M.*

PAINTING IN THE FAR EAST

In fine examples of this school the American collections, especially the Freer collection, the Boston Museum and the Metropolitan Museum, are far richer than Europe. "Masterpieces of the Korin School" has been published by the Shimbi Shoin (Tokyo, 1903, 1904), and "Choice Masterpieces of Korin and Kenzan" by the Kokka Co.

CHAPTER XVI. NEW MOVEMENTS

Principal Painters :

Neo-Chinese School.

 Ryurikyo (1706–1758).
 Taigado (1723–1776). *B.M.*
 Buson (1724–1783). *B.M.*
 Jakuchu (1716–1800). *B.M.*
 Chikuden (1777–1835). *B.M.*
 Buncho (1763–1840). *B.M.*
 Kwazan (1793–1841). *B.M.*
 Hanko (1782–1846). *B.M.*
 Chinzan (1801–1854). *B.M.*

Soga School.

 Soga Shohaku (18th century). *B.M.*

Korin School.

 Hoitsu (1761–1828). *B.M.*
 Honi (19th century). *B.M.*
 Ki-itsu (1836–1898). *B.M.*

Maruyama and Shijo Schools.

 Okyo (1733–1795). *B.M.*
 Genki (1749–1796). *B.M.*
 Rosetsu (1755–1799). *B.M.*
 Nangaku (d. 1813). *B.M.*
 Goshun (1752–1811). *B.M.*
 Sosen (1747–1821). *B.M.*
 Naokata (1756–1833).
 Tessan (d. 1841). *B.M.*
 Keibun (1779–1844). *B.M.*

NOTES

Toyohiko (1778–1845). *B.M.*
Ippo (19th century). *B.M.*
Hoyen (19th century). *B.M.*
Raisho (1796–1871). *B.M.*
Yosai (1788–1878). *B.M.*
Bunrin (1814–1883). *B.M.*
Zeshin (1817–1891). *B.M.*

Ganku School.

Ganku (1745–1834). *B.M.*
Gantai (19th century). *B.M.*
Chikudo (1826–1896). *B.M.*

Good examples in various styles of the Chinese painting of the 17th and 18th centuries are in the British Museum, the Berlin Museum, and many collections in Europe and America, but little information about these Chinese painters is accessible. See Hirth, " Scraps from a Collector's Note-book." The Shimbi Shoin has published " Masterpieces of Jakuchu " and two volumes of " The Maruyama School." Of the masters of the late Kano school, Boston Museum has a vast amount; some good screens (presents from a Shogun) are in the Ethnographical Museum at Leyden.

CHAPTER XVII. UKIYOYÉ AND THE COLOUR-PRINT

Principal painters :

Moronobu (1624–1695). *B.M.*[1]
Moromasa (18th century). *B.M.*
Kwaigetsudo (18th century). *B.M.*
Choshun (1682–1752). *B.M.*
Okumura Masanobu (1678–1690). *B.M.*
Kiyonobu (1664–1729).
Kiyomasu (1679 ?–1763).

[1] In this note *B.M.* indicates that the master in question is represented by a painting or paintings. The reference does not cover the colour-prints. For instance, the Museum contains a large collection of Utamaro's prints, but has no painting by him.

Sukenobu (1674–1754). *B.M.*
Tsukioka Settei (d. 1787). *B.M.*
Harunobu (1718–1770). *B.M.*
Koryusai (18th century). *B.M.*
Shunsho (1726–1792). *B.M.*
Kitao Masanobu (1761–1816).
Kiyonaga (1742–1815).
Yeishi (1756–1829). *B.M.*
Utamaro (1754–1806).
Toyokuni (1769–1825). *B.M.*
Hokusai (1760–1849). *B.M.*
Hokuba (1770–1844). *B.M.*
Hiroshige (1797–1858). *B.M.*

The fullest information yet published on Ukiyoyé is to be found in the five volumes of " Masterpieces of Ukiyoyé " (Shimbi Shoin).

The colour-prints of Ukiyoyé can be studied in many public museums of Europe—the British Museum ; the Victoria and Albert Museum ; the Louvre ; the Musée du Cinquantenaire, Brussels ; the Ethnographical Museum, Leyden ; the Kunst-gewerbe Museum, Berlin ; the Print Room, Dresden ; the Ostasia-tische Museum, Cologne ; the Chiossone Museum, Genoa, &c. ; and in America, the Boston Museum ; the Art Institute, Chicago ; the Metropolitan Museum, New York ; the Public Library, New York ; the museum at Worcester, Mass., and elsewhere. Also in Canada, the Royal Ontario Museum, Toronto.

INDEX

INDEX

297

INDEX

299

INDEX